Pages 89-90, 14

207- 210 ,

are missing

Picasso

PICASSO

Pierre Daix

FREDERICK A. PRAEGER, Publishers

NEW YORK · WASHINGTON

BOOKS THAT MATTER

PUBLISHED IN THE UNITED STATES OF AMERICA IN 1965
BY FREDERICK A. PRAEGER, INC., PUBLISHERS
I I I FOURTH AVENUE, NEW YORK 3, N.Y.
ALL RIGHTS RESERVED

© EDITIONS AIMERY SOMOGY. S. A. PARIS 1964
LIBRARY OF CONGRESS CATALOG CARD NUMBER 65-20072
ILLUSTRATIONS PRINTED IN FRANCE BY SAPHO
TEXT PRINTED IN FRANCE BY INTERGRAPHIC LTD

CONTENTS

INTRODUCTION TO PICASSO

Nothing pleases Picasso more than to return to the place he knows best. It is not for nothing that he is a Spaniard. It is not in vain that he learned at the bull ring that 'the bullfighter who runs away is a bad bull-fighter.'

JAIME SABARTÈS

A hundred years ago, when Edouard Manet's *Déjeuner sur l'herbe* was refused by the Salon, no one even thought of doubting that painting was an imitative art; imitation of nature, and of other arts—the theatre, for example. Littré himself defined 'likeness' as 'conformity between a semblance of the object and the object imitated.' There was no question about it. Frantic efforts were made to dress machines in obsolete forms: railway carriages were made to resemble stage coaches, photographs to look like academic paintings. It was good taste to copy; conversely, any departure from natural resemblance was the acme of bad taste.

Some fifty years later, in 1917, the modern spirit was perfectly defined by Guillaume Apollinaire in his preface to the *Mamelles de Tirésias*: 'It seems to me that we must return to nature itself, but without imitating it like photographs. When man set out to make a machine that would walk he created the wheel, which does not in the least resemble a leg.' So imitation is transformation; conformity, invention; depiction, a form of creation. In France, particularly in Paris, painters and poets found themselves in the forefront of this struggle. There was more

7

at stake than merely the conception of painting; the whole relationship between man and the external world was involved. Picasso has done more than anyone to explode the superficial notion of the imitation of nature. However, to demonstrate that likeness is nothing more than illusion, a lie, does not condemn it altogether, and we owe it to Picasso that he compelled us to ask ourselves what is the real meaning of imitation. Is it a lie for the sake of the lie? Is it *trompe-l'œil*, evasion, passive acceptance of the lie? All academic art makes the claim that imitation can be nothing more than this. But from the very start Picasso put forward a completely new idea: 'Now we know that art is not truth; art is a lie which allows us to approach the truth—at least insofar as truth is discernible to us.'

A painter who talks this way clearly has an objective view of the world, of man and of art. For him, truth is not something given, accepted, conceded. It can only be won, conquered. One must fight to put it across. 'The artist', declares Picasso, 'must discover a way to convince the general public of the complete truth of his lies.'

This amounts to saying that there is no pre-existing truth in art; no truth in possession of the painter, nor of the public, which can serve as a standard by which to judge the work. Picasso challenges us, invites us to move, to change our outlook, to see with him a little better, a little more of reality and truth. It is because of this fundamental relationship of his work to reality—beyond surface or superficial appearances—that so many things have begun to look like Picassos. This also justifies an inquiry into Picasso's life and work, not for the sake of anecdote, but the very opposite: the major outlines of explanation, consistency and perspective on what Picasso calls 'leading the life of a painter'.

Nothing is closer to life than Picasso's work, nothing closer to the truth. His portraits reveal suffering, happiness, love; but this revelation is never static; love is born, triumphs, is defeated; beauty blossoms in joy and is destroyed in anguish. Picasso has done away with the very notion of *nature morte*. In his work things cry out, laugh, sleep, are at peace or at war, and are always alive—as alive as the eye that rests on them.

There is also a Picasso country, without any mystery, clearly marked on all the maps: a series of places that Picasso has looked at more often than others, in which his life and work have been intimately woven. This country is bounded by Fort Carré and Le Suquet, Antibes and

Cannes; in the interior are those lines of steep hills between the Siagne and the Brague, on whose slopes cling Vallauris and Mougins. Here Picasso once remarked: 'It's strange, but I never draw fauns, centaurs and minotaurs when I'm in Paris. You'd think this was the only place they live.' The spirit of ancient Greece, the gentleness of the Mediterranean coast undoubtedly captivated this native of Malaga. Antibes, Juan-les-Pins, Mougins, Vallauris, and 'La Californie' at Cannes represent for Picasso many periods of work, spanning over forty years of his life.

The Grimaldi Museum in Antibes has become the Picasso museum. His *Man with a Sheep* rightly stands in the square of Vallauris, opposite the 'Temple of Peace'. There is an entirely new look to the country. La Garoupe sings in Clouzot's film. The potteries have come to life. The bullfights are gradually taking root. Picasso is a catalyst, not only in art but also in life. Paul Eluard, who was his close companion here, expressed it admirably: 'Pablo Picasso is among the greatest of those who have proved themselves worthy of their existence. After having conquered the world he had the courage to turn it against himself, he was so sure, not of conquering it, but of measuring up to it . . . In defiance of accepted notions concerning objective reality he has re-established contact between the object and the observer who, in consequence, also makes a mental concept of it. With sublime audacity he has restored the proofs that the existence of man is inseparable from the world.'

Pablo Picasso was what is called a child prodigy. From early childhood he ceaselessly and constantly had to overcome all the temptations of virtuosity and also those temptations, more perverse still, born of his own successes. He regained his freedom by liberating himself in hard work. In order to maintain the mastery of his art Picasso bends his whole life to it as strictly as an astronaut to his training. 'I have never done anything extraordinary,' he explained to Marius de Zayas, 'or done any experimenting. Whenever I have had anything to say, I have simply said it the way I thought it ought to be said according to my own feelings. Different motives always lead to different methods of expression.'

To reach his objectives Picasso needs a new kind of precision. His capacity for sustained work, his patience, his accuracy, the speed at which he works, and his ingenuity of execution defy the imagination. He can never rest content for he places himself completely at the service

of his own freedom of thought and creation, and each day that same freedom has to be re-won. 'His hand has to be entirely free', noted Claude Roy after having watched Picasso at work on *War and Peace*. 'Although he knows exactly what he wants, while he is working he has to develop the spontaneity of someone who does not know, who is improvising. This freedom of expression is the fruit of long, exhausting effort, of endless notations in sketchbooks.'

It is at this level that Picasso's singular, exceptional career constitutes part of the great adventure of mankind itself. It brings us face to face with all creators of the past, it provides us with new standards for the aims of our time, its possibilities and responsibilities. It is a new measure of life. 'I don't develop,' Picasso once said, 'I am.' For him, being is to paint, to create, to transform—to transform himself, to create himself. In short, to live.

PICASSO AND SPAIN

*Like other Spanish successes, Pablo Picasso's was forged
on a certain side of Spain. What is profoundly Spanish
about Picasso is his critical sense, his capacity and his
will to question everything as he masters his vision of
the world and of men.*

<div align="right">JORGE SEMPRUN</div>

To say of Picasso that he was born in Malaga is not the whole story.
Velasquez was born in Seville. Goya saw the light of day in Fuende-
todos, and from there his path led him to Saragossa and the Count of
Fuentes. Pablo Picasso is Andalusian in the way that El Greco was Cre-
tan; one cannot hold him within the frame of his province and its parti-
cularities. From his youth he learned to know Spain, but his father's
frequent changes of residence had little to do with it. He made himself
a Spaniard, and remained one even when he left the country to live
abroad. He belongs to that revolutionary Spain dear to the French
heart. He belongs to the Spain of the future, the Spain for which he
painted *Guernica*, the picture now 'waiting' in the Museum of Modern
Art in New York.

His story begins on 25 October, 1881—at half-past nine in the evening,
according to him. His father, José Ruiz, was then forty, tall, slim
and fair; his friends found him a charming and cheerful companion.
He was a painter and taught at the provincial School of Arts and Crafts,
besides being director of the local museum. Picasso's close friend
Jaime Sabartès has traced Picasso's family origins to New Castile and
Aragon, not to the Basque country as was once believed.

Pablo's mother, Maria Picasso Lopez, was a brunette of medium height
with sparkling eyes. Her family had been in Malaga for a long time, but
there is no proof that they were of Andalusian origin. The name Picasso,
spelt with the double 's', is unusual in Spain, but although there was
an Italian painter by the name of Matteo Picasso who lived in Genoa in
the nineteenth century, nothing suggests Italian forebears. Even though
Picasso's family showed imagination in their choice of a name, it was
not Picasso who decided to abandon his father's name and take his

PICASSO'S BIRTHPLACE, PLACE DE LA MERCED, MALAGA

mother's. According to Sabartès, his Catalan friends adopted the habit because the name Ruiz was so common as to cause confusion, while Picasso was unusual, even unique.

In retrospect this seems significant, especially as all his friends of those days agree that he was much more like his mother than his father. Actually, however, Sabartès says that 'while his virtues resembled those of Donna Maria, who was intelligent as well as good, and a model of grace and wit, Don José's personality and looks were a good match for his wife's qualities... Picasso unquestionably owes his sensitivity, good humour and natural grace to his mother; but when he is impatient, tired or upset, or when annoyed or interrupted in his work, his gestures immediately take on the look of Don José—with this one difference, that, in contrast to his son, what really irritated the father was having to go back to his painting.'

At the age of seventeen or eighteen, when Sabartès and his friends first met Picasso in Barcelona, he looked to them like a typical Andalusian. 'To the people of my province', Sabartès tells us, 'Andalusia evokes bullfighting, gypsies, the *chulo* and the *flamenco*.' But this was not the real Picasso, and very few people nowadays would think of

him as an Andalusian at all. Yet it is true that his eyes first opened on the sun-baked soil, the implacable light and the blue sea of Andalusia. Federico Garcia Lorca describes the *cante jondo*, the 'deep song'—the violent harshness and the tragic beauty of that countryside:

> *O lost village*
> *In sorrowful Andalusia.*

The Spanish coastline from Malaga to Almeria is called the Costa del Sol, the sunlit coast. Its brilliance impresses even those who actually live in its dazzling landscape, but we must put aside any superficial tourist idea of it, if we are to see it as it was to the eyes of the child Picasso in the eighties of the last century. To come closer to him, those of us who are neither Spanish nor Andalusian must first of all look at that almost African Mediterranean, which was the end of the world to the eyes of the ancient Greek. And we must then remember that for seven centuries Malaga was Moorish. The Alcazaba, which dominates the port, was built by the Moors on a Roman fortress; and the castle of Gilbralfaro to which it is attached is one of the great monuments of Nasrid art, dating from the last dynasty of the Arab Kingdom of Granada.

Although Picasso cannot be summed up by his infancy in Malaga, neither can his Andalusian upbringing be diluted in any general Spanish background. Thanks to his lifelong companion, Jaime Sabartès, we have some idea of Picasso's youth and family life in Malaga. Notable in these accounts is the recurrence of themes which appear again and again throughout Picasso's life—like musical motifs. Sarbartès' *Picasso*, which was written some years before the *Doves of Peace*, is full of Don José's pigeons and paintbrushes.

A couple of stories give an idea of the kind of child Picasso was. Once when he saw an infant attempting his first steps, he remarked to Sabartès: 'I learned to walk by pushing a tin of Olibet biscuits ahead of me because I knew what was inside.' 'He told me that twice', writes Sabartès, 'and he insisted on the motivation.'

Picasso didn't like school, and in this connection Sabartès gives the following account: 'When father and son arrived at the school there was always the same clash between them. "Why don't you come in with me?" Pablo would ask, "I don't want to go in alone. At least leave me your brushes. Or your cane. Or give me the little pigeon." Don José

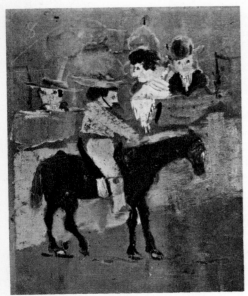

THE PICADOR. 1889-1890

CORUNNA. 1892-1893

used to take his brushes home to clean, and Pablo realized that he couldn't work without them. He was afraid that his father would forget to pick him up after school, so every day the same scene took place. In vain his father insisted that he would fetch the boy exactly at one o'clock. Promises were simply not enough. It seemed to Pablo that if his father's brushes were left with him he would not be alone. "I'll look after them for you", he would say. Don José used a cane for walking. Sometimes he took a pigeon with him to the museum to paint. "I was sure that if he left me the cane or the pigeon he would come back", Picasso tells us. "I preferred the pigeon or the brushes to the cane, because I knew that he could not get along without them."'

Don José painted still-lifes for dining rooms. 'The kind with pheasants and pigeons, hares and rabbits: fur and feathers'. He had a penchant for lilacs and pigeons. Picasso talked as if in a dream about one of his father's pictures, the one with millions of pigeons. But this was perhaps the dream of the lost Malagan paradise. During the equinoxial storm of September 1891, a month before Pablo's tenth birthday, Don José left for Corunna and the northern mists, wind and rains of Galicia.

14

Some of Picasso's sketchbooks from this period have survived. Under a cartoon showing petticoats lifted by the wind, Pablo wrote the legend: 'The wind has started up and will go on blowing until there is nothing left of Corunna.'

By the time he was thirteen his father had stopped painting pigeons, but he insisted that Pablo should make drawings of their claws. 'My father would cut off the claws of a dead pigeon and pin them to a board in the position he wanted; then I would have to copy them very carefully until the result satisfied him.' This was the moment—in 1894— that a great event occurred: Don José turned over his colours and brushes to Pablo—'And he never painted again.'

Picasso was now like the torero in the middle of the bull ring, left there by his father to face the world. From his earliest memories, when he was barely big enough to walk, Pablo's head was full of the arena, the movements of the quadrille, the work of the picador, the bandilleros and the matador, and, finally, that of the puntillero giving the *coup de grâce*. To take acount of all this is to introduce something more than local colour, and is perhaps the best way to understand a man whose life has been an unbroken series of battles—from *lidias* to *corridas*— and for whom the 'deep song' is always the *cante jondo* of the flamenco-singers.

THE YEARS OF APPRENTICESHIP

The revolutionary work of Picasso was not born of vanity seeking to hide the emptiness of desiccated intellectualism, but of overwhelming forces that the painter has always tried to subdue at all costs. Most artists tend towards seduction; he turns away from it.

<div align="right">TÉRIADE</div>

Visiting an exhibition of children's drawings Picasso once exclaimed: 'I could not have taken part. When I was twelve I drew like Raphael.' At fourteen when he was applying for entry at the Barcelona Academy of Fine Arts, it took the other candidates a whole month to do their examination drawings. 'I finished mine the first day,' Picasso recalls. 'I studied it for a long time, and I carefully considered what I could still add to it, but I couldn't see a thing. Absolutely nothing.'

What impresses us most in Picasso's earliest surviving works—*Study of a Foot* after a plaster cast, 1893-94, his *Diploma Drawing* for the Barcelona Academy, the oil *Portrait of Don José*, the watercolour *Portrait of Don José*, the *Portrait of Aunt Pepa*, all of 1895, and the *Girl with Bare Feet*, which must have been done still earlier because it dates from Corunna—is not merely their technical precociousness, but the capacity to choose and make decisions, the maturity and intelligence in a boy on the threshold of adolescence. How else describe that power of penetration which makes the two portraits of his father—one showing him muffled up and stiff in the Northern cold, the other, leaning on his elbows, in the melancholy solitude of old age—proclaim with almost unbearable insistence the tragic fate of the sitter: 'No Malaga, no bulls, no friends, nothing!' And what about the barefoot girl with the air of unwilling but resigned sadness, of apathetic waiting? Doesn't she look as though she had been studied by a mature man, wondering about her and speculating on her destiny? And the *Diploma Drawing*—the astounding way in which the young artist takes in the model, notes with astonishing precision everything the latter's nudity reveals concerning his life, recording with the same close attention his facial expression, seeking to catch what is going on in the man's mind.

This sheds new light on the story of the box of Olibet biscuits. Picasso can no more sketch or paint than walk without knowing what is inside human beings and things. He has the urge to express everything: the wind that will end by blowing away Corunna, the bitterness of his father, the inmost feelings of the man of whom nothing is demanded but to pose in the nude. And once Picasso has told us what there is inside he knows there is *nothing more to be said*, an astonishing expression because it suggests a scientific outlook on reality in this child-painter.

This took place about seventy years ago. A boy of fourteen years, having left the sunshine of Andalusia for the mists of Galicia, rediscovers the Mediterranean, but in a strange country, Catalonia. Many years later at Vauvenargues, in the blazing sunlight that Cézanne also knew, his companion Jacqueline noticed that Picasso was looking straight into the sun. 'I have always looked the sun straight in the eye from my earliest years', he said. Catalonia was for him primarily a return to the sun.

It is difficult to discover what Picasso learned before he arrived in Barcelona, but his father taught him more than the tricks of the trade. In fact, Don José loved making things, colouring and transforming sculptures, making paper and cardboard cut-outs and, as far back as anyone could remember, Pablo did the same.

From his earliest enthusiasm for drawing, he would begin working 'from the bottom up or the other way round', according to Sabartès, 'from the inside out or vice versa, without ever having to make any alterations, so that when the drawing was completed the line ended exactly where it had started, almost as though he had been tracing over an existing drawing.' But even with this mature independence of mind, he nevertheless followed the course of painting at the Lonja, the Barcelona Academy of Fine Arts, where his father Don José had taken a position. 'I detested that period of my studies ', Picasso was to tell Kahnweiler many years later. 'What I did before was much better.'

In 1897 he left for Madrid to study at the San Fernando Academy, to which he found it extraordinarily easy to obtain admission. There is a very interesting letter dating from November of that year to his friend Bas of Barcelona. Pablo relates how his teacher was quite satisfied with the execution and proportion of his figures, but told him that he should pay more attention to the composition on the page (*encaje*), and Pablo exploded: 'In other words, I ought to put my figure in a

box (*caja*)! It seems incredible for anyone to say such stupid things. And yet as far removed as he is from our way of looking at things, he doesn't draw badly. Obviously he is one of those who draws better because he has studied at various academies in Paris. But don't be misled, we are not as stupid in Spain as we pretend to be. The trouble is we are badly taught...

'The picture gallery here is beautiful. Velasquez is unequalled. There are magnificent heads by El Greco. Murillo is uneven. Titian's *Dolorosa* is splendid, and there are some fine van Dyck portraits. Rubens has some fireworks, and there are some good little Teniers drinking scenes. And everywhere *Madrileñitas* so beautiful that no Turkish beauty could compare with them.'

These pronouncements by a boy of sixteen not only offer a long-due explanation of various attitudes and later developments, but also demonstrate Picasso's consistency. It is when he talks of his art that we come closest to him. The other circumstances of his life are of less importance, even the semi-poverty he was then living in (the money a rich uncle had given him as a reward for his initial success allowed him to go to Madrid, but provided him with no more than a pittance while he was there).

Madrid represented more than a mere change of school or habits. The real novelty for Picasso was that for the first time in his life he was on his own. 'The proof of this', Sabartès tells us, 'is that in Madrid he forgot the obligations his family wished to impose upon him and, though not deliberately, he upset their carefully laid plans.' It was not that he formally broke with the academy or deliberately refused to set foot within its doors. He simply forgot. 'Why should I have gone there? Why?' This point needs stressing because there are so many stories about Picasso's eccentricities and his alleged delight in giving scandal. The fact is that his whole life offers the example of great seriousness, simply following his profound impulses with no thought of the example he is setting.

While in Madrid Picasso caught scarlet fever. At the beginning of summer he returned to Barcelona, but left again almost immediately for Horta de Ebro at the prompting of Manuel Pallarès, whom he had met in 1895, and who was his first Catalan friend. Horta de Ebro meant mountains, the countryside and fresh air, but also represented a new world, another aspect of Spain. After Andalusia, Galicia and Castile,

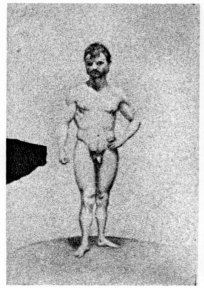 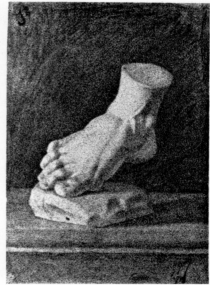

DIPLOMA DRAWING. 1895 STUDY OF A FOOT. 1893-1894

the wilds of Catalonia. There Picasso lived like the peasants, speaking Catalan, taking part in their labours. 'All that I know I learned in the village where Pallarès was born', must be taken literally. Horta de Ebro represented the practical contact with reality, and Picasso made it his own. While Don José always remained an Andalusian in exile, Pablo felt at home in Catalonia. His first stay in Horta de Ebro lasted seven or eight months, and, significantly, he returned there ten years later at the beginning of the Cubist adventure.

He packed a great deal into this short stay, and we have numerous sketches of peasants, gypsies, the work in the fields. But the most important thing is what he discovered about life. 'In touch with harsh reality,' says Sabartés, 'he realized that the coarseness of the Catalan peasant comes from the bitter struggle wresting a living from the soil. The peasants are very poor, their language is coarse, their words crude but expressive.'

It was on his return from Horta that Picasso made the acquaintance of Sabartés, who describes the atmosphere in Catalonia in the last years of the nineteenth century as 'a time when the Catalan language quivered

like a flag in the breeze'. Thanks to the work of poets like Mossen Jacinto Verdaguer and Joan Maragall a brilliant Renaissance of Catalan literature developed, and from then on a press in the Catalan tongue. All this produced a ferment of ideas, reflecting a fever of national revival and longing for liberty. Thus Picasso chose Barcelona in preference to Madrid—movement and youth as against stifling tradition. It was also in this period that Picasso finally succeeded in cutting loose from his family, and after a passing love affair with a cousin, he no longer spent his holidays in Malaga. At this time he frequented the *Hostal dels Quatre Gats*, the Cabaret of the Four Cats, a meeting place of Catalan intellectuals. Picasso now finally broke with his childhood; it was also the time of his first mistresses.

Someone has wittily called this the period of 'Picasso before Picasso'. However, the works he produced in those years do not justify so drastic a dividing line. A canvas like *Science and Charity*, which has a laboured effect, is a very different matter from, say, the *Gypsy*, whose impact remains undiminished, with pure colours carried to maximum intensity, foreshadowing the Fauves. In particular, the surviving canvases of those days, still owned by the artist, give the apprentice of fifteen, sixteen and seventeen years the multifarious dimensions of the mature Picasso. There are, for example, a *Flight into Egypt* of 1895, an *Alms in the Rue de Barcelona*, a procession outside the town moving towards a chapel amongst the cypresses, a full-length portrait of his father, a caustic genre scene with a bridegroom taking to his heels instead of accompanying his bride to the altar, and a night street scene with a prostitute adjusting her skirts as she emerges from the shadow into the light. All these canvases, painted with bold brush strokes, show the same sureness of judgment as the canvases painted before his entry into the Academy of Fine Arts.

The *Flight into Egypt* is painted in sombre colours, making it difficult to decipher in places, and Douglas Duncan relates that he once asked Picasso what was the curious thing floating above the Mother of Jesus, if not the Holy Ghost. 'The Holy Ghost!' exploded Picasso. 'Those are dates. It is a palm tree with dates on it. They had to have something to eat, didn't they?'

In order to understand all that is to come, two important facts must be kept in mind: Picasso adds nothing to a painting once he feels he has said everything, and he never paints anything which is not necessary

to the particular painting and what he wants to say. Picasso was not born twice. From the tin of biscuits to his painting of today, the continuity of his work is evident. To attempt to deny it would be to try to temporize with Picasso, and the one thing above all others which is characteristic of him is his refusal to temporize.

NUEL PALLARÈS: HORTA DE EBRO

POSTER FOR 'ELS QUATRE GATS'. 1902

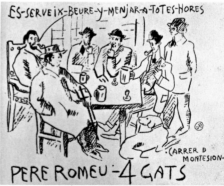

PICASSO'S EARLIEST SELF-PORTRAITS

At the age of twenty Delacroix painted himself as Hamlet, taking melancholy as his subject in the theatrical style of his day. A quarter of a century later Gustave Courbet, who was born at the time of Delacroix's Hamlet self-portrait, painted himself smoking a pipe: 'The portrait of a fanatic, an ascetic, the portrait of a man disillusioned with the principles of his own upbringing'. Gauguin, who was born the year of the Revolution, 1848, painted himself with palette in hand in 1893-94. Nor must we forget Van Gogh's desperate self-portrait of 1889 at the age of thirty-six, or Cézanne's in the bowler hat of the years 1883-85, if we are to understand those of the Picasso who drew or painted himself between the ages of sixteen and twenty-one. At the end of this period, in the winter of 1903-04, he suffered so much from the cold in Paris that he burned a lot of his sketches in order to keep warm.

Picasso dislikes mirrors and still more does he dislike dressing himself in theatrical costumes. His *Self-Portrait* drawn in Conté pencil, which Sabartès dates c. 1897-98, and the *Self-Portrait* when he was convalescing before his departure for Horta de Ebro show him strained, with a grown-up look—as if this boy of seventeen were beginning to doubt his physical ability to live long enough to meet the demands of his vision. 'He draws like the others', comments Sabartès, 'but takes care to include nothing but the essentials of what is there before his eyes, wasting no time on useless details, things unconnected with his aim of giving form to expression and to movement.'

The ironical drawing of 1899, in which he depicts himself oddly attired in his overcoat beside the painter Carlos Casagemas, was followed by a romantic version of himself at the side of Soler, which was done for the review *Madrid* in 1901. In this same year he also sketched himself twice for the review *Arte Joven:* first as a dandy, and then looking out at the world with a weary and disenchanted eye. His first *Self-Portrait* in Paris, painted at Mañac's in the Boulevard de Clichy, when he was twenty, is boldly stroked with diabolical assurance; it gives the lean and grave face of the convalescent of 1898 a fixed, hypnotic look which conveys a suggestion that he was near collapse and too proud to admit it. The first *Self-Portrait* of the Blue Period, with a moustache and a fringe of beard, hollow eyes and prominent cheek-bones, is that of a man aged by sleeplessness, cold and perhaps hunger; a man who

looks twice his age, and whose photographs twenty years later were to be the real portraits of youth, the sort of youth one would imagine. Then in a *Self-Portrait* of 1901, in Chinese ink, Picasso shows himself wearing a top hat, the lines of his face reduced almost to a skeleton, looking as if he had exhausted all the pleasures that money can buy, had lived every kind of life and was already tired of the pleasures those bare-breasted girls silhouetted behind him could bring. 'Picasso just wanted to see himself dressed up the same way as others', Sabartès explains simply.

There follow the self-portraits in profile Egyptian-style: wearing a cravat and with his hair brushed back; naked before a travesty of Manet's *Olympia*, with his friend Sebastian Junyer in the background, also nude, holding up a bowl of fruit. Others show him naked to the waist beside the sea with a palette in his hand; fully clothed, but with the minimum of lines; then younger, without moustache or beard, wearing a polka-dot tie; or muffled up, with a moustache and wearing a scarf and beret, surrounded by naked women; then in a Cordovan hat and in profile, with his friends Angel de Soto and Sebastian Junyer in full-face. Then in the stages of his return to Paris; then with a beret, moustache, scarf and overcoat, leading his dog. It was a period of terrible privations, cold and disgust—'especially disgust'. Sheer physical misery and also moral misery. 'We are inclined to forget', Cocteau was later to write, 'that Picasso is the pope of a church whose first martyrs were the cursed painters (starting with van Gogh).' These first self-portraits are by a painter who was damned at the age of twenty but who defied the condemnation.

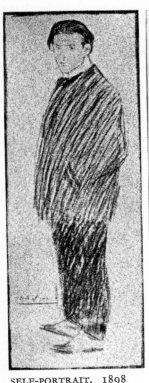

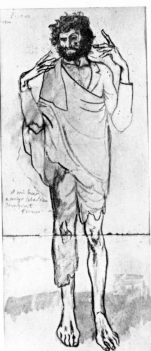

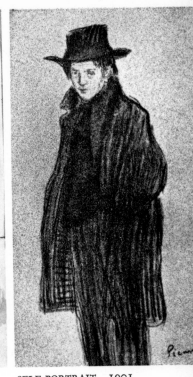

SELF-PORTRAIT. 1898

SELF-PORTRAIT: THE
POOR MAN. 1904

SELF-PORTRAIT. 1901

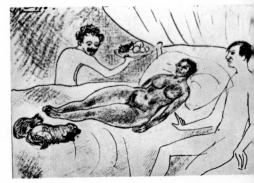

SELF-PORTRAIT. 1901

TRAVESTY OF MANET'S OLYMPIA. 1901

THE YEARS OF TRAVEL

A painter is nothing more than a painter and nothing less.

<div align="right">JEAN CASSOU</div>

Did Picasso ever see the Romanesque frescoes of Taull, Ripoli and Montbui, which are all near Horta de Ebro? Actually, the question is academic, for frescoes that in France would have been restored *in situ*, have in Catalonia been moved to the museums of Barcelona, Vich and Gerona. What is important is that Picasso captured and put to use the lessons of Catalan Romanesque art. He was nourished on that art born of the clash of two civilizations, the Arab and the Lombard, on the remnants of the Iberian and the Roman. It is an art in which all the cultures of the ancient and barbarian world mingle with Nordic, Carolingian and Frankish elements, and one is tempted to say that this melting pot was the *sine qua non* of a new and functional discipline.

Despite late nineteenth-century movements seeking an escape from bourgeois trivialities and decadent refinement by a return to early sources, Romanesque art was not in fashion. Yet Picasso's work was to be unmistakably influenced by it—a measure of his independence and curiosity, although there were also of course contributions from Catalonia and Catalan life itself.

Barcelona was then taking an active part in the intellectual movements of Europe. The intellectuals of the city were familiar with that mixture of anarchic revolt and Nietzschean frenzy which expressed itself in Paris in the *culte de moi* of Maurice Barrès, and *Les Nourritures terrestres* of André Gide, but at the turn of the century they also felt themselves the bearers of new responsibilities. Catalonia aspired to emancipation; she wished to shake off the torpor of feudal and bigoted Old Spain, but her progress remained barred. The frustration seemed greatest among the young Catalan artists, the curse irremediable, so much so that some of Picasso's friends were even driven to suicide.

But, as becomes apparent in all that follows, Picasso cannot be forced into any narrow historical or social framework. He was formed in the displacements that taught him to know Spain, to judge Malaga, Corunna, Madrid by the measure of Barcelona. He absorbed the originality of

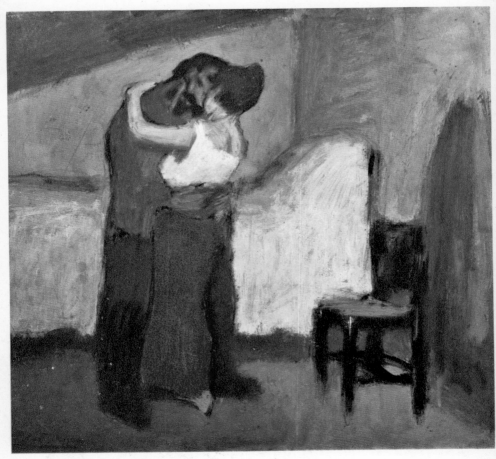

THE EMBRACE. 1900

Catalonia, the life of Barcelona, but he cannot be circumscribed by reading Santiago Rusiñol or looking at the houses of Gaudi. He must also have given careful thought to the aims of the Nabis in their attempts to subject painting to the expression of ideas, and their taste for unaffectedness; he was likewise not insensible to the Pre-Raphaelites, or to Ruskin's ideas, or reproductions he might have seen of the work of Burne-Jones. But whenever we track down some influence, we find that he mastered it and went beyond.

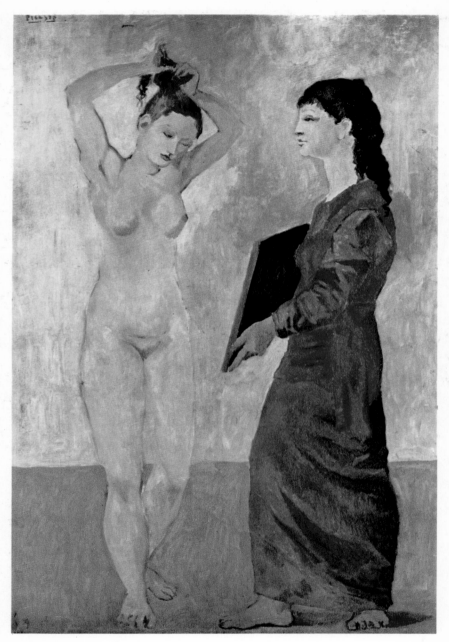

THE TOILETTE. 1906

It is not surprising that in the year 1900, when he was nineteen, he decided to leave Spain. At first he considered going to England, but in October of that year, shortly before his birthday, he took the train for Paris. He was accompanied by a young painter of his own age, Carlos Casagemas, and they set up their quarters together in Montmartre, rue Gabrielle. Picasso found an outlet for some of his bullfight paintings with Berthe Weill, who was later to become the chief dealer for Matisse. He also met a Catalan industrialist named Mañac, who offered him a contract: 150 francs a month in exchange for his whole production, which he accepted.

From this stay of three months are some canvases clearly related to Lautrec, both in subject—eg. *The Can-Can*, and *Moulin de la Galette*—and in style. But in contrast to the full light of Lautrec's *Bal du Moulin Rouge*, Picasso's *Moulin de la Galette* is a typical night scene, the light piercing through here and there, in a setting like the canvases of Picasso's youth in the back streets of Barcelona.

Cutting short this stay in Paris, Picasso returned to Spain with Casagemas, ostensibly because the latter had had an unfortunate love affair, but according to Sabartés, 'this may have been a pretext to justify a period for soul-searching.' The two young men arrived in Malaga on 30 December. Picasso left almost immediately 'as though he were escaping'. He had failed to extricate Casagemas from his troubles. Casagemas now sought relief in drink, and later returned to Paris and committed suicide there. Picasso reached Madrid in the middle of January, and became involved with one of those ephemeral reviews in the taste of the day, *Arte Joven*, (the 'New Art'), which proclaimed itself 'a journal that is sincere'. By the following May Picasso was back in Barcelona, but only for three weeks. 'What', asks Sabartés, 'was the best place to realize an ideal which he was only just beginning dimly to sense in a mind still young and a prey to indecision?' Sabartés goes on to compare this vacillation to 'the swinging of a pendulum, induced by the need to weigh and measure, the need to compare the memory of a place with his present impression of it.'

The pace of Picasso's life now quickened. On 24 June, 1901, his first exhibition opened at Ambroise Vollard's gallery in the rue Lafitte. It was organized by Mañac and consisted of seventy-five canvases on a great variety of subjects. *The Bar*, painted in the spring in Barcelona, was a successor to his first Paris canvases. *Longchamp* displayed subtlety

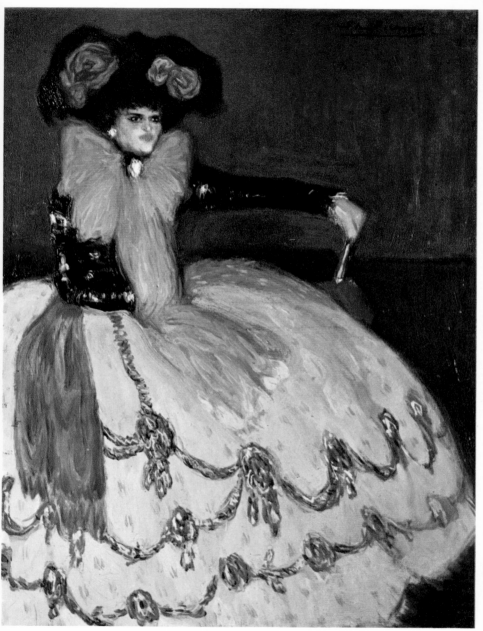

WOMAN IN BLUE 1901

and virtuosity in unexpected colour combinations, demonstrating that Impressionism and Pointillism no longer held any secrets for the young artist, still under twenty. Here, too, was the same faculty of passing judgment, of expressing everything until nothing whatever remained to be said.

The Embrace, now in the Pushkin Museum, Moscow, is one of his greatest paintings, on a theme already explored at some length, particularly in *Lovers in the Street*. In contrast with *Longchamp*, this painting is the essence of conciseness, stripped down to absolute essentials: an attic room, a powerful young man in a blue blouse, and a young woman with a mass of chestnut hair, in a white bodice and long red skirt. It conveys everything: home from work, the couple are together again, united in frank eagerness, in healthy sensuality and human warmth. Only what is necessary for the story is there, and this gives the picture its lyrical impact. Close to Manet, Van Gogh and Gauguin is *Child with a Dove*, with a sureness of touch and stroke equalled only in the confident play of blue with greens and whites, the whole painting radiating tenderness—perhaps in memory of Don José's pigeons. *The Tub* (or *The Blue Room*) tells the story of the studio in the Boulevard de Clichy. Blues predominate, in a subtle but sharp play of colour. Many canvases were now to dwell on such themes, into which Picasso flung himself with all the ardour of youth: women at their toilette, in chemise, washing themselves, washing their feet. In *The Tub*, and *The Toilette* of the Buffalo Museum, Picasso resorts to a traditional approach. But the dominant use of blue cannot be dismissed with oversimplified explanations such as poor lighting. For instance, in the *Burial of Casagemas*, Picasso revolts against the senseless suicide of his friend by a parody of a pious picture, associating the burial of the dead man with a couple embracing under a paradise of naked women in coloured stockings. *Woman in Blue*, of the Madrid museum, with bold glance and mouth set as she takes her place for the quadrille, is what Bruant would have called an asphalt flower; one of those Lautrec had in mind when he said that the women of the brothel were better made and less sophisticated. This canvas was left unfinished by Picasso when he went to Barcelona, which dates it March 1901, six months before *The Blue Room*.

'It was in Paris that I realized what a great painter Lautrec was', said Picasso. People are inclined to forget Lautrec's blues, the blue of his portraits, of his outlines from 1892 on, and the *Woman with the Black*

Boa, the bluish white of the sheets in *The Bed*, the artificial light of the stage in *Miss May Belfort*, besides all the nocturnal scenes: the *Moulin Rouge*, *Bal de l'Opéra*, *The Private Room*, the bistro of Monsieur Boileau. Lautrec found himself facing the challenge of electric lighting, gas lighting and petrol flares. But Picasso as a young man of the era of electricity, in one sweep penetrated that language of blue, blue shades, blue hair, the blue transparency of glasses and bottles. Also the power that blue gives to light and to what catches light (naked flesh, for instance). Lautrec, 'The poet of human flesh,' wrote Jean Bouret, 'excelled at expressing that quiver of muscles which is directly produced by a given lighting.'

Steinlen first came to Picasso's attention in Barcelona, through the periodical *Gil Blas illustré;* and Picasso's charcoal sketches, *Spanish Types* and *Women in Black Stockings*, bear direct witness to the impact that Steinlen's line had on him. But beyond Lautrec's blue and Steinlen's line Picasso sought to extract also their meaning. In them, through them and with them he sought to penetrate to the very depths of *la belle époque* : the human animal, the dives and the fallen women. The youth of twenty was determined to continue his search for just what it was that enabled his predecessors to reach beyond the mask. With his usual perspicacity Sabartès notes: 'To avoid the danger of being influenced by the artists of the day Picasso began to frequent the places where he could study their sources first-hand.'

If we compare *Pierreuse with Hand on Shoulder*, *The Courtesan with the Jeweled Necklace*, *Woman with Cigarette* or *Woman Drinking Absinthe* with Lautrec's *La Buveuse*, it is striking how Picasso brings the aura of alcohol and naturalism to the deepest strata of their beings. In those dazed, sometimes drugged eyes, Picasso lays bare the weariness of life, and the self-loathing—things not openly confided, but sometimes revealed in a furtive glance. Then Harlequin appears on the scene, introducing the dimensions of the stage and the entertainment world. *Harlequin and His Companion* represents the summit of this exploration in Picasso's twentieth year. Blue creeps over the made-up faces, the woman's hair, the marble table top and the reflection of the alcohol in the glasses; it serves to express the loneliness of the two figures, the futility of their huddling together, no human warmth passing between them. Again everything contributes to the story—here the opposite of *The Embrace*, the couple who cannot come together. Not a single

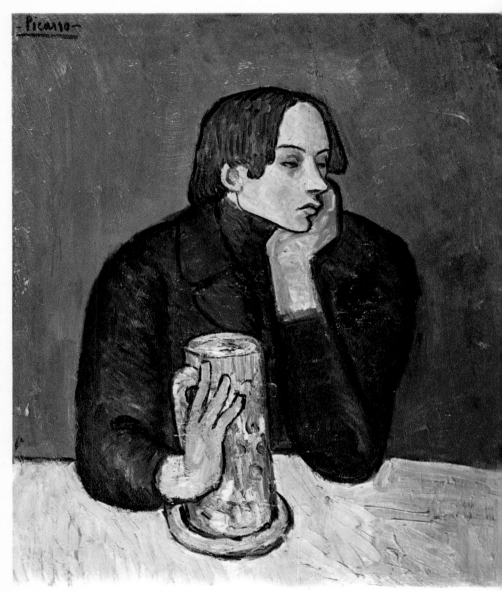

THE BOCK (PORTRAIT OF JAIME SABARTÈS). 1901

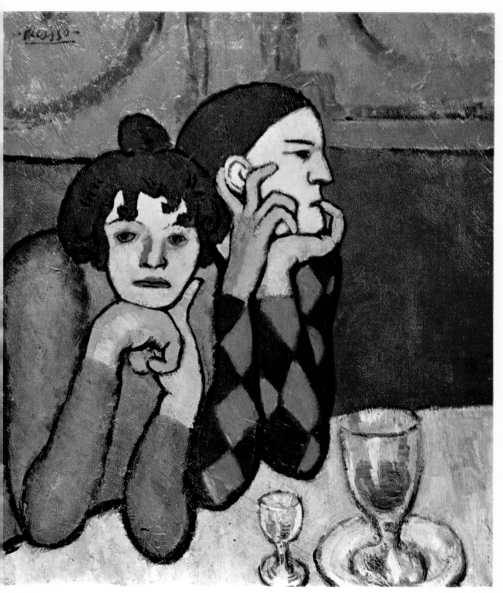

HARLEQUIN AND HIS COMPANION. 1900

superfluous detail; just enough of the bistro, the seat with imitation leather and the wall panels, as setting for the couple's anguish.

The Dwarf Dancer, of the Barcelona museum, extraordinary marriage of the world of Montmartre, Spanish tradition and a virtuosity deriving from Pointillism; *The Woman in Blue Stockings;* the frozen smile of *Bibi la Purée;* they all indicate Picasso's fluctuations and experiments.

Sabartès himself, on his arrival in Paris, was unable to connect the *Portrait of Coquiot* with the Barcelona canvases. This picture resulted from the meeting with the art critic at the beginning of the summer of 1901. Picasso mercilessly dissects the aging playboy and presents him against a background of cabaret dancers. Six months later Picasso painted Coquiot beardless, with a trimmed moustache, a self-satisfied collector with his pictures. Sabartès was shocked by the violence of the colour—and by the artist himself. Soon afterwards Picasso paints him at a table in a bistro drinking his bock. 'It was a picture of loneliness as seen from the outside', writes Sabartès. 'My gaze dissolves into shadows it is unable to penetrate. My thoughts are wandering. Thoughts and glance come together in the void to lose themselves there, since my gaze was myopic and my thoughts could go no farther.'

Decidedly, Picasso was starting where the others left off. He was doing the rounds of life at the speed of a Rimbaud or a Lautréamont. All the rest would be won against silence, achievement, virtuosity— against the flight to Harrar. *Harlequin and His Companion* and the *Portrait of Jaime Sabartès* convey not only the age-old lamentation over the miseries of the human condition, but also the power of art when it undertakes 'to change life'.

On Picasso's return to Barcelona, his explorations in the paintings of others came to an end. Thereafter Picasso was to invite into his own world those painters who occupied his mind and world. The initial manifestation of his independence is known today as his Blue Period.

THE BLUE INFERNO

*An epoch can only be recorded by the artists of that time,
that is to say, the artists who have lived through it. Each
age must have its own artists to express it and to record
it for the future.*

<div align="right">GUSTAVE COURBET</div>

The evidence of Sabartès is definite: from the beginning of the Blue
Period Picasso was determined to go to the sources of art, to forget
everything acquired by learning, to rediscover the spontaneity, the
innocence of primitives. ('The direct expression of the artist we call
pure; but not that which is produced deviously, by merely transmitting
what he has learned, without putting anything of himself into it... If we
insist on sincerity on the part of the artist, we must realize that it cannot
be independent of suffering. For Picasso, art is the child of sadness and
suffering (and we agree with him). He believes that sadness lends itself
to meditation and that suffering is the foundation of life.')

These words of course reflect the exaggeration of a young man of
twenty and must not be taken too literally. There was, in fact, nothing
religious, resigned or suffering about Picasso's plunge into the blue
inferno; on the contrary, it was altogether humanistic. He was a man
who looked directly at his fellow men, and explained them to us, but
first explained them to himself.

'The artists here', Picasso wrote from Barcelona to the poet Max
Jacob, 'find there's too much soul and no form in my canvases, and
that's very funny.'

Max Jacob had seen the Vollard exhibition of June 1901 and wrote
on a calling card that he had been immensely impressed by it. In reply
he received a letter from Mañac inviting him to visit Picasso in his
studio in the Boulevard de Clichy, and a friendship immediately sprang
up between the young Spanish prodigy, who could hardly speak a word
of French, and the twenty-five-year-old Jacob.

What is called Picasso's Blue Period ranged over three full years from
the autumn of 1901 to the end of 1904. During this interval Picasso
alternated between Paris and Barcelona, but whether he was in one city

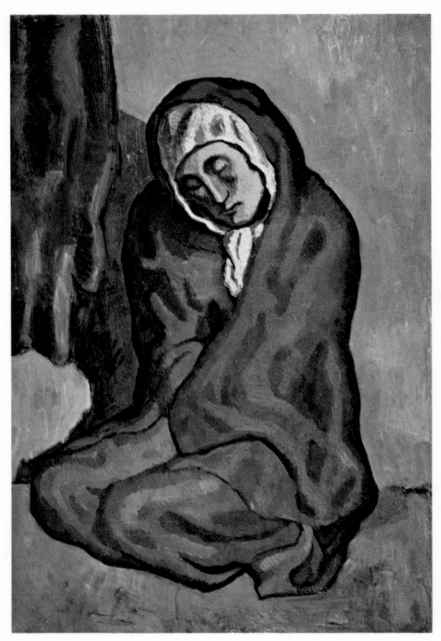

DESTITUTE WOMAN. 1902

or the other he worked like a man possessed. It was a time of great privations for him and, in winter, of suffering from the cold. On leaving Paris Picasso broke his contract with Mañac. His decision to return to Spain was no doubt motivated partly by a longing to see his family, his father. However, experience warns us that we must never seek to interpret Picasso's movements too simply. There comes a time when, for personal or practical reasons, Picasso can no longer work and live in a given place. That is all there is to it. 'He felt a need for a change of surroundings. He finds what he is looking for and settles down', according to Sabartès' straightforward account.

These changes of surroundings do not alter the direction of Picasso's work. Sabartès observes that the Barcelona canvases (1901-20) 'are of a rather richer tonality. But', he goes on to say, 'I soon forgot this as my own eyes grew more accustomed to the intenser light of Barcelona.' And this provides further information on the relationship between blue and the light. *Destitute Woman* is a remarkable example of this. Within the dominant blue, the symphony has changed both in tone and in feeling. The blue itself seems to have changed from the night blue of Paris to the day blue of Barcelona, but more important is the complete break with what was left of Impressionism in the canvases of Paris. Blue has become an idiom, even though—with the green of the cape and especially the headdress—we are still far away from the monochrome blue of 1903. Just as *The Drinkers* of 1901 turns its back on naturalism, the *Destitute Woman* goes beyond mere social criticism, the psychology of the sitter, the outward circumstances. Picasso asks himself, and forces us to ask ourselves, what is the meaning of that woman's life, of life itself. Blue is the means of expressing the compassion, the sadness in this poignant interrogation. It is interesting to note that what appears puzzling to many commentators today was no problem for Apollinaire, who in his first article on Picasso in 1905 wrote of 'this painting of tears, blue as the humid depth of the abyss, and altogether pitiable'.

Picasso left for Paris like a man starved for friends, for conversation, for liberty. 'If Cézanne had worked in Spain they would have burnt him alive', he confided to Raynal. The dominance of blue in his work was not affected by the change. Studying the canvases of 1902 one has the impression that Picasso is conducting his search on two levels: one, a kind of secularization of subject, substituting the poor and real

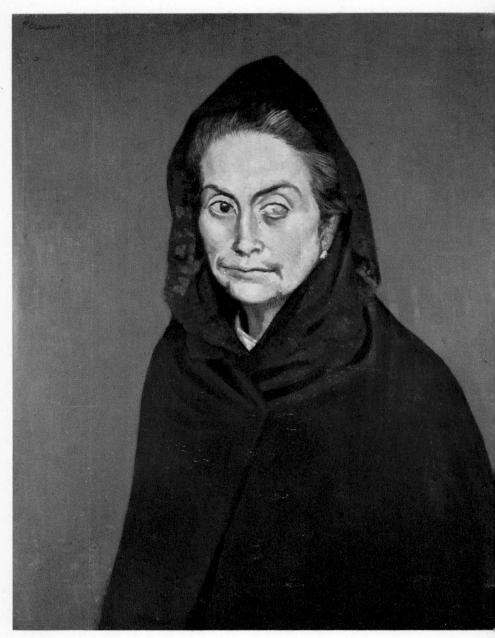

CÉLESTINE. 1903

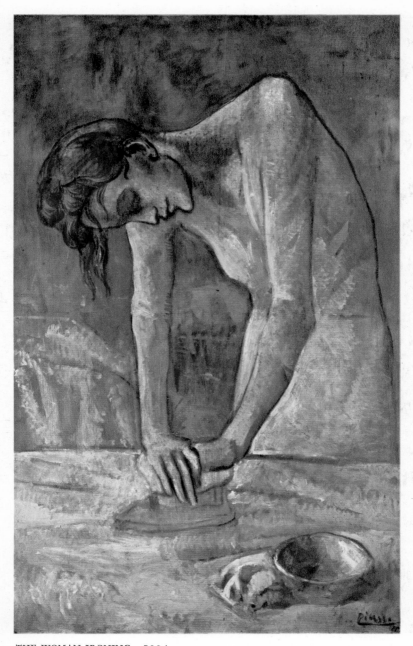

THE WOMAN IRONING. 1904

misery for the spiritual subjects of classical Spanish painting; the other, deliberate and independent technical experimentation with the rhythms of line and the possibilities of blue. But for the intimate plastic fusion of these two levels, and their free interaction in a unique creation, the painting itself is the sole evidence.

It is within this context that Picasso explores the different harmonies of blue. There is nothing casual or improvised about his vision. He studies blue and then gives himself increasingly free rein. Shadow, night, misery in blue, anguish in blue, hunger in blue. All his friends are in blue: Angel de Soto, the closest companion of the Quatres Gats period, the Solers and others. Was it from this moment that Picasso began to like blue, or had he always loved it? Thirty years later he was to write poetry in its praise.

In this way Picasso discovered the power of monochrome colour, of superimposed tones, to make the figures stand out from the background, which is thus neutralized. In this way, light falls on the canvas in harmony with the eye of the spectator. Perhaps this power of blue derives from the reflex of our vision, trained to distinguish the spaces of the sky, the sea, the night. In any case, Picasso makes it convincing.

Picasso's power carries over into the rhythm of his outlines. Women seated, squatting, stooping, like the one giving soup to her hungry son, or *The Two Sisters* which shows a young woman visiting her sister in the prostitutes' prison of Saint-Lazare—provide the first variations on the plastic themes with which Picasso never tires experimenting. It is not that Picasso isolates himself from the outside world, but simply that he uses only what interests him. The sea, possibly because he rediscovered it: *Mother and Child on the Beach.* Classic types presented by reality: *Célestine,* the one-eyed old procuress, painted in lively blues; *The Old Jew,* unseeing and huddled against the child who rivets his gaze on us; *The Déjeuner sur l'herbe of the Soler Family* (first painted without a background, Picasso leaving it to his friend Junyer to put in the trees); *The Old Guitarist,* shrunken, broken in the void of his blindness and misery, just as the Romanesque sculptors broke Christ on the Cross.

The Woman Ironing is perhaps the summit of Picasso's search in the blue inferno: the stark and naked tragedy of a broken human body. It is just a woman at her work, a simple woman with a simple task, and what the work does to her. By stripping it down to the bare essentials, avoiding all storytelling and allowing no unnecessary distractions,

Picasso gives ideological power to the subject. The blue of misery, a blue without horizon, as opposed to the sparkle of Impressionism, the aggressive happiness of light in a Renoir. No doubt Picasso was manifesting the need of breaking with his predecessors, but when we try to trace the path his painting was taking, we are struck by the compulsion to say everything about life, all that is known, all that should be known, so that nobody will misunderstand.

Everything else flows from this. It is not a question of imitating reality, of trapping it. The aim is to create an organism of signs and colours which will express the essence of that ageless woman wasting away over her iron. And in the very effort and tension of creation, the painting emancipates itself from naturalistic or impressionistic positivism, attaining a new fullness of expression, giving shape and meaning to what Baudelaire has called 'the moral sense of colour and line'.

Where another painter would revel in his mastery, Picasso analyzes his own motions, is dissatisfied, reflects, goes beyond. At the beginning of 1904, once more in Barcelona, he paints the bluest of all the portraits of Sabartès, also the most masterful and the least austere. 'In Paris', says Sabartès, 'the glistening gold tie pin would not even have been noted, even if the sun had made it stand out. The even brighter colour of my lips would hardly have interested him more. Excessive simplification and violence were necessary to him then.' Picasso painted the portrait in two sittings, the second of which was very short.

This is the typical Picasso, a compulsive painter who wants to paint the way a poet seeks the exact combination of words. 'Because his experiments taught him the possibilities of blue,' Sabartès remarks, 'he felt a desire to see how far he could go without it.' In effect, Picasso cannot mark time. Even if he takes up the same theme a hundred times, at an interval of many years, it is never an end in itself, but just a means, a way in which, brush in hand, he can carry the subject a little further.

MONTMARTRE ROSE

*More than all the poets, the sculptors and the other
painters, this Spaniard hits us like an icy blast.*

When Picasso left Spain to establish his new life in the studio on the
top deck of the 'Bateau-Lavoir', as Max Jacob called that dirty, noisy
but bright structure in the rue Ravignan, the change in his painting was
so evident that even at a distance of sixty years, this move seems to have
altered the course of his life.

THE FAMILY OF THE SALTIMBANQUES. 1905

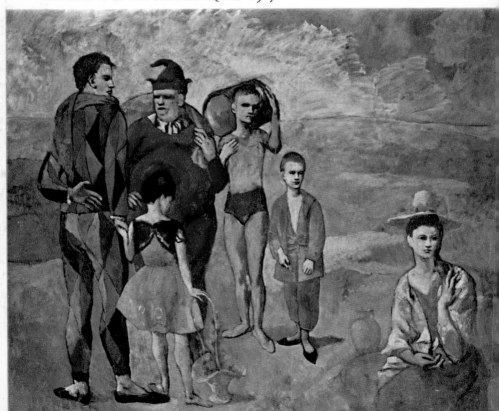

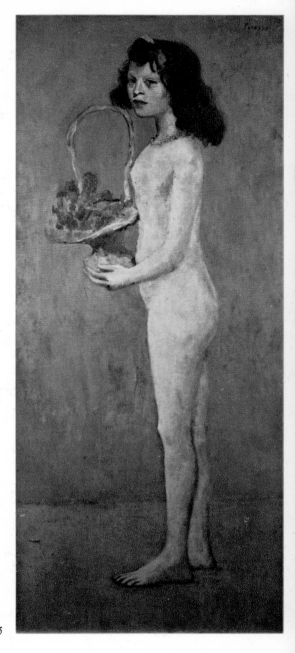

GIRL WITH BASKET OF FLOWERS. 1905

In the first place this break is marked by his choice of subjects. From the summer of 1904 on, Harlequin comes on the scene with his clean-shaven virility, the long muscles and supple gestures of an acrobat, and the same angular grace as his young mother companion, the drawing of which, Apollinaire notes, sometimes approaches the work of the Greek vase painters. At the same time the colours become warmer and more varied in delicate tones, and the disappearance of monochrome colour calls for a new type of composition in three-dimensional space.

Notable in this change of outlook is the distinct relationship that exists between form and content. The monochrome blue of Picasso's previous work expresses the feel of public places, without human warmth, in contrast to the present emphasis on rose tonalities which speak of the intimacy of the private home, as in *Still-Life with Picture*, or the big canvas, *The Actor*, in which the figure addresses himself to an invisible public. The space is varied, constructed in curves which respond to the movements of the actor like the gestures of the prompter's hands; it is a space organized around human activity.

Picasso had now settled down for the first time in his life. He felt at home in the rue Ravignan. The affinity between his new life and what lives in his paintings is no mere chance. In Picasso, the plastic expression always has a direct relationship with the circumstances of his life—he was to say it was 'a way of keeping a diary'. Any change in his life produced new subjects of interest, and brought about modifications in the very conception of his painting.

The *Girl with a Basket of Flowers* gives the impression of being a transitional painting because of the ashen-blue background, diluted as in *The Woman Ironing*, but what points to the future for Picasso is the awkward, graceless body; a head which is no longer that of a child, a large mouth and a tired look lacking in innocence. The slenderness of the body is no longer the emaciation of hunger; it points to the uncertainty of adolescence. The blue world of Picasso was already marked by life; here, life is still to come. This figure is full of ambiguity. The artist plays up the warm blackness of the hair and the flaming red of the flowers, while at the same time recording with brutal accuracy the intangible in this young girl hardly yet formed, with ugly legs and too big feet. When Gertrude Stein's brother Leo bought the picture from the dealer Clovis Sagot, she was disgusted, so Sagot suggested simply cutting off the lower part of the picture.

44

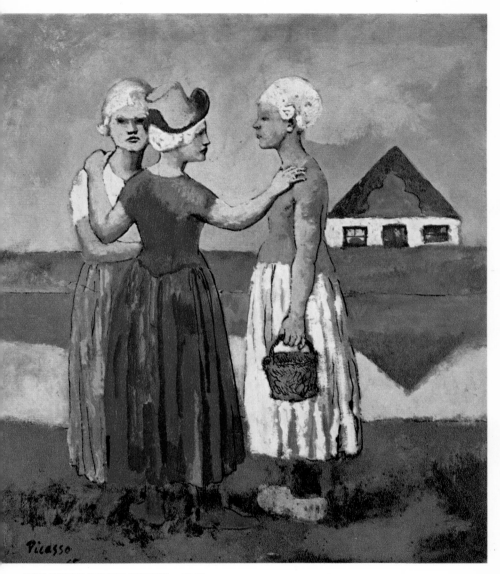

THE THREE DUTCH WOMEN. 1905

The Woman in a Chemise, with her strange, fragile, almost sinister beauty, and even more the *Woman with a Fan*, in profile, hieratic in her blue tunic, captivate us with the enigma of their stare beyond the picture, and have the obsessive presence of figures in Egyptian bas-reliefs. The modelling is almost entirely created by the single stroke of the outline. These two elements ultimately become the outstanding characteristic of the Rose Period; psychologically speaking, the presence of the persons is conveyed by their attitude, their ambiguity, their gravity, the questions they put to us, and plastically speaking, by their independence from the external world.

Slenderness, delicacy, grace and pride pervade the romance of the Harlequin and his wife, the young mother whose attractiveness maternity has not marred; likewise the world of actors, mountebanks and acrobats, whose prematurely old faces belie the remnants of youth in their lean bodies. Now living in a milieu of artists, Picasso went regularly to the Médrano circus, just off the Place Pigalle. Yet even nearer than the world of the strolling players was that of the young bohemian intellectuals amongst whom were Picasso's friends. What is called the Rose Period is also a reflection of the lives of young men like Max Jacob, Guillaume Apollinaire, Pierre Reverdy, Pierre MacOrlan and Maurice Raynal, not to speak of the Spaniards, the ceramicist Paco Durio, the sculptor Manolo. It was also in the Bateau-Lavoir that Picasso made the acquaintance of his neighbour Fernande Olivier, who belonged to the same milieu. Although barely emerging from adolescence she bore the secret burden of her short marriage to a young sculptor who had sunk into madness. However it was not until later—towards the end of the Rose Period—that Fernande began to share Picasso's life.

A further significant happening now occurred in the painter's development: the iron collar of blue anguish gave way to wandering and exile. The series of *Saltimbanques*, in which androgynous litheness is contrasted with a colossus or an enormous clown, combines the joy of painting with a new departure into a world still to be peopled. Maurice Raynal has spoken of 'unsurpassable perfection' in connection with works like the *Actor and his Child*, *Young Girl on a Ball*, and *Boy Leading a Horse*, masterpieces in a series which reaches the summits of Picasso's œuvre. 'A tapestry lost in the universe', was Rilke's description of the picture that represents a superb synthesis of all these experiments, *The Family of the Saltimbanques*.

That halt of a wandering circus, with the fat clown, the romantic harlequin, the adolescent with the narrow hips, the two boys with their bodies already wiry from training, the little girl with the basket of flowers, the urchin with the face of an adult, arise out of the depths of time and past ages, in a stony waste reminiscent of the back country of Malaga. Do they see the Majorcan woman on the other side of the picture? Is she aware of their presence? The canvas snatches us up and bathes us in unlimited space and time. This contrasts with the blue series, seemingly made up of closed snapshots. Here, we plunge into history, human continuity, just as if we were before a Poussin, before the *Arcadian Shepherds* deciphering an ancient inscription, with entirely different means from Poussin, but foreshadowing the combinations he was seeking fifteen years later.

This large canvas stamps the Rose series, but the year 1905 is not limited to these magic canvases. In the first place it was interrupted by a trip to Holland in the summer, out of which comes a stocky female model recorded by Picasso in a masterpiece, *The Three Dutch Women*, revealing how marvellously he makes use of suggestions from life to fertilize his researches. Accented outlines, silhouetting infinite space, even the phlegmatic, immutable sluggishness of the people and the land, all that absorbed Picasso is here reinterpreted in the light of Holland, a blue light, flat to the edge of the world.

1905 also witnessed a development of another order, toward sculpture, with a smiling *Clown*, a *Squatting Woman*, deriving from contemporary painting and, according to Kahnweiler, reflecting 'a state of mind satisfied with the technique of the day, whose effectiveness Picasso is not yet called upon to dispute, seeing that it is suitable to his present purposes.' On the other hand, his first prints give us food for thought. They develop the theme of the Harlequin family, without any obvious surprises, although amongst them a dry-point, *Salomé*, is revealing about Picasso's methods of work. For the depiction of Herod, he resorts to the outlines of the fat clown, and takes advantage of an imperfection in the plate to frame the delectable nude figure of Salomé in a diagonal composition of rare beauty. Apollinaire emphasises 'Picasso's taste for pure line which recedes, changes and penetrates, producing almost unique examples of linear dry-points, in which the universal aspects of the world remain unaffected by the light modifying the forms and altering the colour.'

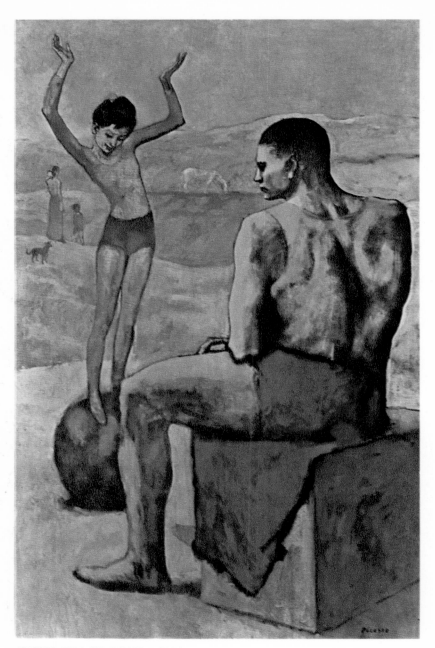

YOUNG GIRL ON A BALL. 1905

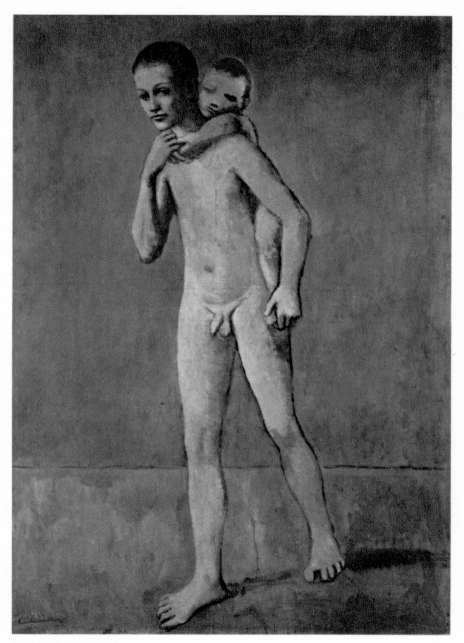

THE TWO BROTHERS. 1905

The above lines were published in the review *La Plume* on 15 May, 1905, accompanied by reproductions of five pictures: three of the *Saltimbanques* series, a portrait of Frédé's daughter (Mme Pierre Mac Orlan) titled *Woman with a Jackdaw*, and a blue canvas of 1904 representing two nude women embracing, *The Two Friends*. At the zenith of equilibrium, of apparent harmony, Apollinaire's text brusquely states what were to be the terms of the Cubist adventure: exactly how is the world, with its space and its forms, to be represented without distorting the colour? In other words, at the very moment when he seemed to be succeeding superlatively in all he undertakes, Picasso is already far beyond. The miracles of his draftsmanship are just so many attacks on the shortcomings of painting.

GOSOL, OR THE RETURN TO SOURCES

'In a head by Raphael', Picasso once said to me, the distance between the mouth and the end of the nose cannot be exactly measured. I would like to make it possible to do so in my paintings.'

<div align="right">

DANIEL-HENRY KAHNWEILER

</div>

The pictures of the Rose Period gained favour immediately. The Steins introduced American collectors to Picasso. One day Vollard went to the Bateau-Lavoir and bought thirty canvases *en bloc* for the sum of 2,000 francs. The relative affluence that this created, and the now intimate presence of Fernande, succeeded in transforming Picasso's life. His painting changed to a rapid rhythm. Fernande drove away the angular female, the slender androgyne. She catalyzed a new sensual image: broad hips, full young breasts, almond-shaped eyes under the delicate and pure double arc of the brows, a voluptuous mouth drawn in the perfect symmetry of the face haunt the canvases of this time.

Picasso took Fernande as a model for exploring the possibilities of expressing three-dimensional form by contour alone without variations of light. The *Nude with Hands Joined*, rose on rose, the light chestnut of the hair corresponding to the warm brown of the floor, treats the modulations of colour in a new way. 'If you use black,' Picasso points out, 'the observer will think it is solid, and, in fact, this is the only way you can indicate thickness, whereas if you paint a sculpture pink, it will remain pink.'

Picasso's problems now began to accumulate: outlines, the power of the individual stroke, colour values, the exact figuration of space and volumes. Pablo sketched Fernande in pencil (spring of 1906) making successive approaches to his aim, the methodical conquest which foreshadowed the *Nude with Hands Joined* of the Zacks Collection, in which Picasso sings the praises of beauty more freely than ever before. *The Toilette*, now in the Albright Gallery, Buffalo, NY, inflects the theme of a nude woman with arms raised holding her hair, and the motionless figure of a servant in profile, who, by being clothed, is removed in space from the nude woman. She holds a mirror only the back of which is

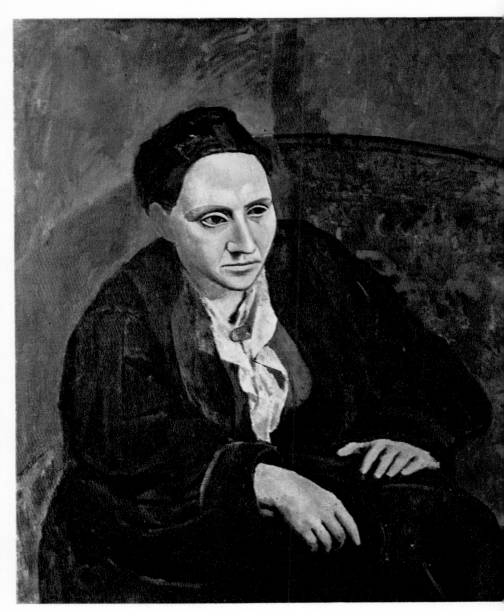

PORTRAIT OF GERTRUDE STEIN. 1906

visible, and stands with the material presence of a classical statue. This diversity of means foreshadows the confrontations which were to follow throughout subsequent work up to the series of the painter and his model. Both the *Sleeping Nude*, painted in the summer of 1906 at Gosol, and the *Woman with Head Scarf* freely develop the forms suggested by the face and body of Fernande, sifting the visual evidence, seeking the characteristic harmonies and specific features that express her personality rather than mere resemblance.

At the same time the search for the representation of measurable volume, the wish to paint a three-dimensional presence, was to produce a series of truly sculptural paintings, with vacant eyes, ranging from the *Nude Girl with Long Hair* to the splendid foreshortened *Draped Nude*, in the Samuel Marx Collection. For the year 1906, the chronological order of the paintings is particularly difficult to establish. Picasso worked on a number of canvases simultaneously. For example, in the winter of 1905-06, when Matisse was exhibiting his *Joie de Vivre*, Picasso started a *Portrait of Gertrude Stein*. Today we have only the final stage of this picture, which dates from the autumn of 1906, after innumerable sittings and a long interval.

It is even more difficult to isolate the influences to which Picasso was then subject. Moreover, the word 'influence' is misleading in regard to Picasso's work. The cult of originality is to him a foreign language. When a problem arises, the question is to resolve it. There is no need to re-invent what has already been discovered. The important thing is to find the means appropriate to the situation. Just as he never works 'after nature', but always 'with' it, Picasso never works 'after' what previous artists have attempted, but only 'with' what they have realized.

The first monograph devoted to El Greco appeared in 1906. The author was Miguel Utrillo, a friend of Picasso's from his Barcelona days. In the spring of that year an exhibition of Iberian sculpture, including reliefs from Osuna, was held at the Louvre. Picasso shared the new interest in the sources of art which motivated these manifestations. To look in the history of art for the solution of problems was a perfectly natural step for him. Wrestling with the contradictions born of his own work, he 'fled forward', but this process went hand in hand with reflections on early Mediterranean art, archaic Greek art, Etruscan art, vase painting on Attic *lekythoi*, Egyptian steles, or simply Gauguin's paintings.

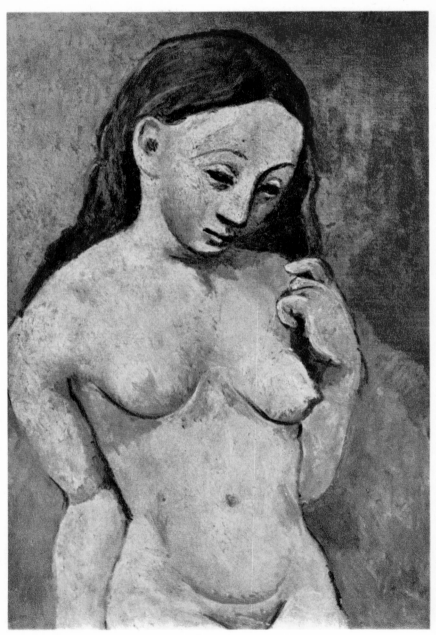

NUDE GIRL WITH LONG HAIR. 1906

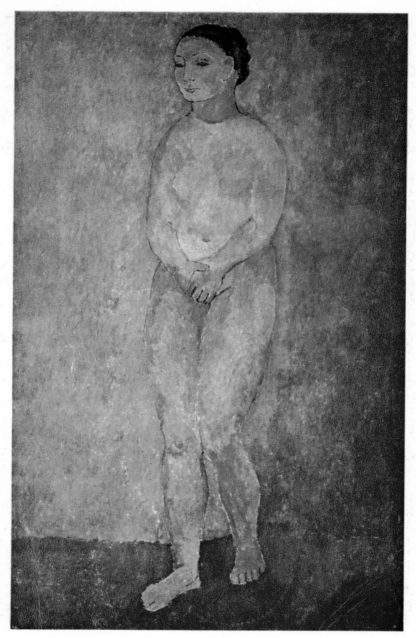

NUDE WITH HANDS JOINED. 1906

Picasso's attitude has nothing in common with the conventional interpretation of originality. He belongs to his own time. The ten years since his *Diploma Drawing* of 1895 witnessed the development of pre-history, archaeology and proto-history as sciences, and the upsetting of all accepted ideas about the origin of man. It was now realized that the Altamira rock paintings belonged to art. Anthropology became the true museum of man. In the same way, it became clear that painting does not fall from heaven, but that it is a human activity, a part of the history of man.

When Picasso decided to use part of the 2,000 francs he had received from Vollard to go to Spain, it was not because of nostalgia for his native country. What he sought was the primitiveness and rude simplicity of the Catalan highlands, which he had discovered during his convalescence in Horta de Ebro with Pallarès. Gosol, where he now established himself with Fernande, is in the heart of wild mountains, not far from Andorra. There he spent several months, 'working steadily, in good health and high spirits, happy to go off shooting or mountain climbing above the mists that covered the valley. What a different person,' exclaimed Fernande, 'and how cheerful he became, living in that village of smugglers!' He seemed to be seeking the harshness, the barrenness of that life cut off from the rest of the world, to enable him to break the rose melody of Montmartre, just as the *cantadores* of his native Andalusia break their voices in the flamenco song.

The mountain cure bore fruit. When Picasso returned to Paris, fleeing an epidemic of typhoid, he rapidly resolved the problems left in abeyance in the spring. In quick succession, he now painted the *Portrait of Gertrude Stein* and a *Self-Portrait*. Without doubt he now also executed the canvases depicting two nude women who give the impression of having been previously sculpted, and which he composed as if to document without equivocation his need for stereoscopic reference, going so far, in the *Two Nudes* of the G. David Thompson Collection, as to create the impression of seeing the same nude from the front and the back simultaneously.

Previously sculpted? It is true that his stay in Gosol offers evidence of something one can only call a process of concretization. Neither this approach, nor the process of abstraction has anything modern or exceptional about it. The alphabet itself was born of a process of abstraction extending over two thousand years, leading from a hieroglyph

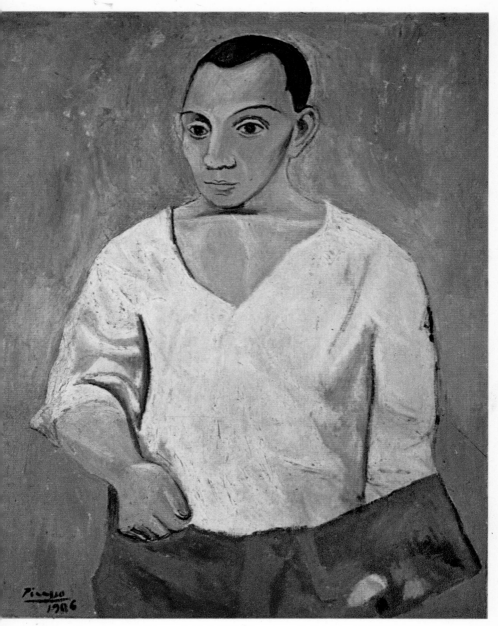

SELF-PORTRAIT. 1906

representing the head of a bull to the letter A (the abstract head of a bull turned upside down). In the same way, our letter O was born of a hieroglyphic eye. This is the way in which modern archaeology, going back from the Latin alphabet to the Mycenean linear B, then to Egypt, and finally to Sumeria, demonstrates the movement towards concreteness. As far as Picasso is concerned, *trompe-l'œil*, chiaroscuro and descriptive perspective are abstractions, and, what is more, falsifications. To seek to attain the concrete involves adventuring into a domain in which all resemblance to conventional abstract appearance is denied and banished.

Using the face of Gertrude Stein, and sometimes his own, Picasso now sets out to give us a reading in depth. He breaks with appearance in order to be faithful to volume while at the same time avoiding abstraction, generalization, and the inexpressiveness of pure volume. He dismisses details in order to preserve the attitude and the characteristic essence of the sitter. The final result is that the *Portrait of Gertrude Stein* and the *Self-Portrait* tell us more about the fundamental natures of the two subjects than the snapshot of a fleeting expression could. It is the development of photography that has emphasized the contradiction between movement caught in the fraction of a second and the deliberate pose. Picasso sets out to resolve this contradiction by seeking identity, not by mechanical reproduction such as photography gives, nor by freezing his model into any particular pose, but by reconstructing and plastically developing this identity.

I do not wish to imply that the debate here is between Picasso and photography. That question was, in fact, the concern of Picasso's predecessors, Delacroix and Degas. Picasso belonged to a generation which no longer felt inferior in the face of the camera. The proliferation of the instantaneous snapshot has revealed the inaccuracies of classic depictions of movement, but it has also shown that resemblance is not synonymous with visual data. Resemblance is, in fact, artificial, a representation standardized by habit, fashion and conventions. Picasso realized that in freeing himself from it he could at the same time get nearer to reality and obey the exigencies and laws of painting itself.

For a painter less attached to the painting of ideas, the obstacle of 'non-resemblance' would probably have proved unsurmountable, but Picasso realized that he was getting nearer to the immutable essence of his model. This prompted his famous observation that in time Gertrude

Stein would resemble his portrait of her. He had painted not only what he saw, but also what he 'knew' both about Gertrude Stein and about himself. These experiments gave him courage to go on. *Two Women Embracing* and *Two Nude Women* break with all ordinary conceptions of beauty, but they have the presence, the weight, the independent existence which primitive peoples confer on their gods. Picasso respects the external reality of matter and of the world, and in consequence he treats his persons as objects. It is this 'objectivity' which allows him to carry the process of re-creation and abstraction still further, as foreshadowed in the figure on the right in *Two Women Embracing*, certain parts of which are treated geometrically.

Maurice Raynal points out very rightly in this connection that these ideas of invention and re-creation were then given prominence both by the progress of science and by some 'great historical examples from Ingres to Seurat and Matisse'. This is the source of Picasso's conviction that 'the picture may be considered as an object independent of all pictorial representation, an object capable of suggesting emotion, because it is subject to the laws of human sensibilities and the ordering power of the mind, and that henceforth painting will no longer serve simply for visual delight.'

This amounted to a departure from Impressionism even more drastic than from classical painting. The Impressionists did, indeed, exhaust the possibilities of visual analysis and broken colour, of instantaneousness and the dissolution of reality in a welter of sensations. Picasso seized upon the idea that there is no independent vision, but he blamed the Impressionists for their submission to visual data uncontrolled by their senses. He reimposed reality in its structure—nature in its masses, its forms, its duration. This becomes a duel between man and matter, between the painter and the external object, toward the creation of a painting.

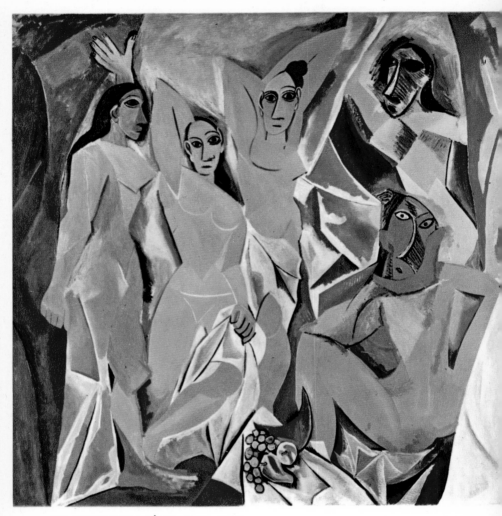

LES DEMOISELLES D'AVIGNON. 1907

STUDY FOR LES DEMOISELLES D'AVIGNON. 1907

INTELLECTUAL COURAGE:
LES DEMOISELLES D'AVIGNON

In the Middle Ages, scenes were superimposed. In the Renaissance, space was broken through by tricks of perspective. Now look closely at Picasso's great figures. Everything moves. I might call this a kind of cinemascope.

ÉDOUARD PIGNON

Fortified by the rigours and severity of the Catalan mountains Picasso gained new strength, and this carried him beyond the solid, powerful painting of the autumn of 1906 towards a greater fidelity in expressing space and volume, and towards an authenticity of colour. This resulted

61

in more complete emancipation from the simulations of classic perspective, which not only blinds the observer and flattens colour, but also tends to negate the personality of the painter himself; a photographer's equipment can achieve much the same effect. The champions of academicism knew this perfectly well when they refused to allow their canvases to be photographed. Actually, Picasso was continuing to search for a language appropriate to painting, which had already led him to study the possibilities of blue, the harmonies of rose, and the power of line. His strength lies in the coherence of his work and the unflinching affirmation of his responsibilities as a creative artist.

Fernande has described how he went out less and less, closing his door when he was working, and for peace and quiet developing the habit of painting at night by the light of an oil lamp. 'He would sit on the floor or on a low stool, or he would stand up, according to what he was doing, his canvas often on the floor propped up against the easel, his palette and brushes scattered about on the floor around him.' This was to remain typical of Picasso's studio habits—with variations according to the facilities of the place. He needed not only to be at ease but also to be surrounded by an order—or disorder—familiar enough so that it would neither hold nor distract his attention. He always had to arrange his own field of operations, so to speak—to take possession of the place both physically and plastically. That is the setting of numerous still-lifes and landscapes. What Fernande calls his palette actually has nothing in common with the conventional smooth wooden board. Picasso's palette consists of several newspapers piled up to form a flat place on which to lay his brushes, tubes and pots of paint. When it becomes covered with dabs of colour, a new 'palette' has to be made. Sabartès remarks that 'he liked to have the sun brown the paper and tone down the harsh crudity of its whiteness, or to spread a little turpentine or oil to tarnish it... The urge to work would give life to the new palette, transforming it into a neutral element adapted to Picasso's way of living and working.'

This was the kind of incubator atmosphere in which *Les Demoiselles d'Avignon* was produced. Far from being a demonstration intended to draw attention to himself, this painting was produced with relentless concentration, in solitude and moral isolation. Not until about twenty years later was it regarded as a manifesto, and then by the Surrealists, who were still infants at the time it was painted. Until Jacques Doucet

bought it in 1920 it remained rolled up in Picasso's studio, shown only to an occasional visitor. Braque was astonished by it when he was taken to Picasso's studio by Kahnweiler, who had just abandoned his career on the London Stock Exchange to become a picture dealer in Paris. Matisse thought it was some kind of hoax intended to discredit modern art. André Salmon summed up the general reaction: Picasso's intimates believed that he was abandoning them and was losing his hold on the new painting. Someone is said to have remarked on Picasso's change of style: 'What a loss for French painting!' This has been attributed by Gertrude Stein to the Russian collector, Shchukin; but it may be inaccurate, since it was not until 1908 that Matisse first took Shchukin to Picasso's studio.

Due to the commercial value which has since become attached to the canvases of this period, there is a tendency to assume that Picasso was compensated for his efforts by success. Actually, when he threw himself into this adventure, he had everything to lose and nothing to gain. No one, he least of all, knew whether or not this would be a solution. More precisely, he was the only one to look for the solution in the plastic experience of primitive art, in a conceptual representation of reality, not in an imitation. But this does not mean that he had any less independence or intellectual courage.

Picasso was not the first to have thought of renewing painting by delving into primitive art, but he was certainly the first to formulate the problem in technical and aesthetic rather than moral terms. From the Pre-Raphaelites to Gauguin, the Nabis and the Fauves, despite differences of aims and methods, each in essence was looking to the primitives for the same things: sanity, spontaneity, simplicity, freshness, ingenuousness. The very fact that they used the term 'primitives' is an indication that they turned their backs on the industrial age as corrupt and decadent, that their return to the past was a kind of retreat or revolt. Picasso, on the other hand, looks to the primitives to learn the lesson of modernity. He told Salmon, for example, that he liked Negro sculpture because he found it 'so rational'. It is also perfectly clear that he never regarded the 'primitive' painters and sculptors of Catalonia as either ignorant or clumsy, but as artists more attentive to expressing their own ideas than the artists who followed them. Picasso had the really modern attitude of judging civilizations not by their alleged progress, but by their creative achievement. In short, what

he was looking for in the primitives was not idyllic beauty, but a means to an understanding of his own time, a key to the future.

This was the attitude that allowed him to forge ahead. It was his confidence in the rational capacity of the artists of Osuna, in their *non-primitiveness* and their *science*, as in the *science* of Catalan art in the Middle Ages and the *science* of Negro sculpture, which sustained him and encouraged him to persevere. He was alone, as regards both friends and his whole epoch, but he was in the company of precursors, that crowd of unknown, anonymous artists, rejected until then but taken by him as precursors, in whom he acknowledged creative qualities.

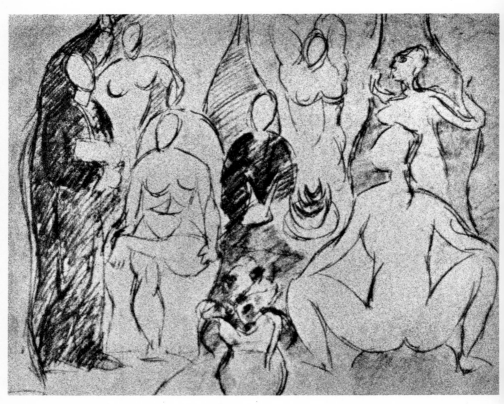

SKETCH FOR LES DEMOISELLES D'AVIGNON. 1907

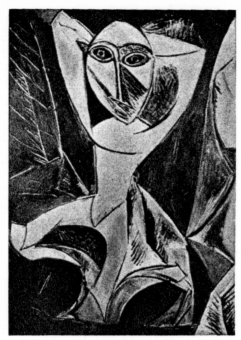

THE DANCER OF AVIGNON. 1907-1908

The Gosol period opened the way to mask-like portraits such as *Gertrude Stein* and the *Self-Portrait*. Forms are cut out in sharp angles, the eyes left blank, and modeling indicated by rough and powerful diagonal shading. The *Head in Full-face* and *Man's Head* have disproportioned ears like the Iberian sculpture of a man's head in the Louvre, one of the pieces stolen by Géry-Pieret and sold by him to Picasso that same year. However, the oval elongation and the thinning down of the lower part of the face are the result of Picasso's own researches, and were to lead to the new *Self-Portrait* of 1907.

In the Moscow Museum's *Bust of Nude Woman*, the nose is marked by dark, flat tones and a black stroke down to the left which, together with the accented right ear, gives an effect of rotation to the face. The *Woman's Head* of the André Lefèvre Collection, a profile bust, blue on a blue background, retains the refined oval of the face, but a nose exaggerated by blue and red hatching, and eyes emphasized by heavy circles, break with familiar conventions of representation and create a sensation of absolute strangeness, archaism and exoticism.

In addition to these studies of the human face, Picasso was also working on the theme of the nude woman with arms raised, fixing her hair, or crossed above and behind her head. This is the theme which had obsessed him since the end of the Blue Period, superseding his shattered and crouching women. Just as he did in developing the *Family of the Saltimbanques*, he now serialized the various problems, worked his way forward in separate explorations, compared results. This method of working, attested by photographs from Horta de Ebro in 1909 and from the Boulevard Raspail in 1912, elucidates the trials, studies and sketches for *Les Demoiselles d'Avignon* which have come down to us.

The subject of the painting is a brothel parlour, and the Avignon referred to is the *carrer d'Avinyo*, an alley of bad repute in Barcelona where Picasso, who lived nearby, used to go to buy his paper and watercolours. There were seven figures in the original composition: five women and two men, and there exist sketches of one of the men, a sailor in the act of rolling himself a cigarette. The first sketch of the picture seems to contain references to Cézanne's *Baigneuses*, the *Trois Baigneuses* of the Petit-Palais. It is quite possible that one of the factors that led to the creation of this great composition was the death of Cézanne on 22 October, 1906, three days before Picasso's twenty-fifth birthday. Cézanne had concentrated on the architectonic relationship between these nude figures, grouping them together in one great composition.

But even supposing that this sort of indirect homage played a role in the production of Picasso's painting, the picture itself very quickly developed its own dynamics and violence, although the figure of the crouching woman is probably related to the figure seated on the right in the version of the *Trois Baigneuses* which belonged to Matisse. John Golding, who agrees with John Richardson in suggesting this resemblance, bases his opinion on x-ray photographs made at the Museum of Modern Art in New York, which reveal an earlier version in which this figure has her hair in tresses down her back, and her forearm bent, not twisted.

The movement of the arms, the arch made by the arms of the two girls who stand full-face in the centre of the canvas, and the general disposition of the faces, repeat the 1906 experiments and go beyond them. The eyes are large and staring, the noses flattened, the ears seen frontally, and there is a twisting movement of the bodies. On the right side of the

canvas, the hatching and dissociated flat planes create a feeling of tension which contrasts with the pose of the central figures, creating movement and giving the canvas its dynamic power. This tension is due in particular to transpositions caused by breaks in the outline of the figures. This can be observed in a related study, *Head of a Man*, in ink and water-colour, belonging to the Museum of Modern Art in New York. The nose is reduced to a fringe of hatching, and Picasso has confined himself to merely suggesting the contour of the face. As John Golding points out, this *Head of a Man* in three-quarter view was inspired by an archaic Iberian sculpture in the Louvre, an asymmetric head.

The standing figure to the right of the canvas reflects the latest stage of Picasso's experiments with hatched lines and geometrical cut-outs, while the movement of the squatting figure is expressed by views from different angles, seen simultaneously in clearly-defined monochrome surfaces. These surfaces still contain certain colour modulations and there are traces of hatching and relief, but they fore-shadow the clearly-marked planes of the subsequent phases of Cubism, as does the basket of fruit in the foreground, which serves almost as a point of reference.

The breach with the spatial and temporal fixity of classic perspective is now complete. It is this contradiction between the continuity of contour and the discontinuity of different aspects which creates the so-called 'distortions'. The *Demoiselles d'Avignon* stresses the reality of a problem discarded and left unsolved by the Renaissance: the fact that our vision, the persistence of retinal impressions and our habits of looking allow us in a certain fashion to see—or imagine—the back of things, the other side of an object, of a person. In contrast to Velasquez' mirror or Caravaggio's light, Picasso dwells on mass itself, with volume unrelated to both ground plan and light.

What was so disconcerting and scandalizing about *Les Demoiselles d'Avignon* was not so much this technical revolution as the fact that Picasso had attacked the human figure itself and discarded the conventional representation of man made in the image and likeness of God. His challenge is no longer that of the impious Don Giovanni to the statue of the Commendatore. Centuries have passed since then. Picasso's confidence in the justification of his painting is unshakable. The age of science had arrived, the moment when, in order to represent physical phenomena correctly, scientists had to disregard physical appearances and common sense. Hertz was filling the air with invisible waves. In

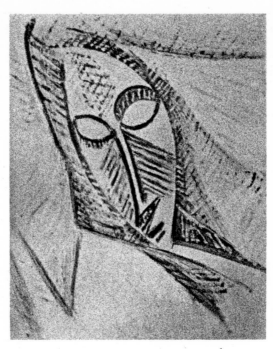

STUDY FOR NUDE WITH DRAPERY. 1906-1907

1900 Max Planck asserted that energy, like matter, has a discontinuous structure. Einstein introduced the fourth dimension. Inviolable definitions and the formerly sacrosanct invariability of time, space and matter were simultaneously demolished.

I have no intention of attempting to establish correlations, relationships of case and effect between fundamentally different investigations. Nevertheless, the fact remains that the generally accepted vision of the world was convulsed simultaneously both by physics and by modern painting; a physicist of twenty-seven and a painter of twenty-five both simultaneously found courage to oppose ideas which were so solidly established that they constituted axioms and dogmas. They were also opposed to one another, for as Garaudy rightly says: 'Where scientific reality demands the absence of man, artistic reality on the contrary demands his presence.'

Les Demoiselles d'Avignon alone is far from accounting completely for the year 1907. It represents a break with the past all the more, as we have seen, because the break was internal, but Picasso precisely

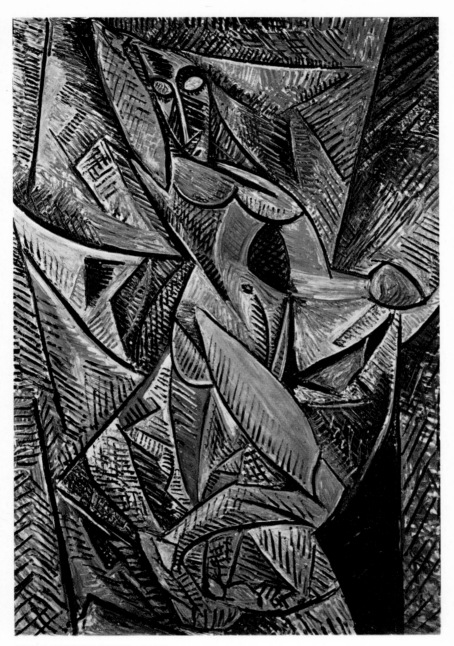

NUDE WITH DRAPERY. 1907

for that reason could not stop there. According to his own recollection, he stopped working on it towards the end of the spring. During that summer, which he spent in Paris, he painted a whole family of canvases culminating in the *Nude with Drapery* (sometimes known as *Dancer with Veils*), of the Moscow Museum.

Developing the theme of the head framed in the angle of the arm, Picasso expresses space and movement in relief by the interplay of diagonally hatched sections. His success was complete, and the lines of the body, the legs and the breast are of rare power and purity. However, for lack of an understanding of the process of stereography and abstraction involved in these experiments, and for lack of a comprehensive view of this whole group of works, the related canvases, *Nude with Drapery* and some other nudes have been cited as evidence that Picasso was now copying the style of Negro masks. In fact, one of these nudes is currently titled *Negro Dancer*, and likewise a *Male Head* of 1908 is labelled *Negro Head*, on account of the blank eyes, because, as explained by Kahnweiler, 'the severe simplification of form in Picasso's figures and their colour made some observers suppose that they are representations of Negroes!'

In reality the thing that interests Picasso—as indicated, for example, in his drawing, *Full-Face Head*, in which all the elements are reduced from the start to geometrical volume and projected onto the picture plane—is to arrive at a rigorous and measurable depiction of volume. That this should necessitate the elimination of factors normally regarded as inseparable from the identity of the model, does not perturb him, as can be seen from such a canvas as *Mother and Child*. His aim is to arrive at the structure, at the essence of the object, and he deliberately rejects all fortuitous aspects, just as in his landscapes of this period he ignores the time of day, and of course all attendant circumstances such as clouds, snow, rain and the season of the year.

All this is the prolongation of *Les Demoiselles d'Avignon*, and employs the same means. In fact, to call his *Nude* the *Great Avignon Dancer* is correct, because Picasso is still wrestling with the contradictions between the expression of volume, contour and colour. The bold tones of *Les Demoiselles d'Avignon* are contradicted by the hatching. On the other hand, though the method he uses produces wonderfully plastic rhythms, even to the point of creating an impression of dancing—something which was at first no more intended than the resemblance of certain

faces to Picasso's own features—they culminate in quite considerable 'distortion'. Actually, the epithet 'Negro'—the misinterpretation which persists despite the evidence of both Picasso and Kahnweiler—is a derogatory one, in the way that similarly derisive epithets are invented to damn all innovations in art from Romanticism by way of Impressionism and 'the cage of wild beasts', or Fauves, to Cubism. As Courbet observed: 'The title of realist was imposed on me in the same way as the title of romantic was imposed on the men of 1830. Titles have never reflected the real situation. If it were otherwise, the works themselves would have been superfluous.' Therefore, I shall keep to the term 'Negro' only for the sake of convenience because it does provide an historic point of reference, marking the coincidence of the work of Picasso and the discovery and first collections of Negro art.

The *Self-Portrait* in the same style, recaptures identity. The face cut out, set at an acute angle, great staring eyes, hair treated as an undifferentiated mass, emit an obstinate and hypnotizing power not easily forgotten. The *Portrait of Max Jacob*, executed in bold, simple strokes, is reminiscent of the *Sailor Rolling a Cigarette* which derives from a preliminary study for *Les Demoiselles d'Avignon*.

Still-Life with Skull, Nude with Towel and *Flowers on a Table* are all evidence of what Kahnweiler calls 'the mad audacity with which Picasso grappled with all problems simultaneously'. The abandonment of perspective, the conquest of space by the fractioning of planes, heavily outlined flat tones or hatching, the attempt to retain colour in spite of the hatching, the search for relief by exaggerating blue contours on a brown background and by thick hatching—Picasso's experiments are striking in each of these canvases.

As Eluard was to write: 'Picasso knows that the man who goes forward discovers a new horizon at every step.' The result has been the opening up of new horizons, more than to any other painter before this twenty-five-year-old prodigy deliberately turned his back on everything he found ready to hand. Let us add a remark by Picasso that tells a great deal: 'Success is the result of windfalls rejected. Otherwise one would become one's own patron. I don't buy myself.'

The result was what Louis Vauxcelles, who had already invented the term 'Fauves', called 'Cubism' in an attempt to deride and ridicule the experiment. The term dates from the year 1909, but the movement had started the previous year.

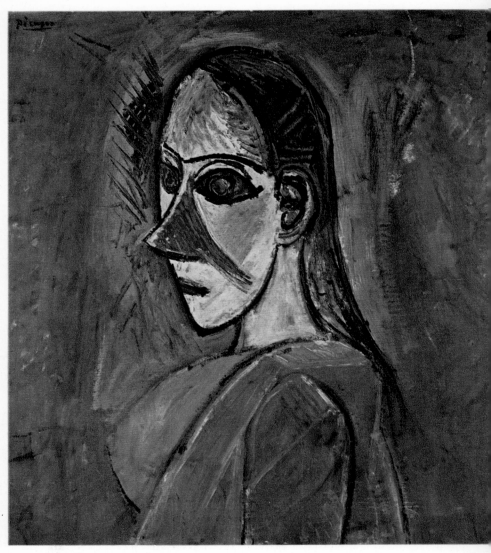

UNE DEMOISELLE D'AVIGNON. 1907

MEETING WITH BRAQUE,
OR GEOMETRICAL CUBISM

*To represent nature with the cylinder, the sphere and
the cone, and to put them all into perspective... For us
as men nature exists more in depth than on the surface.*

LETTER OF PAUL CÉZANNE TO ÉMILE BERNARD

The autumn of 1907 belonged to Cézanne: a great retrospective exhi-
bition at the Salon d'Automne, seventy-nine watercolours at Bernheim
Jeune, and the *Mercure de France* published his letters to Émile Ber-
nard and recollections of him by Bernard.

Looking at Picasso's pictures from the winter of 1907-08 we are
particularly struck by the interest he shows in Cézanne as a painter of
volumes. The series of still-lifes in the Moscow Museum take up again
the representation of objects in the round, but articulate the coloured
surfaces and emphasize the sculptural aspects and feeling fo rmass with
far greater decision than do the nudes of Gosol. The viewpoint, clearly
derived from Cézanne's perspective, dominates the objects and reveals
them, but at the same time Picasso emphasizes the breach with classic
perspective, stressing the interaction of forms and utilizing the effect
of refraction in the transparency of a glass to accent it. *Fruit and Glass*,
bought by Shchukin, is a study of apples and pears beside a glass, with
the edge of the canvas near the level of the fruit and cutting through the
glass, leaving only half of it in the picture. This motive affirms Picasso's
homage to Cézanne, and the restriction of space is still further accentuated
by the viewpoint looking down from above.

This 'return' to Cézanne has sometimes been interpreted as a pause
in Picasso's explorations, but this interpretation ignores the series of
small canvases which have remained in the possession of the artist
and which have become known through Douglas Duncan's book.
Unlike the so-called *Negro Dancer* in the hatched and whirling style of
Nude with Drapery, these studies of faces are carried out in a few very
heavy, extremely simplified strokes. One *Head* is even reduced to a few
symmetrical, geometrical indications: the nose to a vertical line, a hori-
zontal stroke and three pairs of slanting strokes; the ears to rectangles,

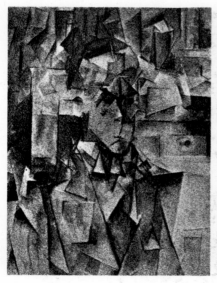

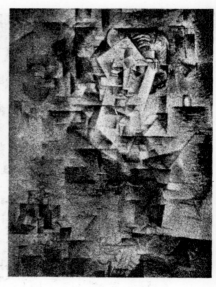

PORTRAIT OF WILHELM UHDE. 1910

PORTRAIT OF DANIEL-HENRY
KAHNWEILER. 1910

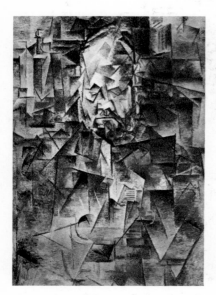

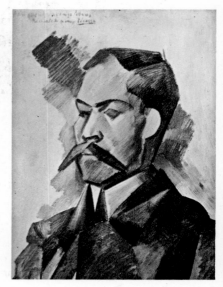

PORTRAIT OF AMBROISE VOLLARD.
1910

PORTRAIT OF PALLARÈS. 1909

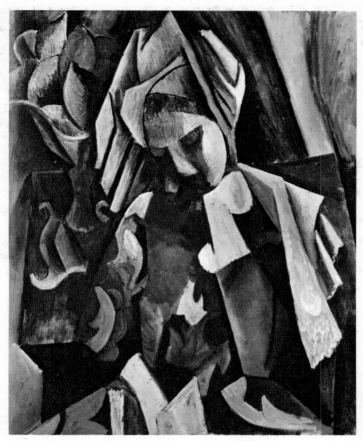

REINE ISABEAU. 1909

in the style of tattooing. A series of small studies catch the silhouette of a woman by manipulating a number of heavy black outlines which project oval masses and at the same time convey an impression of both volume and movement. The palette range is reduced to brown, black and a very pale yellow.

The series culminates in the *Nude on the Beach*, entirely modelled in curves, seen simultaneously from front and back, and possessing great intensity of presence. This canvas dates from the end of 1908, and combines Picasso's 'Negro' researches and his experiments with geometrical, cylindrical, spherical and cubic masses. In the Philadelphia

Museum's *Nude* of about the same date, the process is carried so far that only the sex is recognizable.

The year 1908 seems to be a time when Picasso re-established contact with reality. It could almost be called a year of 'realism', provided that the word is given its precise meaning of expressing the totality of reality. This is the interpretation which Pierre Reverdy has quite correctly used to stress that 'Picasso has always striven for a realist conception of art, not in the usual sense of the word, which emphasizes only the surface aspect—an art full of literary meaning and ideology—but *a truly plastic art*, concerned with the reality of objects, even to their physical composition, and independent of all charms, snares, illusions and deceptive atmospheric appearances.'

These reflections date from 1918, but they would have been perfectly valid ten years earlier. In his series of still-lifes Picasso was thinking not only of Cézanne, but of ordinary, simple reality, on which he relies. And when he left Paris in the summer and headed for the banks of the Oise, it was not the noble landscapes beloved of the Impressionists that he chose, but a simple village called Rue des Bois, between the Forest of Halatte and the river, between Creil and Pont-Sainte-Maxence. It is a hamlet of small houses by the side of the road where the forest ends. The landscape has hardly changed since then, though the big poplars have been cut down and the cottages have been improved and electricity brought in. It is worth visiting the place because of the paintings Picasso did there. One realizes then that the breach with Impressionism was not merely a matter of technique, but of a completely different concept of the world.

Picasso falls back on the lessons of Cézanne, rethinking the landscape, stressing modelling, volume and mass by articulating light and dark places and dislocating the perspective, but the rupture lies in more than this arrangement and geometrization of reality. The Impressionists opened up the landscape and gave us wide spaces; Picasso, on the contrary, drives us into it and holds us there. Nature is seized no further away than a porron, a glass or some fruit on a table. Where the Impressionists give us the sense of being lords and masters, Picasso keeps us at close quarters, shows us a tangible, everyday beauty.

Beauty is a big and vague word. Here, beauty is no longer hand-picked, distinguished, but something expressed in the truth of its plastic structure. As Kahnweiler says, this is lyrical painting: 'It has taught us

76

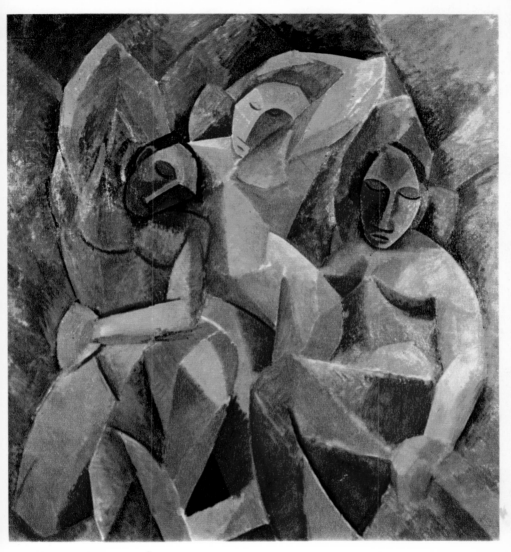

THREE WOMEN. 1908

to see beauty in the shape of the simplest objects, things which previously had never attracted our attention. But now these objects will forever have a halo of that radiant beauty the painter was able to extract from them.'

Therein lies the essential originality of Cubism. By an extraordinary coincidence, while Picasso was painting the cottages in Rue des Bois and the trees of Halatte Forest, at the other end of France, under the entirely different light of Estaque, Braque was painting landscapes which are structurally similar in all respects to those of Picasso. Such a remarkable conjuncture of the work of two painters—one starting out from a blue austerity, the other from a Fauve orgy—was not mere chance, even though they had worked quite separately and without knowledge of each other's work. It is the kind of coincidence which occurs in the sphere of scientific research when two scientists make the same discovery simultaneously, each without knowledge of the other's researches. The three-dimensional reconstruction of reality by means of uniform light and the articulation of coloured planes reflects an internal necessity for the painting of that time, and not just a whim of Picasso's.

The jury of the Salon d'Automne rejected Braque's landscapes, and although Albert Marquet and Charles Guérin each managed to rescue one, Braque withdrew them, and they were exhibited in November by Kahnweiler, who had just opened a gallery in the rue Vignon. Matisse having told Kahnweiler that Braque had submitted some canvases to the Salon 'entirely made up of little cubes', Vauxcelles, who had not seen the pictures himself, coined the term 'Cubism'.

From 1907 on Picasso was experimenting with the simplification of volumes as well as with hatching. *Woman in a Hammock*, *Still-Life with Bananas*, and *Landscape with Bare Trees* represent experiments in different directions. *Bust of the Farmer's Wife*, and *The Farmer's Wife*, both painted in Rue des Bois, convey an astonishing impression of weight and solidity, while *Landscape with Two Figures* and, notably, *The Bathers*, which is more abstract, have a remarkable presence and movement. The big canvas, *Three Women*, of the Moscow Museum, is painted in the same combination of ochre and green and represents an extraordinary achievement in conciseness and the conquest of space. One senses a new assurance in the painter, as though he were relishing his liberation. Finally, *Woman with a Fan*, her right breast bare, also now in the Moscow Museum, releases the same magical impression of presence

78

and of projection beyond the limits of the canvas. The contrast between the ochres, the browns and the warm grays, and the simplifying freedom which retains only the movement of the arms and the gestures of the hands, dislocating the shoulders, led the painter on to particularly happy and rich discoveries.

The friendship of Picasso and Braque, and their exchange of ideas, began in the winter of 1908-09, but it is unwise to draw conclusions from this concerning Picasso's work, if only because the 1909 canvases are extremely varied, and it is impossible to establish their chronology with sufficient accuracy to allow us to judge the development. In its colouring and the clarity of its construction, *Woman with Mandolin* seems closely related to *Woman with a Fan*, whereas *Young Seated Nude* is treated in lighter colours, more subtle planes, with a greater definition of volume. However, the contradictions between three-dimensional construction, the colour and the contours immediately begin to reappear, entailing 'distortions', although without affecting the suppleness, charm and delicacy of the female presence. *Reine Isabeau* combines volumes in the round with simplifications and displacement of perspective in a harmony of warm tones, in exactly the same way as *Bouquet of Flowers*. *Fruit-bowl with Pears, Pears on a Table* and *Still-Life with Gourd* all pay more direct homage to Cézanne in the manner of the still-lifes of 1908. Picasso now returned to the subject of *Woman with a Fan*, in a canvas in which greens, ochres and dark reds harmonize still more sumptuously than in *Reine Isabeau*. At the same time the curves harmonize with the planes to represent volume, the shadows being indicated by flat tones, one of which, on the face, seems to forecast the technique later adopted by Léger. 1909 was also a year of portraits: *Clovis Sagot, Braque, Pallarès, Vollard* and *Wilhelm Uhde*.

Thanks to the good offices of Kahnweiler, Picasso was now living more comfortably. As in 1907, he went, one might say, on a pilgrimage, to Horta de Ebro to see his old friend Pallarès. The series of landscapes he brought back with him to Paris are among the purest and most 'classical' of modern painting. *Houses on a Hill* records the clarity of the Catalan sunlight made uniform, with distances systematically abolished and the elements of the landscape simplified to the utmost. *The Reservoir, Horta de Ebro* and *The Factory* are expressed in harmonies of almost metallic harshness, as though to thrust us into the artificial, industrial world.

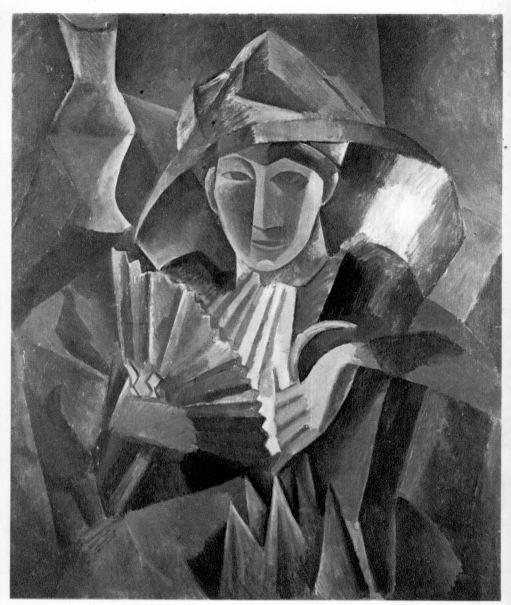

WOMAN WITH A FAN. 1909

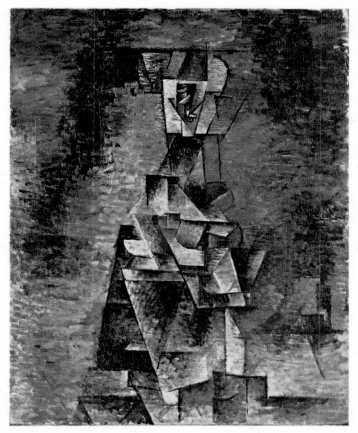

NUDE WOMAN. 1910

It was when he returned to Paris from Horta de Ebro in September that Picasso left the Bateau-Lavoir and established himself in a more comfortable apartment with a studio at No 11, Boulevard de Clichy, just at the foot of the Butte Montmartre. Fernande records that she felt sombre misgivings about this change in their way of life.

THE GREAT BREACH

The things that Picasso and I said to one another during those years will never be said again, and even if they were, no one would understand them any more. It was like being roped together on a mountain.

<div align="right">BRAQUE</div>

The new studio was near the Place Pigalle in a fine house which belonged to Delcassé. It was a large room and very airy, facing north and looking out towards the Sacré-Cœur, which Picasso painted in the style of his Horta de Ebro paintings as soon as he moved in. The apartment overlooked the delightful Avenue Frochot. 'The walls', recalls Fernande, 'were hung with old tapestries, Negro masks and musical instruments, and there was a small Corot of a pretty woman.'

Seated Woman, which was painted in the autumn of 1909 after the move, carries the break up into planes and the geometrical analysis of form much further than *Seated Young Nude*, from the beginning of that year. The tensions set up are considerable and lead to rotations and reductions in a reconstruction still more independent of appearance, and to problems in colour, leading to the use of dull tones and monochrome effects.

Once again Picasso was fleeing forward. In his canvas *The Piano* he resorts to true relief, and this idea was always to haunt him. Douglas Duncan recalls that when he was trying to photograph a canvas of 1937 with a collage in relief, he came up against unexpected difficulties which were not easy to resolve. Despite everything he could do the reflections dazzled his lens. Picasso, observing his difficulties, slapped him on the back, saying; 'Now you can see that this is not just painting. That is exactly why I did it. This time it really is something else.' But these are still only his first experiments. There is a sculpture from this period, a bronze head with multiple planes in concave and convex forms—it seems closer to Impressionistic sculpture than to his paintings of that time. But it gave Picasso a chance to study the problems of breaking down three-dimensional form into distinct planes.

A problem which first arose in the *Portrait of Vollard* appeared even more clearly in the *Portrait of Wilhelm Uhde*. While the breakdown of

space into planes merges the figure with the background of the picture and creates a new formal unity, this completely alters the relationship of the subject with the outside world. The subject ceases to be *outside*. The accent is now placed on the common features of a material reality. The contrast between the dealer and the scholar is sufficiently striking to indicate that in this new research into spatial depth Picasso was in no danger of losing either his psychological accuracy or the essential characteristics of the sitter.

It was about this time that Picasso took a young woman named Fanny Tellier as his model for the picture *Girl with a Mandolin* in the Penrose Collection. However, she found the long sessions very tiring, so Picasso finally left the picture unfinished. The conflict between the subtle breaking up of form into distinct planes and the coherence of the model is striking. The head is treated in two planes which do not connect, but this break is justified by the integration of the model in space. It is remarkable that despite the distortions and the elimination of details in the treatment of the face, the body and the dress, the identity of the model, and even her grace and charm are preserved. The hands, reduced to a mere indication of their gestures, seem to be playing something more lively, if less melodious, than those of the *Woman with Mandolin* of 1909. It seems as though the object of the experiment was to see just what degree of abstraction the painter could allow himself without losing anything of the richness of reality.

Once again, to understand the development of Picasso's work, one must realize his determination to express what is most important in the real world. What often causes confusion is that the vocabulary of painting and of the arts has become so alienated from its real sense, that even its fundamental terms are now susceptible to contradictory interpretations. In relation to reality Picasso's attitude is one of abstraction, this being the process by which his mind isolates that quality in an object which it regards as independent of all others, independent, in fact, even of the object itself. In Picasso's case, however, this abstraction is intended to take hold of what is characteristic and essential in reality. By definition, therefore, this is a realistic attitude—realism here implying a critique of reality, the decision of the artist to extract its inner meaning, as opposed to naturalism which implies that the artist is exercising all his ingenuity in order to respect the detail and disorder of tangible appearance. Thus in Picasso's case abstraction is the opposite

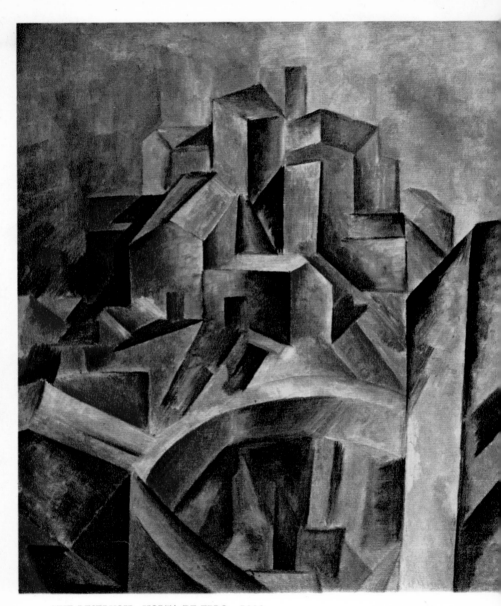

THE RESERVOIR, HORTA DE EBRO. 1909

of what is ordinarily known as abstract painting, since his aim is to preserve the essence of reality, while abstract painting has become specifically isolated from reality, has broken with the dialectical process of abstraction from reality, thereby cutting itself off from it.

Picasso waged his struggle on two fronts. First of all against what I call naturalism, which at that time was Impressionism as far he was concerned. 'Painting dependent on the weather', he called it; window-open-to-nature painting, but from a sheltered viewpoint, resulting in the abdication of the creator. Secondly against decorative painting, which had lost all touch with the world and had degenerated into mere prettiness. In this connection an observation made by Kahnweiler to Francis Crémieux is illuminating. He had just explained that tachism and abstraction are today's equivalents of academic painting, and he added: 'Tachism and abstraction present no difficulties at all. At one time people came to laugh or get angry at Cubism and Fauvism, and even at Matisse. Why was this? Just because they did not see nature in the same way as they believed the painters saw it. In other words, they did not read the pictures properly; they did not yet know how to read them, and that annoyed them. Now, in front of a picture that represents nothing, there is nothing to get excited about.'

Contemporary evidence leaves no doubt whatever about this. In the autumn of 1910 Metzinger wrote: 'Picasso frankly admits that he is a realist'. Apollinaire, Gleizes and Metzinger were all in agreement that 'Courbet is the father of the new painters'. Later Braque was to say: 'The fragmenting of objects which appeared in my paintings around 1910 represented a way of getting as near the object as painting permitted.'

Returning to Picasso's *Girl with a Mandolin*, this canvas demonstrates, as we have seen, the hitherto unsuspected possibilities of freedom in the interpretation of reality. In fact, in recalling that period for Marius de Zayas in 1923, Picasso did not put the accent on the *object*, but on the *subject* and its importance: 'In our subjects, we dwelt on the joy of discovery, the pleasure of the unexpected; they had to be a source of interest.' John Golding says: 'The iconography of Cubist painting itself confirms the realistic intentions of the painters... Cubism expresses the everyday life and experiences of the Cubist painters.'

Hence the new breaking up of forms carried out by both Picasso and Braque in 1910. Their explorations led them towards a form of painting from which all representation was banished, and this led them

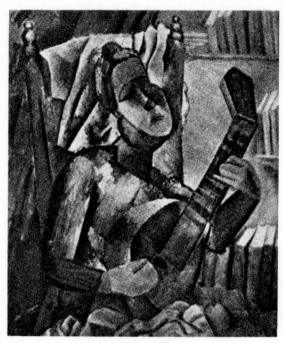

WOMAN WITH A MANDOLIN. 1909

on to an almost complete abandonment of colour and a reconstruction instead of an imitation of reality. However, 'distortion' was the concomitant, and with this grew the difficulty of 'reading' canvases. The difficulties of using colour also increased, and the paintings became further removed, not only from the appearance of the subject, but also from the subject itself. The truth is that painting and the plastic arts have their own laws, and these laws are as elusive to the painter as the laws of nature to the physicist.

Kahnweiler tells us that: 'In the spring of 1910 Picasso repeatedly tried to give colour to structured forms; that is to say, he tried to use colour not merely as chiaroscuro, using light to reveal form, but also as an end in itself, introducing it into the picture in its own right. But each time he was forced to paint out the colour he had used.'

Picasso spent the summer of 1910 at Cadaqués on the Costa Brava with Derain. It was here, to use the words of Kahnweiler, that he 'broke up the homogeneity of form'. He carried abstraction so far that all that

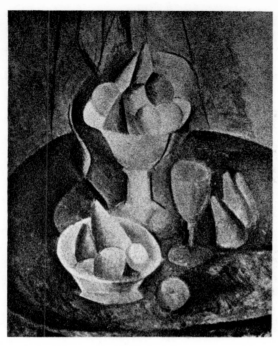

FRUIT-BOWL WITH PEARS. 1909

remained of his model were a few elements which he regarded as signi-
ficant, its essence—its characteristic bearing, its configuration. To this
end he organized cut-out planes, geometrically projected into space
without concern for cohesion of contour or lighting. He was carrying
his breach with reality to the extreme. The etchings he did for Max
Jacob's *Saint Matorel*, which was published by Kahnweiler, are typical
of these experiments.

But Picasso was dissatisfied with the canvases he brought back from
Cadaquès, perhaps because he felt that he had made the relationship
with reality too tenuous. This had several consequences. These 'inde-
cipherable', 'hermetic' canvases helped to confirm those misconcep-
tions which identify Cubism with the suppression of reality and with
what was henceforth to be called abstract painting. This was the moment
when for the first time the Salon d'Automne exhibited 'Cubist' paint-
ings: two Metzingers 'as a penance', and a landscape by Le Fauconnier.
The choice incensed Apollinaire. He wrote: 'This is a shallow, feeble

imitation of works which are not being exhibited, works by an artist of powerful personality, a man who has not, incidentally, betrayed his secrets to a soul. The great artist I refer to is Pablo Picasso. But the Cubism the Salon d'Automne is showing is a mere jackdaw in borrowed plumage.'

At this time Picasso began a *Portrait of Kahnweiler*. The choice of subject and the twenty sittings required attest to the painter's determination to grasp reality as closely as possible. While the construction is similar to the Cadaquès canvases, the more elaborate fragmentation of planes permits Picasso to retain such details as the eyes, the mouth, the gloved hands and a button on the jacket, all of which serve as guides to the identity of the sitter. In the portraits of Vollard and Uhde, Picasso recaptures the expressive force of the sitters without abandoning the experiences of Cadaquès, using them here to achieve an extra precision. These masterpieces were to serve the painter as a springboard for new explorations.

It is a notable fact that Braque, with whom Picasso had abruptly stopped all contact during his stay at Cadaquès, now independently began to engage in experiments similar to Picasso's, as at the time of the Estaque and Rue des Bois landscapes. The truth is that in this first decade of the twentieth century, a breach with the conventions of Renaissance art had become inevitable. Electricity, the internal combustion engine, the progress of chemistry and metallurgy, all these things had completely and radically changed the relationship of man with nature. The work of Picasso and Braque of the years 1910-11 freed painting from subjection to sensory representation and paved the way to the conquest of modern realities. Experience was to show that Braque and Picasso had inaugurated the real dialogue between painting and reality. And it immediately became necessary to reconsider not only the content and the methods of painting, but the very act of painting itself and its profound significance.

This event also marks a change in Picasso's paintings. If we compare *Woman with a Zither*, the first canvas of the dozen dedicated to *ma jolie* or to *Eva*, with the *Portrait of Kahnweiler* there are no important differences in structure, in the indication of outstanding features—fingers, eyebrows, etc—or in the monochrome colour. The one thing that stands out is the inscription *MA JOLIE* in printed lettering at the bottom of each canvas.

Toward the end of 1909, Braque was the first to introduce a nail painted in *trompe l'œil* in order to provide a point of reference for the scale of the new plastic transpositions; and then in 1911 he had the idea of using printed letters. 'These were forms which needed no distortion because, being already flat, the letters existed outside of space and their presence allowed objects in space to be distinguished from those which were outside of it.' In short, the letters represented the ideal point of reference, owing nothing whatever to the will of the painter, in the same way as Braque's nail or Kahnweiler's gloved hands.

However, letters not only have an independent existence but can also introduce an extrinsic, autonomous element into a picture. The result of the introduction of lettering was that both Braque and Picasso began to regard the canvas as just an object that could readily be replaced by another. Braque lined the walls of his studio in the rue Caulaincourt with paper reliefs, none of which survives today. But Picasso's creations in more durable materials, such as wood, sheet iron and cardboard, still exist. They retain the rectangular limits of the canvas but their forms are arranged in superimposed planes.

If the canvas is an object, and the forms can be obtained by cutting out, folding and montage, then colour is likewise replaceable. And instead of imitating things, one can introduce real objects—the actual texture of matter. This constitutes the ultimate abolition of illusionism in painting. But now the work itself has become an object, independent and autonomous. Up until then, there were conflicts between the ways of re-creating reality—between line and volume, between colour and the projection or decomposition of form—but now the conflict broke out between the reality of actual materials and reality re-created. Painting itself and the work of the painter were brutally called into question.

Picasso now introduced an industrial product into his canvas—in the oval shape of which Braque was fond. It was a piece of linoleum with a pattern imitating chair caning, pasted on and incorporated into

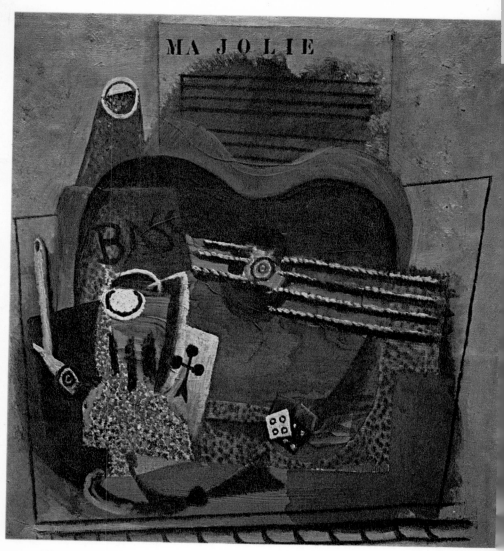

MA JOLIE. 1914

THE CARAFE. 1912 SOLDIER AND GIRL. 1912

a still-life painted in oils. This canvas, *Still-Life with Chair Caning*, dates from the winter of 1911-12, as does *The Letter*, in which he painted a letter addressed to him on which he stuck a real postage stamp. These are just two of many still-lifes of commonplace motives, deliberately dwelling on everyday subjects: *Pernod and Saucer*, *The Sausage*, *Café 20 centimes*, and so on. The use of printer's type becomes more explicit in *Bottle and Glass*, and, particularly, in *Our Future is in the Air*, from the spring of 1912, and *Aficianado*, in which the letters serve as accents. The use of collage became more general in the autumn of 1912, and in 1913 Picasso cut a *Roast Goose* out of brown paper and over it drew a bottle which immediately presents an unsuspected transparency. In the following year he made *Dice and Tobacco Packet*, in which an actual tobacco package is used.

In this way colour as such ceases to be used by the painter. 'At this point', said Braque, 'colour becomes clearly dissociated from form, a very important achievement. Colour acts simultaneously with form, but is entirely unrelated to it.'

93

To compare this new phase with the post-Cadaquès phase, and to speak of 'Synthetic Cubism' succeeding 'Analytical Cubism', inadequately conveys the true significance of these discoveries and the creative power released by Cubism. Collage developed from Braque's *trompe l'œil* nail, his decorative imitations of wood, cloth, marble, etc. But above all, the use of collage exploded the false dignity of the painter's skill, and exposed the hitherto buried conflicts between industrial society and the painter with his solitary craft. Leonardo, Raphael, Delacroix, all were on an equal footing with other craftsmen, manually preparing their own colours and canvases. But the development of industry, standardisation and mass production, the spread of photographs and colour reproductions, all these things now confronted the secret processes of painters—their alchemy. Collage was one way of taking up the challenge. Picasso and Braque came forward and presented themselves stripped of all magic, displaying their works, their materials and their craftsmanship simultaneously, abandoning all secrets of workmanship, all mystifying techniques, to be judged purely on their responsibility as organizers of reality.

This is equivalent to saying that art is man. Only the hand of man can create beauty. Standardised, mass-produced products fall into the same category as things in nature. Beauty can be expressed with a sheet of music, a postage stamp, a piece of newspaper, a scrap of painted paper or oilcloth. 'We were trying to express reality with materials we did not know how to manage, but which we valued precisely because we realized that they were not indispensable, that they were neither the best nor even the most suitable', Picasso was to explain later on.

Thus utilized by the artist, these commonplace objects and discarded commodities, such as the tobacco container and used stamp, having lost their *raison d'être*, once more became impregnated with humanity, recovering the dignity which human labour had originally conferred on them, at the same time becoming symbols of a new plastic language.

When Fernande speaks with indulgent and somewhat irritated incomprehension of Picasso's taste for 'buying, often with a sense of irony, the most commonplace things', it is easy to speculate on the coincidence of Picasso's first attempts at collage and his new love for Eva. (The spring of 1912 was not an easy time for the young couple. Picasso had changed his way of life and had ceased to drift around,

'tired of the circus and the cabaret because none of this was any longer necessary to overcome the boredom of eight years of life shared with another', as Sabartès puts it. At the beginning of May he left Paris for Avignon. But on 18 May, his retreat having been discovered, he took Eva to Céret. Before long Fernande arrived and new complications developed. At about the moment Picasso was writing to Kahnweiler (letter of 12 June), saying that he loved Eva and 'I'm putting her into my pictures', he settled in the villa of Les Clochettes at Sorgues-sur-l'Ouvèze, a little to the north of Avignon. Not long after, Braque and his wife joined them there.

Céret was as close to the Collioure of the Fauves as the Rue des Bois was to the Oise and the Seine of the Impressionists. Sorgues remains the mecca of Cubism. In the flush of his new happiness Picasso painted numerous canvases that rise above his previous explorations, with a mastery that reaches extraordinary purity and balance. On the wall of his studio there, he painted an oval picture which he did not want to abandon when the time came to return to Paris. It had to be carefully taken off the wall and mounted on canvas. This particular still-life with sheets of music and a bottle of marc, titled *Ma Jolie*, and the associated one called *J'aime Eva*, on which Picasso wrote this inscription the way young lovers cut their names in the bark of trees, are much freer than *Woman with Zither*.

Freedom of rhythm, freedom of conception. Picasso had now learned to do without monochrome effects and alternating light and dark planes. He was progressing towards the perfect clarity of the 1913 collages such as *Head of a Man* and, particularly, *Student with Pipe* with cutout cap over an extremely concise network of lines. The use of pasted paper turned out to be a remarkably effective and clear method of indicating the various planes. But Picasso was already getting similar results by actual painting, exploiting the possibilities of colour juxtapositions independently of any imitation of reality, resorting to pointillist procedures, which was to cause this phase of his researches to be called Rococo Cubism. *Guitar, Playing Card, Glass and Bottle of Bass*, which belongs to the *ma jolie* series, is a particularly fine example of the transition from the austerity which had reigned since Cadaquès, to renewal in the sensual joy of bold colour.

Picasso even carried the experiment so far as to paint some *trompe l'œil* imitations of pasted paper in *Seated Woman against Green Background*,

demonstrating that while it is possible to negate academic illusionism by collage, the latter itself has no intrinsic value and can be replaced by the art of the painter. This leads to drawing the logical consequences of the new attitude toward painting, which is the basis of Cubism. Tristan Tzara was to say that 'pasted papers are the proverbs of painting and can be equated with the use of commonplace subjects and expressions in poetry.' In expressing reality, painting can develop into a criticism of painting, just as poetry can criticise poetry, and language can criticise language. The death of art is not due to the attrition of language, but to a lack of awareness of that attrition. There is novelty everywhere for him who knows how to seize it. In the inventory of the world which the Cubist adventure represents, Picasso contributed not merely the Pernod bottle, the bouillon cube, the gas jet and the sea-shell. At Sorgues he painted a *Landscape with Posters* in which printing type suddenly takes its place in reality, and painting

DICE AND TOBACCO PACKET. 1914

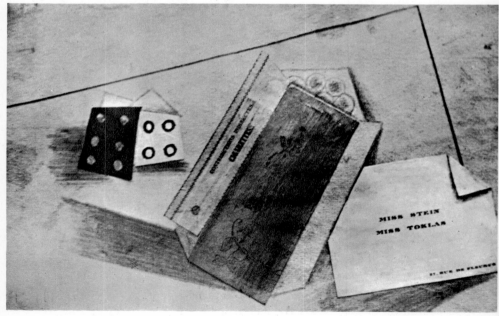

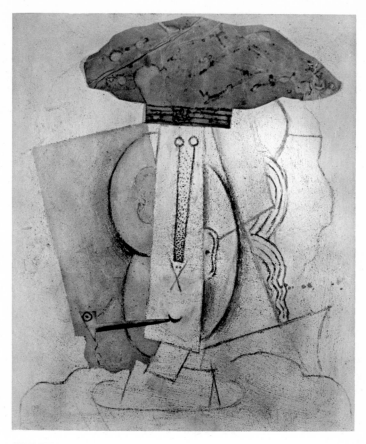

STUDENT WITH PIPE. 1913

exploits the power of the poster, a procedure which was subsequently systematised by Dada and the Surrealists. This constitutes a profound link between Picasso and the experimental poets Max Jacob, Guillaume Apollinaire and Pierre Reverdy, and the young men of the post war period such as Aragon, Breton and Eluard.

That inventory is not limited to objects. Landscapes, such as *Pointe de la Cité* and *l'Avenue Frochot,* and people, such as *Negro Boxer, Soldier and Girl, l'Arlésienne* and *l'Aficionado*—to mention only a few particularly significant titles—also have a share in the blossoming of Picasso's

art. There is austerity in the means, but this does not in any way exclude humour, as evidenced in the series of oval canvases such as *Souvenirs du Havre* and *Fêtes de Céret*, or such a canvas as *Au Bon Marché*, in the mode of an advertisement.

Woman in Chemise in an Armchair, dating from the end of 1913, shows very clearly that Cubism was not an end in itself for Picasso, but a new language, a new weapon to use in the conquest of the world. There exists a watercolour sketch which incorporates all the structural rhythms of the definitive work and yet preserves a non-abstract aspect; and a comparison with the finished canvas reveals how Picasso sharpens and intensifies his means of expression to its maximum potentialities in order to lend full strength to the subject. This is a major canvas which combines a mastery of Cubist language with clear references to structural motives in Negro art—the double breasts, for example —and at the same time carries on all the innovations since Gosol for giving beings their true volume and expressing them in space.

By the year 1914, Picasso was thirty-three years old. He had lost his father the previous year. Since living with Eva, he had broken with Montmartre, living first in the Boulevard Raspail and then in the rue Schœlcher. The direction his painting now took loosened his relationship with Braque, and the outbreak of the war completed the dissolution of the world of his youth. Braque was called up. Apollinaire volunteered. Kahnweiler, as an enemy alien, went into exile in Switzerland. And for a while Gertrude Stein found herself immobilised in England.

Picasso's painting now followed its own sensual path. The still-life called *Vive la France*! prolonged the exuberant rococo of *Ma Jolie*. Colour now triumphed in the exaltation of pure harmony, and people began to speak of 'Crystal Cubism'. The independence of painting had never been so brilliantly affirmed. But before long Picasso was to find that he had to defend what he had won against the Cubists.

Let us close this period by citing a *tour de force*—the painted bronze sculpture, *Glass of Absinthe*. The glass contains a real silver spoon on which lies a lump of sugar—in the way absinthe used to be served. One side of the glass is cut away to show the interior, like the Olibet box when Picasso was learning to walk. In this way the most ordinary object is transformed into a work of art. The element of surprise provokes the order of reality.

98

DISOBEDIENCE TO WAR AND TO CUBISM

Only pure line escapes imitation. Drawing in line has its own light, created, and not imitated.

<div align="right">PICASSO</div>

Many theories have been advanced to explain the change of 'manner' in Picasso's work at the beginning of the war in 1914, but none of them considers the facts and their logic. Wilhelm Uhde regarded it as a reaction to the charge that Cubism was 'German', and asked: 'Did he feel that the finger of scorn was being pointed at him by those who charged him with secretly conniving with the enemy? Was he therefore trying to take up a specifically "French" position?' The insinuation shows that Uhde had no understanding of Picasso, who never allowed outside influences, whether political or financial, to divert him from his path as a painter. For Picasso, painting embraced the whole of life, thus including politics in the best sense of the word.

By 1914 seven years had passed since Picasso had burned his bridges. Cubism had now become—independently of him—a school. Cocteau was to write: 'A dictatorship oppressed Montmartre and Montparnasse. The objects associated with a café table were the only themes permitted. To paint a whole interior was a crime. Picasso scandalised "La Rotonde" by accepting this proposition.' He was indeed acutely aware of his creative independence, of complete autonomy, subjecting his life only to his art. This explains the explosive violence of some of his decisions both in his life and in his art. But although the 'discipline' of Cubism did not bother Picasso, it did to some extent bother the writers and critics—so much so, in fact, that the reappearance of line and realism in drawing and the re-acceptance of two-dimensional representation aroused as much controversy and distortion as the breach that took place after the Rose Period. It is as if, having extracted a philosophy from Picasso's innovations, the Cubists, the Futurists and the Informalists now wished to force art—and Picasso himself —into submission to their philosophy. But Picasso's philosophy and his conception of the world are expressed in his creative activity, in the work itself.

On 7 January, 1915, according to the postmark, Max Jacob sent New Year's greetings to his friend Apollinaire, who was stationed in Nîmes. He told Apollinaire that he had experienced 'a second vision of Our Jesus Christ', which had induced him to be baptized. And he added: 'On 20 January Pablo is going to be my godfather... He wants to call me "Fiacre", and this grieves me. He is drawing a pencil portrait of me which is very beautiful. It resembles at the same time my grandfather, an old Catalan peasant and my mother.'

The date of Max Jacob's letter is significant, even if the portrait was finished later. In all probability it was begun at the end of 1914; that is to say, far from following the last Cubist canvases, it comes toward the end of the 'Rococo' period, the most exuberant and baroque, with its pointillist elements and its emancipated colour, and right at the beginning of the 'Crystal' period which was the most vigorous and as abstract as the collages. The *Portrait of Max Jacob* belongs to precisely the same time as *Still-Life in a Landscape*, a 'Rococo' master-piece, and the big *Harlequin*, a miracle of bold colour combinations against a black background, in which all references to the subject are interpreted and given meaning, which is typical of 'Crystal' Cubism. The co-existence of 'classic' drawings and Cubist experiments had in fact already been foreshadowed in sketches for Cubist paintings with figures, such as *Woman in an Armchair*—in which there is no facial transposition—the *Man in Bowler Hat* of 1914, and *Reclining Woman*, which is contemporary with the *Portrait of Max Jacob*. It is after his abstract experiments that Picasso feels a need to reintroduce concrete elements into his work.

The *Portrait of Max Jacob* is a masterpiece, one of the world's great drawings. As always, Picasso goes straight to the essential, capturing his friend in that mixture of mystical humility and physical awkwardness which is reflected in his letters of that time: 'The rest of the day I am in church or at home, trying to live the Christian life as well as I can.' Today it is easy to fit this portrait in with the Cubist masterpieces of the war years, and the parallelism between the two disciplines of reduction to the essence is striking. Contemporaries, on the other hand, saw the matter quite differently. In the first place, hardly anyone had an overall view of Picasso's Cubist production. Further, Cubism—by which I mean the Cubism of Picasso and Braque—is so far removed from the classic vision of reality propounded by the Renaissance that

100

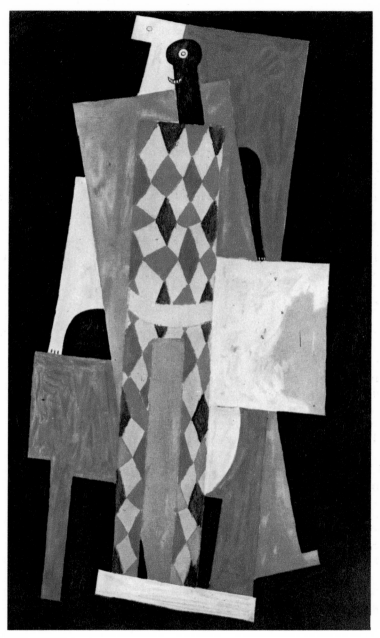

HARLEQUIN. 1915

those who regard that as normal vision cannot detect any difference between Picasso and Piet Mondrian, who is abstract in the real sense, or Malevitch, to whom 'art reaches a desert in which nothing is recognizable but sensibility', or Kandinsky, for whom art is 'a means of turning away from the soulless content of present-day life'. Insofar as the avant-garde represents clearing the road for a different reality, with untried means, it involves a violent clash between realism and idealism, between art regarded as a conquest—the greatest possible sum of reality—and stultified, escapist art. The whole history of Cubism, and subsequently of Dadaism and Surrealism, is there to prove it.

It is precisely because he wants to conquer reality that Picasso uses line, no less than collage, as a means of expression. We know from his very first engravings of 1905 and the pencil portraits of Fernande that he has something quite different in mind from a simple imitation of the model before him, that for him the line is the antithesis of imitation and has to be a creation—creation of space and creation of light. Max is a privileged sitter, a testing-ground as important as the *Desmoiselles*. We should be just as wrong to interpret this *Portrait of Max Jacob* in the light of, let us say, Dürer's *Portrait of Erasmus*, as to condemn the *Head of a Man* in pasted paper of 1913 by the same standard.

What complicates matters is that the *Portrait of Max Jacob* was executed in the middle of the First World War when Cubism was the target for furious attacks from the extreme chauvinists. The tension between the Cubists, (as soon as they had formed themselves into a group in room 41 of the Salon des Indépendants in 1911), and those attached to tradition, was from the start so violent that all additional arguments added after the outbreak of the war concerning the obvious cosmopolitanism of the supporters of the new art, its success in Germany, and the German nationality of its early defenders—Kahnweiler and Uhde—were completely lacking in objectivity. The socialist deputy Jean-Louis Breton asked Parliament to forbid 'that our national palace should be the scene of manifestations of such an anti-artistic and anti-national character'. This outburst provoked a rebuke from Marcel Sembat: 'If you think a picture is bad you have a perfect right not to look at it and to look at others instead. But you don't call the police'.

In the atmosphere of inviolable unity created by the war, Picasso showed not the slightest intention of abandoning his neutral position,

an attitude which required considerable courage. Likewise, in departing from the rules of the Cubist school he demonstrated no less independence of spirit. It is clear that these rules and this doctrine had been established without either his or Braque's participation. However, it was perhaps easier to break with five hundred years of Western painting than to affront the Cubists, who claimed him as their own and who would certainly feel abandoned in adversity. Especially since he was well aware that all those who agreed with Jules Romain that 'Picasso's activity is nothing but one ceaseless imposture', would regard his new experiments as an admission of defeat.

This was the setting for the series of portraits which now followed: Vollard in the spring of 1915, Cocteau, Apollinaire wounded, in 1916. Far from suggesting an effort to 'reconcile' himself with the world, or repudiating the ten years' breach with the classic tradition, these portraits provide evidence of the implacable struggle Picasso was waging on two fronts: against the champions of academicism, who were intent on exploiting the war hysteria in order to destroy Cubism, and against those who were striving to set Cubism into a fixed mould. This is far from the serenity that some people suppose. Braque was seriously wounded, and then Apollinaire. Then Eva fell ill and died in January 1916. A letter from Juan Gris to Raynal at the front, gives an idea of the nightmare character of Picasso's life at the time: 'There were seven or eight friends present at Eva's funeral, which was a very sad affair, and Max's facetiousness added greatly to the horror.' Writing to Gertrude Stein on 8 January to tell her of Eva's death, Picasso said: 'I want very much to see you and talk to you as a friend'. And it is from Gertrude Stein that we can comprehend something of the lonely Picasso now fleeing from the studio in the rue Schœlcher to bury himself at Montrouge, in order to forget, and deaden the pain in promiscuity. Photographs of him at this time—the last self-portrait was in 1907—show him as a young man looking less than his thirty-five years, his hair in disorder, a watch chain in his button-hole, and wearing a tie.

At this point Cocteau appeared on the scene. Eric Satie was a neighbour of Picasso's at Montrouge. The result was the ballet *Parade*. Picasso left for Rome, glad of the work and also, no doubt, glad of the change of atmosphere. *Parade* belongs to the Rose Period, but nothing reveals more clearly the extent to which Cubism and the seemingly classic experiments interpenetrated in Picasso's work. Thanks to him

the ballet became Cubism in action, Cubism as spectacle. Sets and costumes drove choreography toward paintings that moved, Cubist montages in motion. On the other hand, the curtain presented the world of the 'Rose Suite' with its horsewoman, harlequins, guitarist and an immense Pegasus, all in fresh, lively tones, organized in rigorous and ample curves, reminiscent of the stance of figures in paintings by the Douanier Rousseau. Léon Bakst, who was Diaghilev's regular designer, found it somewhat 'passé'.

In the space of a month, according to Sabartès, Picasso accomplished what had brought him to Italy and also found the time to visit Rome, Naples, Pompeii and Florence. In addition he made the acquaintance of Olga Khoklova, one of Diaghilev's dancers.

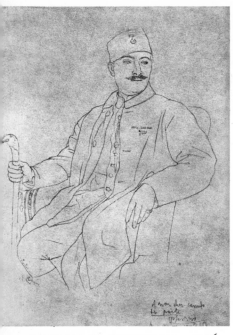 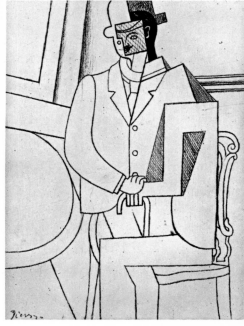

PORTRAIT OF APOLLINAIRE. 1916 MAN IN BOWLER HAT. 1914

DIALOGUES WITH POUSSIN
AND MONSIEUR INGRES

> *No stories are told in Rubens. It's journalism, historical film. But look at Poussin—when he paints Orpheus it's real storytelling. Everything, the smallest leaf, is part of the story.*

<div align="right">PICASSO</div>

Parade was staged at the Théâtre du Châtelet, and the first performance was on 18 May, 1917. Apollinaire, in an introduction to the programme, wrote that Picasso and Léonide Massine had forged 'the alliance of painting and the dance, of music and the plastic arts, which is the sign of a more complete art. From this new alliance has resulted something

beyond realism'. This was the beginning of the world 'Surrealism', which was to become famous. But Apollinaire defined Picasso's art in terms that are undeservedly forgotten: 'Picasso's sets and costumes are proof of the realism of his art. This realism, or Cubism—call it what you will—has stirred the arts more deeply than anything else during the past ten years. The sets and costumes of *Parade* show more clearly Picasso's determination to extract from an object the utmost aesthetic emotion which it is capable of yielding... The supreme purpose is to produce a translation of reality.'

Nevertheless, the public felt it had been hoaxed, and cried 'Sales Boches'. Cocteau recalls that 'Souday was the only one who dared to take the responsibility of declaring publicly that Satie, Picasso and I were neither pro-Germans nor criminals.'

When the Paris season was over, Diaghilev, cut off from Russia by the Revolution, left with his company for Spain. Picasso went too, accompanying Olga. He had not been greatly disturbed by the hostile reception given to *Parade*, but regarded it as understandable, particularly since there had been no manifestation of modern painting since the beginning of the war. A photograph taken at the time shows him well-groomed, wearing a bow tie and sporting a white handkerchief in his breast pocket, a phenomenon which wrested from Sabartès this comment: 'The attention he pays to his appearance is unbelievable.'

Picasso had not been back in Barcelona for five years. Since the death of Don José, his mother had been living with his sister Lola, who had recently married a doctor named Juan Vilato Gomez. Picasso's arrival was joyfully celebrated by his old friends Miguel Utrillo, Iturrino and Angel de Soto. He now painted *Olga in Mantilla*, just as in 1906 at Gosol he had painted Fernande as the *Woman in Mantilla*. The new portrait displays the same mastery as his portraits in pencil, the same finesse. Decisiveness and an uncompromising search for essentials instantly seize the character of the face, framed by the mantilla falling over the white of the blouse. Both the background and the pose are unobtrusively arranged to enhance the face. There is direct reference to Ingres in this canvas.

His life with Olga now gave new impetus to Picasso's creative energies. A window opening onto the Mediterranean light inspired a series of *Balcony* pictures. There also appeared harlequins both in realistic and Cubist styles, the latter in flat planes of brilliant, joyous colour;

and, at the same time, drawings of bulls, horses in combat with bulls, in addition to Cubist still-lifes. Since 1906 he had achieved new triumphs over orthodox Western painting and the traditions of the Renaissance. From now on he annexed to the results of these explorations—which, for the sake of simplification, we will call Cubist—a systematic re-eva-luation of classical painting.

This widening of plastic horizons has left its mark on all subsequent work, not only in the choice of themes, but also in a critique of prede-cessors, in terms of painting and drawing, amplifying the debate on col-lages to all representations of reality. Pierre de Champris has percept-ively related Picasso's drawing of a ballet scene showing Olga reclining in the foreground, with Poussin's *Offrande à Hymen*. *Ballet* is entirely executed in line, in such a way as to express volume, movement and rhythms simultaneously. The drawing derives from Picasso's direct experience, and the obvious intention is to celebrate Olga among her companions. But it is clear that it was conceived in and through Pous-sin, not in imitation, not necessarily in homage, but as dialogue be-tween equals—a collaboration.

Poussin's famous observation: 'You must realize that there are two ways of seeing an object, one by casually looking, the other by studying it with close attention', brings to mind a very similar remark by Picasso: 'People do not pay sufficient attention. Cézanne's greatness derives from the fact that when he stands facing a tree, he looks at it as intently as a hunter watching his prey. When he takes a leaf, he clutches it, and with the leaf he holds the whole branch. Nor will the tree escape him. Even if he has only the leaf, that is still something. A painting often amounts to no more than that... It must command your whole attention.' Cézanne, who said: 'I never come away from Poussin without know-ing more about myself than I did before', was now the mediator between Picasso and Poussin as he had been the mediator in the formu-lation of Cubism.

Picasso's concept of reality was not, as with Poussin, Ingres and Cézanne, a way of acclimatizing reality, of domesticating it in simplest terms. On the contrary, just as the abstractions of Cubism aimed at producing the essence of reality, so the dialogue with its predecessors aimed at adding the element of human experience, the increment of mastery and of logic to the expression of reality which is contained in their power of observation. Proceeding in this way, Picasso reverses

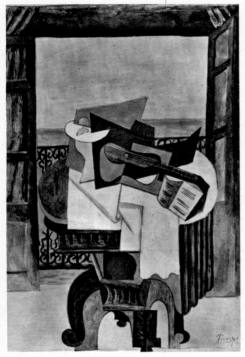 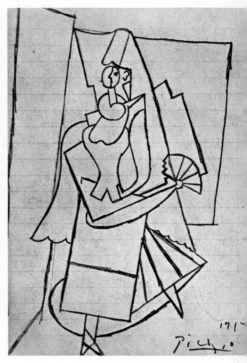

THE TABLE BEFORE THE WINDOW. 1919 WOMAN WITH A FAN. 1917

Cézanne's rejection of Ingres' fixed notion of reality, which had caused him to say that 'Ingres is a harmful classicist... he is not a thoroughbred... he is a draftsman.' Picasso paints *within* Ingres' frame of reference, as he does within Cézanne's, within Poussin's. This recalls Cézanne's comment on Delacroix: 'You can walk around his figures. For the first time since the great masters this is painting in real volume... he has the finest palette in France; no one has greater composure combined with pathos, no one such intensity of colour. We all paint *within him.*'

Picasso had already fought many battles to conquer volume and move-ment by constructing and organizing sensations of reality through the composition, the architecture of the picture. He belongs to the gene-ration which re-established organic structure as opposed to Delacroix and all those after him who emancipated painting from its classical

strait jacket by re-introducing detail with its elusive, moving and disorganizing effects, right down to the Impressionists and all those who see but do not look attentively. Picasso was born at the same time as the snapshot. He is the first great painter to have seen himself photographed from his earliest youth. His Cubist experiments coincided with the development of the cinema as a new means of visual expression, an art based on the recording of movement, which had a profound effect on the way of looking at reality.

Picasso wishes to be the universal painter. He paints as a man who sees, looks, knows. With him painting is no longer servant but master, capable of expressing everything—facts, meaning, volume and movement, colour, memory of things past, association of ideas. He demonstrates that the avant-garde implies no given form, but the liberty to choose a form which is a function of something new to say; whereas academicism consists in choosing a content appropriate to existing forms.

During the year 1917, with Olga, the moving spirit, presiding over his work, Picasso produced a construction of painted wood entitled *Guitar and Bottle of Bass* which is an example of his continued interest in three-dimensional form. The series *Woman in Armchair* exhibits such vigorous planes and abstraction of colour that it gives somewhat the impression that the canvas is a cut-out imprint of the model. Yet at the same time his drawings can be as classical as *The Neapolitan Woman*, or as Cubist as the *Woman with Fan*.

When the Diaghilev ballet company left for South America, Olga remained behind with Picasso, and they settled in Montrouge. A photograph of them together there shows Picasso wearing a cap, and Olga one of those large round hats which were fashionable at the time. In the shade of the hat the camera has caught the smile, the interior light, that Picasso was seeking to capture in his paintings of her.

As the war had exiled Kahnweiler, Picasso's affairs were handled by Léonce Rosenberg. The latter's brother Paul found the young couple an apartment in the rue La Boétie, near the Rosenberg gallery. Portraits of Olga seated now followed one another, and they again show his consummate skill in representational painting. In one, Olga is seated in an armchair, holding a fan, gracefully defined against a tapestry background with floral motifs. It is almost in classic style, but the painter has taken only what he wishes to 'spotlight'—the guileless look of the beloved, the softness of her arms, the eyes full of reverie, the face treated

with great finesse and extreme delicacy. The reference to Ingres is more clearly marked in a succeeding painting which presents Olga in three-quarter length. The light strikes the face, the profile of the nose and mouth, and the two hands, with the same force and precision as in Ingres' *Portrait of the Architect Desdéban*.

From 23 January to 15 February, 1918, Paul Guillaume held a joint exhibition of works by Matisse and Picasso in his gallery. This was the first time canvases in the new manner were shown side by side with Cubist works. In the preface to the catalogue Apollinaire wrote one of his best comments on Picasso: 'Picasso is the heir of all the great artists... He changes direction, retraces his steps, and sets off again with greater assurance, all the time growing, fortifying himself by contact with unexplored nature, or by testing and comparing with his peers of the past... Picasso is often a lyric painter... He has greatly extended the domain of art, and in the most unexpected directions.'

Although the presence of Olga produced an element of classicism in Picasso's work, the momentum of Cubism produced some handsome still-lifes with *trompe l'œil* frames and projections of an audacity exceeded only by the uninhibited colour. This was a new and happier period, released from all austerity.

After their marriage, which took place on 6 July, 1918, Picasso and Olga went to Biarritz to stay with Madame Errazuriz, in whose Paris salon he had begun work on *Parade* with Cocteau and Satie two years before. Now appeared the themes of the *Sérénade* and *The Bathers*, executed in pencil—the movement of nude girls, the movement of waves, of hair being dressed and combed—no longer in the harem of the *Bain turc* but in the freedom of the open air by the sea. This seaside reverie is a triumph of linear harmony simultaneously enclosing and liberating successive movements in a unity which neutralizes distortion. In the central figure, Picasso resolves the problem of multiple views by twisting the body in such a way that both the front and the back are visible without discontinuity. Ingres had achieved this with one breast only; but Picasso subtly distorts the whole figure with such assurance that it is difficult to imagine it differently.

Picasso also painted murals, in one of which, in the space between two nude female figures, he wrote one of Apollinaire's verses: *C'était un temps béni, nous étions sur les plages.* (It was a hallowed moment, we were on the shore). A short time before his marriage, at which Apolli-

naire was best man, Picasso himself acted as best man at Apollinaire's wedding. There was a general feeling that the war could not last much longer, and that then the *temps béni* would return. But it was not to be so for Apollinaire—he succumbed to the epidemic of Spanish influenza just before the Armistice. Picasso and Olga were with him as he sank into the final coma. Outside on the streets, crowds were shouting 'Down with the Kaiser'.

Picasso left the house at dusk. The wind whipped the black veil of a war widow into his face. The telephone call announcing Apollinaire's death reached him at the Hôtel Lutétia. Picasso made a sketch of his own face as he saw it at that moment in a bathroom mirror. Grief has suddenly frozen the young man's features into a mask. This drawing done in the face of death, is Picasso's last *Self-Portrait*.

The end of the war marked the opening of a new period in his work, but the sudden death of a dear and loyal friend was a bitter blow for Picasso and it heralded a new solitude. He was now thirty-seven and the world he had known as a youth had fallen apart.

RUNNING AHEAD OF BEAUTY:
THE YEARS 1919 TO 1923

Exactly what is a painter? He is a collector who wants
to form a collection by making his own paintings of
pictures he has taken a fancy to in other people's houses.
That's how it is—but then it becomes something else.

PICASSO

Ancient, Heroic, Roman, Classic series. None of these applies—Picasso
slips through the net, and all of these descriptions together account
for no more than a third of Picasso's work in the years 1919 to 1923.
His Cubist production accounts for perhaps another third, including

THE THREE MUSICIANS. 1921

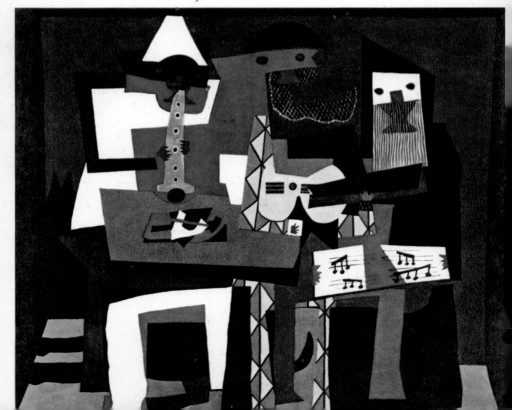

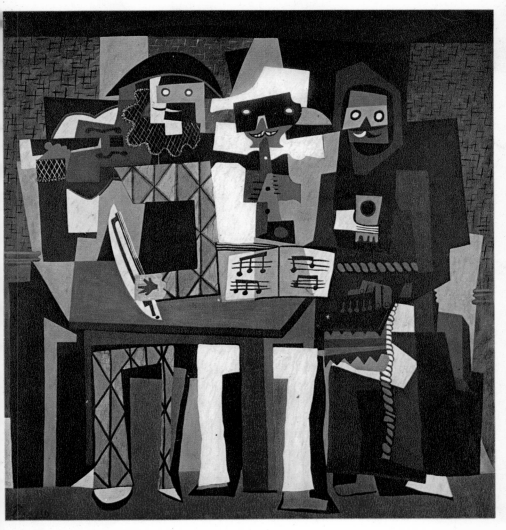

THE THREE MASKED MUSICIANS. 1921

just as many masterpieces. As for the remaining third, many people
—including many critics—just give up. They are canvases that defy
classification. It seems to me that Cocteau must have had these canvases
in mind when he wrote: 'The work of one who runs faster than beauty

will seem ugly, but he will compel beauty to catch up with him.' It seemed as if the representational canvases had blinded observers.

In 1919 Picasso went to London to join Diaghilev and design the costumes and scenery for *The Three-cornered Hat*, a ballet with music by Manuel de Falla. The drop curtain depicted an arena as seen from the stands. The production had a huge success. In that first year of peace, the avant-garde had become fashionable. Olga enjoyed people and Picasso went along. His collaboration with Diaghilev continued in 1921 with *Pulcinella* with music by Stravinsky, and *Cuadro Flamenco* —the *commedia dell'arte* of his native Andalusia.

These works had repercussions on Picasso's life. They led to a break with Juan Gris, who claimed that he had been asked to design the décor for *Cuadro Flamenco*, and that Picasso had taken the job from him. Braque, in poor health and bad humour after an operation, denounced his old friend's new way of life. However, this did not prevent their meeting now and then, nor did it undermine the admiration they had for each other, coloured perhaps by Braque's possessiveness which impelled Picasso to say with an irony at once both cruel and tender: 'Braque was the woman who loved me most.'

The Côte d'Azur being fashionable only in winter, Picasso went there in the summer of 1919 and stayed at a hotel in Saint-Raphaël. There he resumed his series of *Balconies* and *Guéridons* (pedestal tables), shattering the plane of his first Cubist canvases, opening it up to landscape backgrounds and, in particular, to light from all sides. Though the organization of planes is more complex and there is greater variety of tone, light-and-shade with its deceptions is banished, volumes and three-dimensional structure being created by cut-outs and the relationships of colour planes. The pencil studies for these works have the same quality as portraits like the one of *Igor Stravinsky*, with its dazzling mastery of line used to express light and volume. This return to nature also emerges in a *Landscape* which is treated objectively, to present universal order. It is a scene with large trees opening on to a mountain like Cézanne's Montagne Sainte-Victoire and, in contrast to the Rue des Bois and Horta de Ebro canvases, the equilibrium of masses and relationship of lines is all that is needed to break through into the background distance.

A drawing of this period, *Woman with a Pitcher*, deserves to be compared with the *Portrait of Mme Wildenstein*, done at Biarritz the previous

autumn. We realize that Picasso is no longer trying to impose on us the vision of Mme Wildenstein seen against the back of a Louis XIII armchair, but is now deliberately involving us in the world which inspired the *Woman with a Pitcher*. The dialogue is now with Corot, and two canvases are involved, the *Pensive Gypsy* and *Italian Girl with a Pitcher*. As Pierre de Champris says: 'Beyond Corots, Picasso sees for Corot, rediscovering his inspiration, reviving his characters, repeating their gestures, even preserving the intimate details of the world Corot loved. He frees Corot's poetry of its excessive sentimentality, condenses dispersed intentions into a drawing, protesting in Corot's own name against a too facile acceptance of the model.'

This capacity for decision, this sense of what is essential and typical, does not astonish us any more, either in relation to reality or in relation to Picasso's predecessors; but in the following year, 1921, he was to give us a demonstration of his genius in strict relation to himself. His two canvases of the *Three Musicians* also represent an anthology, but this time it is not of Corot or of anyone else, but of the Cubist Picasso himself.

The two versions of this work are distinguished by their titles: *Three Musicians* and *Three Masked Musicians*. They look as if Picasso had resorted to stereoscopy, just as compositions of paired women appear in canvases at every stage of his career. Compared with the canvases of the crystal Cubist period, with the *Harlequin* of 1915 and the *Guitarist*, *The Three Musicians* represents the same kind of revaluation as the works related to Poussin. Picasso takes into account everything his own painting has taught him, and in particular the reconquest of depth. His *Three Musicians* exist in the kind of space he created in his *Balcony* pictures facing sky and sea. But at the same time they indicate to what new heights of discipline and precision the reconstructions and abstraction of Cubism have reached—notably in *The Italian Woman* of 1917, the *Woman in Armchair* of 1918, *Harlequin and Guitar* of 1919, and *Two Harlequins* of 1920—expressed in coloured planes geometrically organized. The version belonging to the Museum of Modern Art, New York, has a slightly greater width than height. The flautist is on the left, and the harlequin playing the violin is in the centre. The same sharp, flat blue is used to construct both men. In the other version, belonging to the Philadelphia Museum, the height is slightly greater than the width, and the colours are not

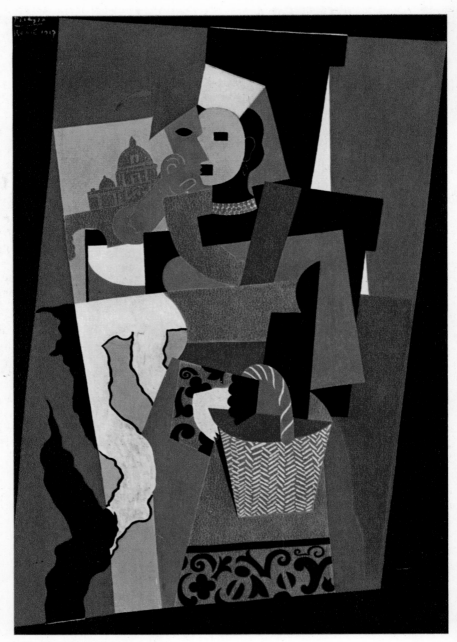

THE ITALIAN WOMAN. 1917

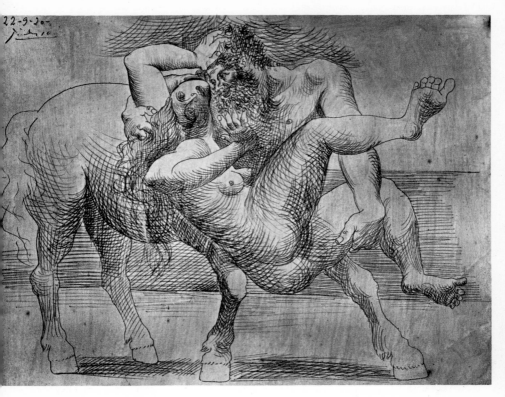

THE RAPE. 1920

as vivid, being developed and nuanced more like the colours in the *Balcony* series. The harlequin flautist is in the centre, and the monk here is playing a keyboard instrument.

This double anthology unquestionably has a touch of bravura about it, representing a culmination of Picasso's experiments, a fusion of his Rose-period *commedia dell'arte*, the musical instruments dear to Braque, his own *Young Girl with Mandolin*, and the harlequins of his Crystal period. But anyone aware of what is still to follow this pair of masterpieces of the artist's fortieth year, can hardly help thinking of all that this great *tour-de-force* foreshadows for the future. Nothing is less arbitrary either in the whole or in detail. Just like a chemist creating previously unknown substances, the painter of this thoroughly embraced Cubism does not proceed at random, or create just what

he pleases. Both the chemist and the artist master nature only by obeying her. This is the goal of the Cubist road: the painter is no longer an imitator, one who copies nature. Like his scientific colleague, he masters and takes hold. Never less subject to appearances and superficial resemblance, he was at the same time never more subject to the new laws now uncompromisingly manifested, laws of form that govern the flat colour, allowing the different planes to be indicated by the sheer play of form and tone.

After attentively studying the two versions of the *Three Musicians*, it seems inescapable that everything is deliberately calculated, organized and painted in order to entrance us with this strange masked-ball orchestra, like a dream out of Shakespeare. Impossible here, as in the *Grande Odalisque* of Monsieur Ingres, to count how many vertebrae there are. Like the earlier academic critics, we are compelled to admit that it is quite clear that 'the artist has sinned knowingly, that he purposely did bad work'. And as for the vertebrae, the matter was deferred, as we shall soon see. Picasso keeps in mind Ingres' idea: 'Accessories must be sacrificed to essentials; the essential is the form, the outline, the modelling of the figure.' Picasso proceeded to give astonishing demonstrations of it in the language of Ingres.

It was in the summer of 1920 that Picasso first came to Juan-les-Pins. That spring he had dreamt of a sun-drenched landscape. 'I don't claim to be clairvoyant', he said to Antonina Vallentin, 'but I was astounded. There it was, exactly as I had painted it in Paris. At that moment I realized that this landscape was mine.' The series of *Rapes*, of a nymph seized by a centaur, shows that this native of Malaga felt the presence of ancient Greece in his landscape, but he celebrates it as though he were animating a still-life; for example, the *Basket of Fruit*, which he did in that same summer.

The group of works which have been called monumental, are impressive because of their immobility, their massive aspect and sculptural weight. The affinity of the subjects with those of 1906 is eloquent. *Two Nudes Embracing* corresponds to *Two Young Girls*, one standing, the other sitting, done in pastel on 18 April and in oils on 28 April, 1920. In addition, *Two Nudes*, back and front-face, standing, are followed by a whole group of gigantic nudes, some seated, others shown half-length: *Two Nudes with Drapery* of 1920, *Seated Draped Nude* of 1921, and *Seated Woman* and *Female Bust*, both of 1922. In the interval

we meet the same huge woman reclining, holding an amphora upside down, her gaze lost in a classic park: *Spring*.

Reference to the ancient world is even more strongly marked in a preparatory study, *Woman at the Fountain*, which is succeeded by a large canvas, *Three Women at the Fountain*, executed in the tones of ancient terra-cotta, with tunics in fluted folds as in fifth-century Greek sculpture. *Young Woman and Child*, and *The Lovers*, both of 1923, parallel the search for purity of plastic expression of *Maternity*, of 1922, and of various versions of the *Portrait of Olga in an Armchair*, of 1923.

In the same period another series of experiments opens up a different perspective. It is a series in movement, in contrast to the previous group, but one which complements it, as we shall see. This series also takes up a theme which is very dear to Picasso, the beach and bathers. The *Three Bathers* and *Group with Running Bather*, studies done in 1920, are very closely related to *Seated Women*. *Bathers with a Dog*, 1921, reveals a different technique, with the shadows very clearly stressed; and the same approach is repeated in the groups of *The Pipes of Pan Player*. But the 1920 drawings return first to the immobile grouping of bathers, then again the running bathers, which in 1922 serve for the *Two Women Running on a Beach*, and in 1923 for the big canvas *Women on the Beach at Dinard*.

This series is an affirmation of liberty. It draws its inspiration from the new reality of games played on the beach, of men and women who, after so many centuries, have rediscovered the taste for sun on bare skin. But this liberty in which the painter indulges—contrasting the running bathers of 1921 with two others standing motionless and looking at each other, the one putting a hat on the other's head, exactly as in *Bain turc*—is not merely his way of pulling down the walls of the harem. He is striving to master forms in movement. On examining this series one is struck by the peculiarities of the distortions, which resemble those produced by a slow-motion movie.

The foreshortenings and the elongations, such as those used by Cézanne in his *Young Man in a Red Waistcoat*, appear in both series, and everything suggests that in the immobile, monumental series Picasso made a static study of the 'distortions' in order then to express them dynamically in volumetric movement, in the beach and bathers' series. The immobile series indeed develops from works which—after the abstractions of Cubism—seem to indicate a return to 'clas-

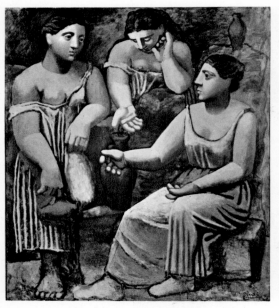

THREE WOMEN AT THE FOUNTAIN. 1921

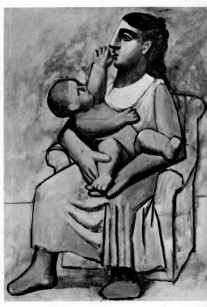

MATERNITY. 1921

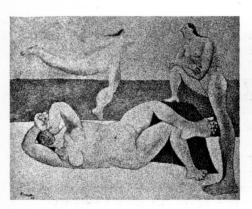

THE BATHERS. 1923

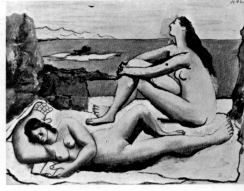

WOMEN BY THE SEA. 1920

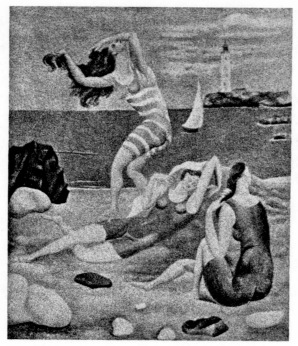

WOMEN ON THE BEACH AT DINARD. 1923

sicism' and 'resemblance', but which, actually, speak a very different language. Take, for instance, the drawings Picasso did after his visit to Italy, such as *Fisherwoman* and *Two Neapolitan Women Embracing:* unquestionably, Picasso has faithfully depicted the exotic headdresses and the particular style of their clothing, but—even more than Chassériau in painting the *Two Sisters*—Picasso reduces the size of the heads, magnifies the hands, exaggerates the size of the fingers on the shoulders, the arm holding the paper, the hand brandishing the fish. The enlargement here serves to detach what should project from the plane of the drawing, and in this sense it is the linear successor of the pasted papers and all the discoveries in the conquest of space, in the flat planes, collages and projections of the second Cubist phase. This is a general principle, observed from *Siesta* of 1919 to the giants of the immobile series.

The series of *Bathers* helps us to understand the modifications of space governing the immobile series. In fact, Picasso consistently opposes immobility to movement, thus providing inner points of reference, elongation in the direction of movement, enlargement and thickening of what is stable and immobile, and the dialectical reaction of movement to stability. The arm of the bather diving toward the dog is really extended, while the nude bathers running away from their companions grow smaller as they move away, going out of the plane under our eyes by a dynamic application of classic perspective.

The summer of 1922, which Picasso spent in Dinard, gave us some very interesting Cubist still-lifes executed in stripes and checks, and hese led in 1923 to the *Bathers* in which the laws of receding lines in movement are carried to their ultimate possibilities. The bather lying on her back, the bather with one foot up on a rock, and the bather dashing into the sea are all drawn from the viewpoint of someone lying down in front of them with eyes at sand level, so that the disproportions immediately become tremendous. The big canvas, *Women on the Beach at Dinard,* offers the full summary of all those years of experimenting. This dynamic painting radiates a *joie de vivre,* the liberation of the women, their hair flying in the wind, while the body of one of them, twisted to more than 180°, recaptures the Gothic élan of Botticelli's *Spring,* without any of the trammels of Renaissance discipline.

At the same time, in *Wounded Horse,* and also *Exhausted Horse,* the new conquest of movement contrasts action in the bull ring with the motionless audience with big women sitting impassively in high white mantillas. Life is not just immobility or movement. The big *Harlequins* for which the painter Salvado posed are there to remind us that man can also contemplate, seeking perhaps in vain to know, like that *Moorish Woman* who is as much the prisoner of her condition as Gros' *Madame Récamier in Old Age* is a prisoner of her infirmities. Life is also tenderness. Paulo catalyzes the canvas *Mother and Child,* which is as gentle and beautiful as Leonardo da Vinci's *Madonna. Paulo on his Donkey, Paulo Holding a Lamb, Paulo Drawing:* the Infant Jesus Himself was never made so much of by painters. Then, in the summer of 1923 at Antibes, comes the grandmother, painted with the same joy and delight, but listed in the catalogues as *Mother of the Artist.*

A NEW FIGURATION

Nature and art are two different things. In art we express our conception of what is not visible in nature.

PICASSO

Right after World War I, Kahnweiler's pictures came within the scope of a law ordering the sale of confiscated German properties. All efforts to save these pictures from liquidation and keep them in the country were in vain. As a result of public indifference, and to the satisfaction of those who had been awaiting an opportunity to settle old scores with Cubism, seven or eight hundred canvases by Picasso, Braque, Derain, Vlaminck and others were thrown onto the market in five big sales at intervals throughout the years 1921, 1922 and 1923. Of course, the bottom dropped out of the market. No one profited from the affair except a few young writers. Picasso was not materially affected and now began to be reasonably well off. From 1923 on, while still selling to Paul Rosenberg, he re-established his relationship with Kahnweiler, and this ultimately led to complete agreement between them.

Out of the Dada movement of this time was born Surrealism, and thus it is that the years immediately following are referred to as Picasso's Surrealist period. Actually, the situation was much more complicated than that. On the one hand, Picasso is never very far from important contemporary events. Although he isolates himself to paint, he asserted emphatically that the 'artist is a political being, constantly aware of the agonizing, passionate or pleasant events taking place in the world, and moulding himself completely in their image. Indeed, how could an artist possibly lose interest in his fellow men, shut himself up in an ivory tower and cut himself off from a life which offers so much?' On the other hand, the Dadaists and even more the Surrealists were to draw support from his experiments and claim him as one of their own, annexing him so to speak, at least in the eyes of the general public. Picasso, it goes without saying, remained outside the movement as such, although it should not be forgotten that he attached to the term Surrealism the meaning given to it when it was first coined by Apollinaire: a return to nature, but not by imitating its visual aspect. When man invented the

wheel to imitate walking, 'he was being Surrealistic without knowing it', wrote Apollinaire in the preface to the *Mamelles de Tirésias*, which dates from the summer of 1917. This reflects the discussions published in Pierre Albert Birot's review *Sic*, which was instrumental in establishing a transition between the generation of Apollinaire and Reverdy on the one hand and the younger generation of Breton and Aragon on the

JUAN-LES-PINS. 1925

other. It is a point to be kept in mind to avoid misunderstandings. Picasso, as well as Breton, Eluard and Aragon, when they expressed themselves on the subject, were implicitly aware of the changes that were taking place, and particularly of the radical transformation of Surrealism itself, between the time Apollinaire refused to be regarded as a Symbolist, and that moment in 1924 when the Surrealists constituted themselves as a group and issued their Manifesto, which was published in the review *La Révolution Surréaliste*.

It is true that there is something in Picasso which the acknowledged painters of the Surrealist group have hardly realized. Nevertheless it cannot be denied that Surrealist painting is represented by Picasso, Klee, Miró, Max Ernst and Masson rather than by Picabia, Dali, etc.

While one can characterize Picasso's experiments in the breach following the Rose period at the end of 1905 as a systematic and logical revaluation of the whole art of painting, the period from the *Portrait of Max Jacob* at the end of 1914 to the 'Surrealist' still-lifes of 1933 can be regarded as a counter-revaluation which runs parallel to the former for a long time and does not get the upper hand until after 1926. It is a psychological revaluation centering on spontaneity, directness of

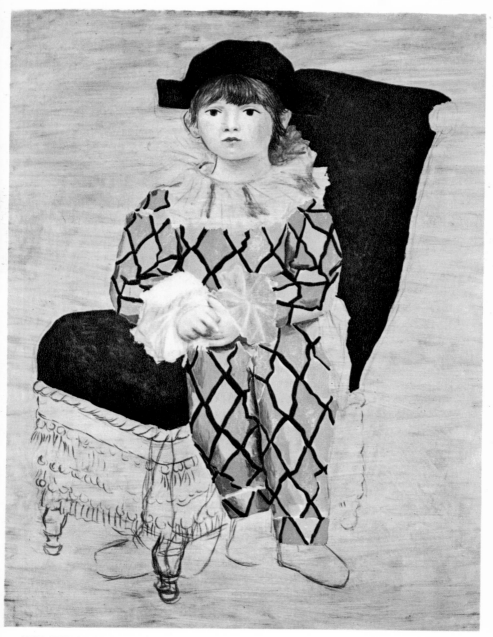

THE SON OF THE ARTIST AS HARLEQUIN. 1924

experience, ingenuousness, the subconscious, and nightmarish monstrosities.

If the banquet given for the Douanier Rousseau at the Bateau-Lavoir in 1908 was a more important event in his life than that of his host, Picasso, it was only after the curtain for *Parade* and during the twenties that the Douanier's painting became a creative influence in Picasso's work. The series of portraits of Paulo, which still retain their miraculous freshness and purity, probably represents the flood tide of that leaven which infuses Picasso's painting with the wonder of everyday reality, though parallel with these paintings we find 'monstrous' canvases, shrieking the rejection of reality, revolting against its inhumanity.

These contradictions are not peculiar to Picasso; they are inherent in the different interpretations of the word 'Surrealism', at the very heart of the group of men who founded the movement. Although the sacrifices of the war, monuments to the dead, profiteering, the sale of Kahnweiler's pictures, the occupation of the Ruhr, the Riff war —all these products of the mind of man—have opened the door to the subconscious, to psychic automatism and a world of monsters, they do not necessarily mean that we should despair of human reason. As Breton said, 'If the depths of our being harbour mysterious powers capable of strengthening our outward capabilities, and even of prevailing over them, we have every reason to take hold of these powers if we can, in order to subject them, if necessary, to the control of our minds.'

Like the younger members of the Surrealist movement, Picasso felt himself struggling with an intolerable and unacceptable reality, though it was also a time when he felt the attraction of beauty as never before, so that he experienced an intense desire to make his painting express the delight he felt in his wife and son and in all the joys of life. In view of this it is absurd to try to set this reconciliation with reality down to escapism. The two things co-exist in Picasso just as they did in Paul Eluard, who was just then leaving for Polynesia, and just as they did in the Surrealist movement itself, which dissociated itself from its opposite only at a later stage. Picasso's interlocutors now gradually changed. Gauguin and the Douanier Rousseau succeeded Poussin and Ingres; the Mycenean figure and the nightmares of Hieronymus Bosch succeeded the Iberian and Negro influences. But all this took place without in the

least breaking the continuity, either of Picasso's work, or of his dialogue with those who had gone before him, and without affecting the integrity of the painter himself, which was never broken up or denied even though he constantly corrected himself, began again, and subjected himself to a merciless self-criticism.

The most disconcerting thing in this period, however, is that the very necessity of renewing the language of plasticity led Picasso to go to extremes. The album drawings which resulted from his stay in Juan-les-Pins in 1924 carried abstraction to its farthest limit. However, if we compare these drawings with the previous process of abstraction —that of the Cadaquès period, the 1913-14 collages, and the crystal Cubist period itself—the overall artistic unity becomes reintegrated before our eyes. Likewise, the coherence of the means employed becomes evident: the play of hatching in the period of *Demoiselles d'Avignon*, or of the Cubist still-lifes from his stay in Dinard, the dot technique of drawing which had been evident since the *Fireplaces* and *Pedestal Tables* of 1918, and which served in a drawing like the *Two Boys* in the Wildenstein Collection to represent volume in a strictly classical composition.

One thing we must never lose sight of is the fact that Picasso is constantly in movement. His painting is always a bridge between the world and ourselves, and with him abstraction is conquest, so that when he turns his back on ordinary appearances and seems utterly to reject reality, his aim is nevertheless not to expel reality from his canvas but to attempt to encompass the greatest possible measure of it with the minimum of signs. The result is that the apparent discontinuity, the hesitation and the inextricable entanglement of experiments derive much less from Picasso himself than from the incomplete reflection we have of his work at any given moment, and from the fact that we tend to isolate works which in fact co-existed not only in his head, but also actually in his studio.

Picasso has done what he could to help us, but we have not paid sufficient attention to what he has had to say. 'There is no such thing as abstract art', he said to Zervos. 'You always have to start with something or other. You can remove all outward resemblance to reality, but nothing is lost, because the concept of the object has been ineradicably stamped.' The *Juan-les-Pins Album*, with its drawings in curved lines and its dots, which was to be used in 1931 to illustrate the *Chef-d'œuvre inconnu* published by Vollard, is contemporary with the landscapes in

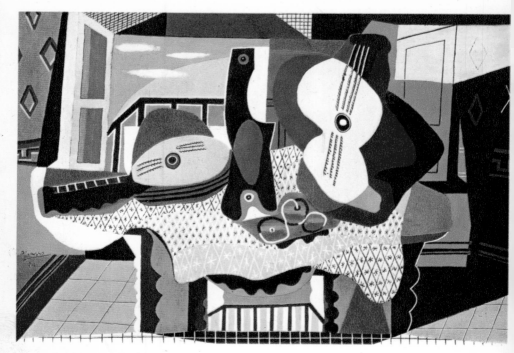

MANDOLIN AND GUITAR. 1924

which Picasso interprets the view from his villa. Once again, a compa-
rison of these different experiments throws light on them all. We
become aware of the severity and mastery which reside in the simplifi-
cation of the elements of his landscapes of Juan-les-Pins.

And now at last we also begin to understand the nature of Picasso's
discoveries. Because he has said a thousand times to those who ask
him what he is after that the important thing for the painter is to find,
people have ended up by repeating his words without understanding
them, as if they were some sort of joke. Picasso is not one of those who
casts around looking for which way to go; he already knows, and his
genius lies primarily in his grasp of what emerges from under his brush,
his pencil or his eyes. It is easy to say that anyone could make a bull's
head with an old saddle and a pair of handlebars, but it was only Picasso
who had the idea.

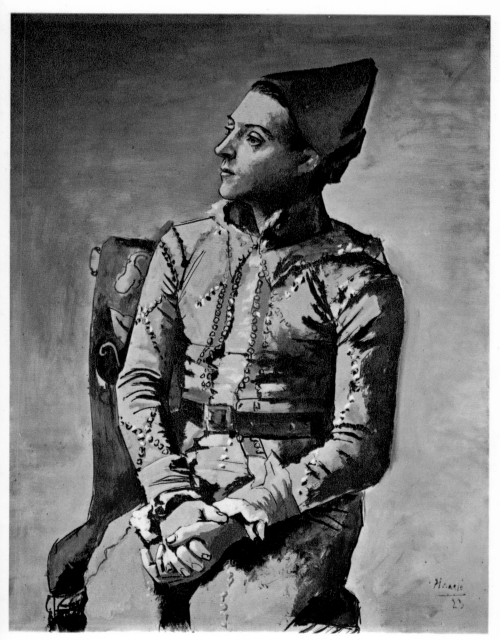

SEATED HARLEQUIN. 1923

In any case, if you take a closer look you will discover that it isn't just any old saddle and any handlebars. Picasso has not just combined two standard objects. He 'discovered' his bull's head by juxtaposition of a particular saddle and handlebars. This was something Picasso 'discovered', not something he had 'looked for'. In the same way that a research scientist makes a discovery within the context of a whole group of experiments, Picasso has found a way of using what reality and chance offered him for a confrontation of that saddle and those handlebars that would transfigure both. He was able to do this not because of any particular interest in bicycle accessories or in finding a way of modelling a bull's head, but because he was looking for a more effective language, a more adequate and powerful means of expression. This *Head of a Bull* dates from 1943, but I am not anticipating. The *Guitar* (dishcloth, string, nails and a newspaper) dates from 1926. Is it a sculpture, a collage, or both? Is this abstraction? Or Surrealism? Unquestionably the introduction of a lowly domestic article such as a dishcloth (on another occasion it was the tail of a dirty shirt) underlines the power of the artist to transmute base metal. But rather than regarding it as a provocative demonstration, shouldn't we rather see it as a Picasso-Hamlet demonstrating to Horatio, the traditional painter, that there are more things in heaven and earth than are dreamt of in painting?

The first number of *La Révolution Surréaliste* appeared at the end of 1924, a few months after the *Juan-les-Pins Album*, and its avowed intention was to crystallize Surrealist ideas. At that time Picasso was engaged in painting his *Still-Life with Black Head*. He gave the new review his Juan-les-Pins drawings for publication and they appeared in its second issue on 15 January, 1925. On the cover appeared a scarecrow with the caption 'French art at the beginning of the twentieth century'.

The first editor, Pierre Naville, having left for military service, Breton took over, and the first thing he did was to publish an important group of Picasso's works in the fourth number (15 July, 1925). It included an account of the *Demoiselles d'Avignon*, collages like the *The Student*, and the reproduction of a picture in a previously unknown style, *Three Dancers*, or *The Dance*.

It has become the custom to associate this particular picture with Breton's formula, 'Beauty has to convulse or it is nothing'. In fact, it was this very picture which inspired Breton's axiom and persuaded him to try to appropriate Picasso, or at least to lay claim to him and

to justify himself by him. 'Without Picasso', he wrote, 'the game we are playing would be a draw, if not lost.' And even more explicitly he wrote: 'His extraordinary perseverance is such a valuable guarantee that we could get along without any other authority.'

The Dance is first of all based on personal experience, dating from Picasso's stay in Monte-Carlo at the beginning of 1925 with Diaghilev and Massine, as indicated by some brush drawings of *Dancers*, shown in the short waistless skirts of the period. It also proceeds from the mobile series of *Bathers*, which incidentally includes studies on the same theme as *Three Dancers*. However, this canvas does not represent movement by contour but goes back once more to the use of flat areas of colours as in the preceding period.

The dynamics of the dance—the frenzy of its jazz beginning one year before the Charleston was launched by Josephine Baker and the Negro Revue—are expressed in this masterful synthesis of outlines bending with the movement and in stylized areas of flat colour. But, once again, nothing is arbitrary. Into this canvas Picasso introduces another element characteristic of the new period. This is based on something just as real as the jazz, i. e., the coloured electric lighting of stage sets and night clubs, even going so far as to contrast it with the blue of the night as seen through an open window. There is nothing 'monstrous' about this canvas, and it is very doubtful whether we should read into it—as some claim—a 'moral' judgment by Picasso on the scene. Picasso invents means of his own to master what is modern in his painting. His *Three Dancers* represents a further degree of liberty in the plastic transcription of reality, a triumph for new methods of figuration.

Once again, 'new' in this connection must be understood in relation to Western painting. Although the use of flat areas of colour and hatching, the schematization of the figure, all the modalities of this language unquestionably are part of Picasso's experience, the method of stylization itself has been rediscovered, re-invented from early Mycenean art seen in the Louvre. The so-called *Venus of Mycenae*, with its bird-like head in profile, its ample drapery treated in crescent-shaped hatching, the breasts shaped by the movement of the raised arms, will for ever more look like a Picasso. All the discoveries of recent research make it quite clear that we are dealing here not with any stumbling, primitive art, but, on the contrary, with a highly advanced one, an art

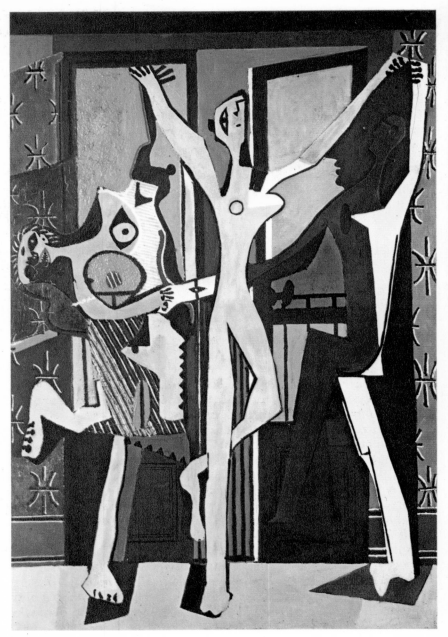

THE THREE DANCERS. 1925

DANCERS. 1925 MAN AND WOMAN. 1921

which in the course of centuries has passed through figurative and geometrical phases—the latter at the time of Homer—and then has returned to stylized and finally to classical figuration. It is further proof that the movements of contemporary art, indeed of Picasso's own movements, are not an anomaly in the history of the plastic arts, but represent age-old fluctuations and conflicts experienced since the dawn of civilization.

The year 1925 was also a year of experimentation with still-lifes, which I have already mentioned but which are more distinctly interiors than those of 1924: *Still-Life with Fishing Net* seen against a night sky, *Still-Life with Ram's Head*, also near the sea, with starfish, sea urchins and shells. Then comes the theme of the studio, but this time the window opens onto another house treated as a stage set. A table is covered with plaster casts of arms, and a bust of Homer is given half a moustache by Picasso. Despite appearances, the relation of this picture to reality is just as direct as in the still-lifes in which, it seems, the painter seeks

to master everyday things as they are around him in their familiar dis-order; for example, *The Cage*, with its stage-set perspective borrowed from a toy theatre belonging to Paulo.

This is the year of *Paulo as a Torero;* also of some very abstract still-lifes in the same general manner of both the still-lifes with hatching, and the *Juan-les-Pins Album*—for example *Still-Life with Stars*, dated 28 February, 1925. One has a very definite impression that Picasso is deliberately operating on all fronts, making a break-through at one point, consolidating his position at another, falling back on his base elsewhere. It must have been a very strange *Milliner's Workshop* whose dark fluidity translates what Picasso saw from his studio across the way in the rue La Boétie.

PAINTING AND IMAGERY

The means available to Surrealism should be extended.
In order to produce the required impact of certain asso-
ciations, everything is permissible: the pasted papers of
Picasso and Braque...

ANDRÉ BRETON

The landmarks traditionally employed for the period of Picasso's work extending from 1926 to 1930-31 are more deceptive than any we have come across so far in attempting to trace his footsteps. Kahn-weiler remarks that: 'When André Masson calls one of his sculptures *Metamorphosis*, it is because it represents a human being in process of changing itself into animal, vegetable or mineral form. Nothing of the kind applies to Picasso, you may rest assured. The sign he invents to indicate "nude woman" is simply made up of elements in a different arrangement from that in the body of a real woman.' In fact, when one speaks of 'Metamorphoses' or 'Monsters' in Picasso's work, one is associating it, wittingly or unwittingly, with ordinary Surrealism, whereas Picasso's approach is entirely different. It is also an over-simpli-fication to look in the pictures of these years for a reflection of the tensions set up in Picasso's life by the fact that he was now approaching fifty and by the crisis in his marriage. Just as the very existence of Sur-realism, such factors no doubt played their role and left their mark on Picasso, who is neither a recluse in an ivory tower, nor a disembodied spirit; on the other hand, his painting and what he is striving to express cannot be reduced to terms of such external circumstances or chance happenings.

The new theme which now began to dominate his work was that of *The Painter and his Model*. The first version, dating from 1926, is inscribed in space by a network of interlaced curves against a background divided into large flat areas of colour. This was followed in 1927 by *Painter with his Model Knitting*, an extremely classic drawing though the canvas between the two figures is covered with entirely abstract lines and curves. The *Painter's Studio* places the model on a chair behind the painter who, in this case, is sketching a perfectly recognizable outline. On the floor behind the table is a head such as haunted the atelier and still-life compo-

sitions of 1925. The *Painter and his Model* of 1928 reverses the relationship between reality and the work, both model and the painter being abstract, reduced to a sheme in which the elements of identification are reconstructed, while the outline painted on the canvas is so to speak 'naturalistic', even representing the purity of an ideal face.

A similar dialogue is put forward in the series of still-lifes which continue in 1926 with *Bowl of Grapes* and *Blue Still-Life*: guitar, bottle of wine, fruit, and, as always, the fruit dish, invariably present since the *Still-Life with Red Shawl*, which marked the transition from the series of pedestal tables to these interiors. The dialogue continues in the experiments in illustration for the *Chef d'œuvre inconnu*, which, incidentally, led in that same year 1926 to a resumption of the abstract drawings of the *Juan-les-Pins Album* with its network of lines punctuated by dots. All this coincides with a *Still-Life with Pitcher*, a bowl of fruit on a rustic

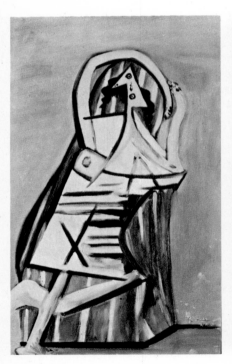

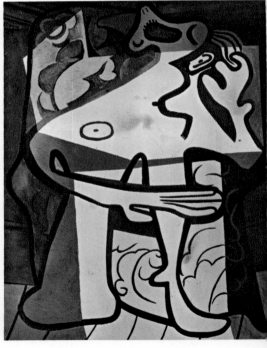

WOMAN IN CHEMISE IN AN
ARMCHAIR. 1929

WOMAN IN AN ARMCHAIR. 1927

table in a vineyard, as completely classic in treatment as *Still-Life with a Jug* of 1921. We are dealing here with undertakings always conducted simultaneously and in succession, of which the date of execution or publication is often misleading, in any case quite different from the date of the creative *élan* which initiated them.

In 1927 in Cannes it seems as if Picasso was dreaming of unheard-of sculptures. His notebooks are full of charcoal sketches reconstructing bathers, men and women. One woman is inserting a key into the door of a bathing cabin, while others, by their very monstrosity and structural anomalies, suggest Freudian symbols, an obsession with sex. This chimerical reconstruction, in Picasso's favourite setting—the sea, the shore and its bathers—represents a simultaneous dialogue with both Hieronymus Bosch and the Surrealists. On the other hand, the following summer, which was spent by the family in a large modern-style villa at Dinard, marks a return to dynamic transpositions in a heavy, sombre palette. The striped bathing suits the Douanier Rousseau was so fond of suddenly howl in contorted poses of bathers disproportioned and disjointed by their very movements, as if the painter's eye were set, like a camera lens, for a long exposure. These savage pictures, *Ball Game* and *On the Beach*, have an extraordinary power of movement. The boldness of these figural reconstructions, based on the Cannes notebooks, is combined with shrieks of colour of a daring equalled only by their incisive expressiveness. In 1929, a *Bather* curled up on the beach, painted in the same sombre, heavy palette, is dated 23 August. It follows on others of outstretched figures similarly transcribed and reconstructed, some dating from April with more geometrical elements, others dated 18 and 24 August with volumetric distortions.

In the same period Picasso attempted still other methods of analysing and synthesizing reality. A pen drawing like *Horse on a Seesaw*, dated 7 February, 1926, while retaining the disruption of space into distinct planes seen in his most recent still-lifes, takes much greater liberties in the reconstruction of volumes, silhouetting them in three dimensions and defining their position in space. In 1932 we find another drawing; *Game on the Sands*, also in pen and ink, makes use of the same effects to indicate the outlines in a free play of the imagination.

Various versions of a *Woman's Head* in 1926, also *Child Harlequin* and *Seated Woman* in 1927 represent similar attemps in which the 'Cubist' stylization and remodelling preserve the aspect of the human face and

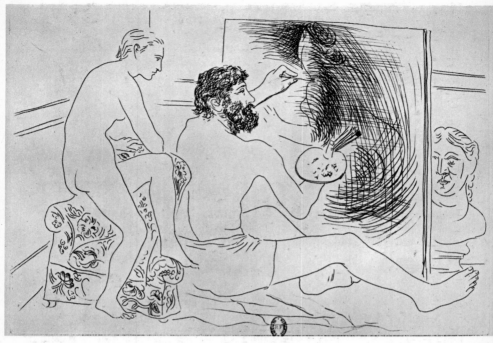

PAINTER AT WORK OBSERVED BY NUDE MODEL. 1927

body. But the *Woman in a Armchair* of the same year is no more than a metamorphosed impression. The *Woman in Armchair* of May 1929 is less transposed, but rendered more fluidly in a sort of anguished abandon. Joy has fled from these canvases, and suddenly everything appears tragic, like the cry of that *Bird on a Branch*, a star of disaster. The canvas called *Self-Portrait* and the *Woman in Red Armchair* go in for montage in the technique of the painter-and-model of 1928, in which the relationship to reality exists only through certain signs arranged by the painter according to the requirements of the image he is painting.

I quite deliberately use the word 'image', which, in reference to a painter, is clearly ambiguous. In fact, when we examine the different approaches of Picasso's experiments during those years, we are struck by the analogy with poetry: it seems as if he is seeking plastic images equivalent to poetic images in the sense that his poet friends Max Jacob,

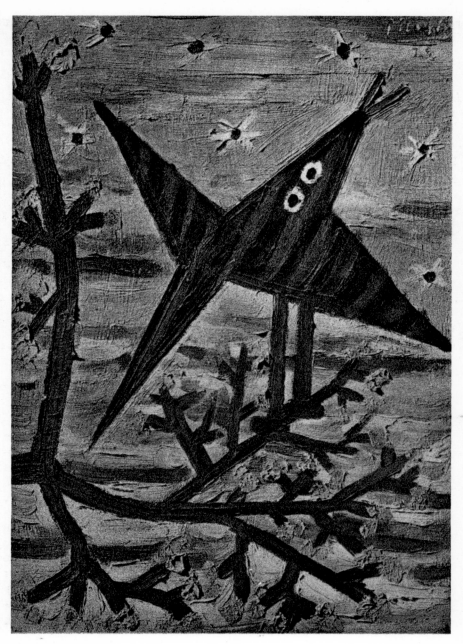

BIRD ON A BRANCH. 1928

Guillaume Apollinaire and Pierre Reverdy understood images. It is in fact notable how, like Picasso in painting, they all broke with metaphor and symbol. Reverdy analyses this new value of the image by saying: 'The image is a pure creation of the mind. It is born not of similitude, but of congruity between two realities more or less distant from each other. The more distant and apt the relationships between the two realities are, the stronger the image.'

Surrealism brings this problem right to the fore. Breton leans on a passage of Reverdy's in the Surrealist Manifesto to postulate that 'Surrealism is pure psychic automatism with the end in view to express the real processes of the mind, in the absence of any exercise of reason and independent of all aesthetic or moral considerations.' Writing in the first number of *La Révolution Surréaliste*, Aragon declares: 'Creation is summed up in the establishment of a Surrealist relationship between concrete elements, and its mechanism is inspiration.' And, writing in *Le Paysan de Paris* in 1926, he declares: 'The image is the road to all knowledge.'

Such ideas owe a great deal to Cubism, and they apply in particular to Picasso's own experience. In return, there is no doubt that in reading about them, Picasso unquestionably recognized his own deep preoccupations, and was incited to seek new affinities and discover unknown images. This search for confrontations involves dislocations of reality. Perhaps this is the key to Picasso's return to sculpture—as though he felt the need to work directly on the objects themselves, to mould them, to relate them, to remodel them. The series of sculptured *Metamorphoses* continues the experiments which produced the *Bathers* of Cannes, but with greater serenity. At the same time Picasso was devising wire or other metal sculptures, which Kahnweiler called 'open sculptures', 'designs in space', 'spatial creations'. Later on, in 1936, we find paintings of such sculptures, and these canvases help us to understand his first experiments in this vein. But in 1929 Picasso painted a *Metamorphosis* which seemed as though it had been previously sculpted. Then, projecting the geometrical construction of the *Woman in the Red Armchair*, he conceived a gigantic monument which led to an astonishing canvas, *Head of a Woman*, structured like a house, three-dimensionally on an enormous scale, as indicated by the tiny silhouettes in the foreground. Another *Monument: Young Girl* traces its strange outlines in a vacant light. The *Woman Bather Seated by the Sea* is a painting

THE RANGE OF POETIC EMOTION

In the last analysis there is nothing but love, whatever form it takes. They really should put out the eyes of painters, just as they do to goldfinches to make them sing more sweetly.

<div align="right">

PICASSO TO TÉRIADE

</div>

In 1931 Picasso found a new place to work—the Château de Boisge-loup in the Eure not far from Gisors. He celebrated the move with an oval painting streaked with rain. In February a young woman appears on the scene. There is a *Head* of her with her arm bent over it as in the paintings of 1907, but now nothing is stylized; the whole atmosphere is tender, the details exact and gentle; curves soften the angles. A new model, Marie-Thérèse, seems to catalyze the *Still-Life on a Pedestal Table* which followed: a conjunction of flat colours and cut-out planes outlined with black contours to emphasize élan and the gracefulness of volume. This song of pure colour was accompanied by other canvases, such as *Still-Life with Yellow Jug*, in which the objects are less overpowering and less confining to the space around them. On the other hand, the areas of flat colour are variegated by reflections, shadows and tonal relationships. In *Still-Life with Fruit and Leaves* space is conquered by the dark curving outlines, while *The Table* is another triumph of simplification in the synthesis of the pitcher, fruit bowl, its spatial curves, flat planes and colours.

It was Marie-Thérèse who inspired this combination of happiness, liberty and discipline. Four lines within four lines create the frame: *Woman's Back*, which was to be repeated in *Metamorphoses*, represents the apex of a subtle understatement of outline which Picasso had sought ever since the beginning of what I call the period of movement. Marie-Thérèse appears again, as though on a visit, in the *Red Striped Armchair*, of 16 December, 1931. Her fair features are seen both in full-face and in profile simultaneously.

At the beginning of 1932 two pictures present her in spherical lines, curves, undulations, again a kind of sculpture in painting, with zones of colour barely indicated by outlines. In March there followed one in which she is confronted with a still-life in the style of those of 1931;

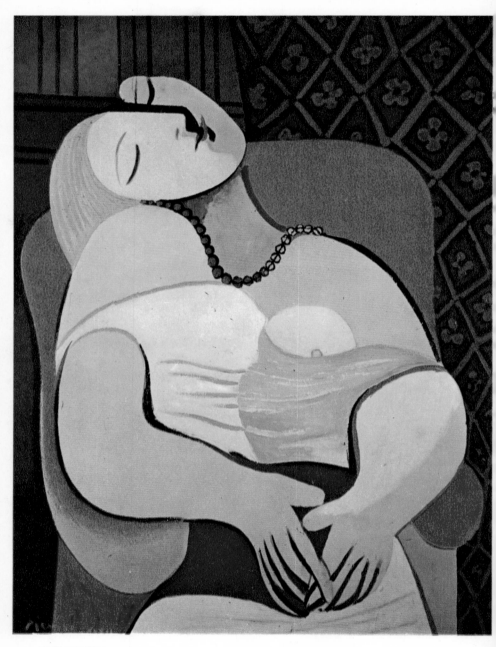

THE DREAM. 1932

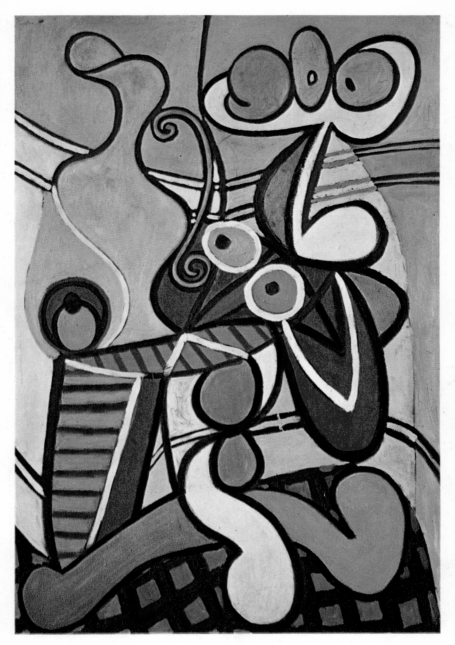

STILL-LIFE ON A PEDESTAL TABLE. 1931

then on 16 March she is caught asleep, with her head resting on her arm. Thereafter she is the *Nude Girl* sitting in a red armchair, *Nude on a Black Couch, Sleeping Woman with an Open Book on her Knees, Woman in a Yellow Armchair*, and finally, she is *The Dream*. This canvas is executed in pale colours; two profiles united on the same plane are separated from each other by a black line which extends the moulding of the room, and—most surprisingly, since one would expect exactly the opposite—stresses the profound harmony of the face and its marriage with the billowing shoulder. This canvas dissolves in tenderness the angular and depressing dislocation of the *Woman Ironing* of Picasso's earlier days. The same bliss is reflected in *The Mirror*, a canvas of Marie-Thérèse asleep.

This feeling of wonder, this joyous renewal takes many forms and is contagious. In 1932 a *Woman and Flower* is partially transformed into a flower, and a *Woman Bather Playing with a Ball* into a ball. Two canvases of *Rescue*, showing an inert and drooping woman, saved in one by a bearded man, in the other by a woman, with forms that seem flattened by the movement that projects them, foreshadow that masterpiece of grace, the pastel *Farmer's Wife on a Ladder*, of 1933. Abstract figures on the theme of the Crucifixion accompany a studio drawing, *The Torso*, in which the mirror is intersected by an arm planted on the reflected body. On the other hand, the watercolour of *The Beach* transposes the outlines into nets, while the plate of drawings entitled *Anatomy* restates them in terms that look like cabinet-work and appear to be a Surrealist refraction of engravings in old technical publications or in the Encyclopedia.

Picasso, who had spent the two previous summers in Juan-les-Pins, did not stir from Boisgeloup in the summer of 1932. He had a studio built in which he could also do sculpture. He renewed his friendship with his old friend Gonzalez, whom he had known from the early days of his wire sculpture. Now he was working at full pressure. 'I feel as happy as I did in 1908', he stated. That referred to the year of the banquet in his studio in honour of the Douanier Rousseau, also the year of his stay at Rue des Bois, but Picasso was really recalling his faceted *Woman's Head* which was completed the following year in Gonzalez' studio. Marie-Thérèse came to Boisgeloup, and there she became a *Woman's Head* in gilt bronze with extended eyes, a straight nose and hair in long, gentle waves.

146

A series of sculptures now transposed into three dimensions the dissociations of profile that characterize the portraits of Marie-Thétèse. Picasso also turned his attention to animal sculpture in a defiant *Cock* and a *Cow's Head*. He also made transcriptions of the movement and remodelling of the years preceding 1930. But cruelty and harshness now gave way to irony and humour, as in the puffed-out *Warrior's Head* with its enormous jutting nose, its prominent eyes and jug ears, and its skull with a mane like a helmet. Some bas-reliefs take up again the theme of Marie-Thérèse's head, and also the kind of fortuitous encounters of which Lautréamont had dreamed. In 1928 Picasso had associated *Plant, Feather Duster and Horn* in this way, taking natural forms and remodelling them. In 1931 he carried out the theme again in iron, producing an *Object* which resembled both his canvases and his current structures. *Matches, Drawing-pins, Blades of Grass, Leaves and Butterflies* is the first of six reliefs made of root ends, string, a toy boat and an old glove, each covered with sand, and so constituting still-lifes, or fragments of life.

There was a total of twenty or so pieces in the years 1931, 1932 and 1933, followed by ten high reliefs in plaster, in particular several *Heads of a Woman* in 1934. Including the experiments in metal and wire this makes more than eighty sculptures in five years.

Louis Fort, who had been introduced to Picasso by Vollard, now transferred his engraving press to Boisgeloup. Between 20 March and 5 May, 1933 Picasso executed the forty engravings which make up the series entitled *The Sculptor's Studio*. The sculptor is bearded like an ancient Greek. In the series, it seems as if each time his creation separates him from his companion, the works themselves become strangers to each other. The agonies and doubts of creation were never so impressively expressed. It represents a dialogue between the artist and his work-object, which has its own specific presence, its own proper life. It is also a dialogue between the model and the work; the artist and his model, his companion, face to face with the irruption of reality into the studio, like the two young horses in a love joust in the engraving of 3 April.

'I had an accident with one of the plates, and as I thought it was spoiled I decided to do anything on it that came into my head and began scrawling. It turned into a *Rembrandt*.' A huge-faced, exuberant *Rembrandt*, with—as Picasso says—his elephant eye. From this Picasso

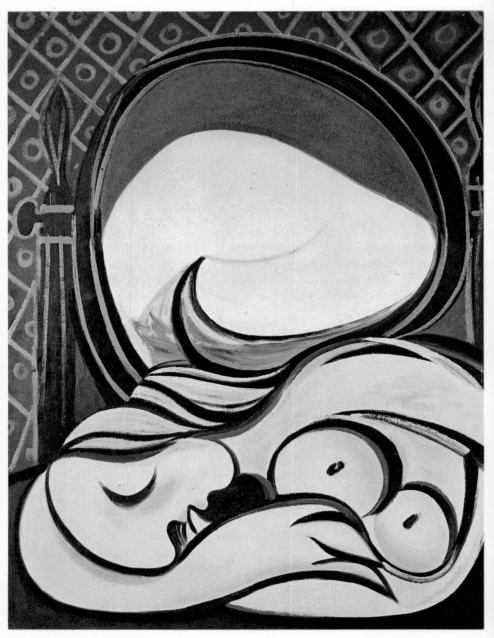

THE MIRROR. 1932

went on to the five plates of *The Rape*, the fifteen plates of *The Minotaur* and *The Blind Minotaur*. All of these together make up the *Suite Vollard*.

The *Minotaur*, which now strikes us as inseparable from Picasso's world, did not, however, enter into it until the years which saw the rise of Hitler and the burning of the Reichstag—30 January to the end of March 1933—simultaneously with the increase in tensions in France and the rest of Europe. It would of course be absurd to reduce the *Minotaur* to the level of an elementary symbol of politics. It should also be recalled that at this moment Picasso had in mind the political pictures of David, *The Oath of the Horatii* and *The Death of Marat*. Also, the Paris *Still-Life* of 25 January, 1934, which has been called Surrealist, is not as automatic as all that, in the sense of being entirely subconscious. The appearance of the minotaur brandishing a lance amidst a bric-à-brac of weapons orchestrates an impression of chaos, with the presentiment and poignant anguish of imminent conflict.

Picasso's minotaur is not a monster; like Botticelli's centaur it descends from two noble races. It comes to represent naked sensuality, a mirror revealing man in a state of nature, a combination of strength and weakness. The *Blind Minotaur Led by a Girl Carrying a Bunch of Wild Flowers* contrasts an image in the style of the terrifying women of 1929 with an ancient scene by the sea, in which the minotaur, struck with blindness, raises its muzzle against the curse laid upon it, and entrusts itself to a serene child with the head of a woman. The child knows where she is going while the anxious fishermen haul in their nets, and an indifferent young man looks on.

Picasso pursues these contrasts with even greater intensity in the big *Minotauromachy* of 1935, in which there is a disemboweled horse, and a swooning woman matador whose beautiful breasts are bursting out of her torn blouse. Though still holding the sword in her hand, she fails to turn it against the huge minotaur as it advances, under the peaceful eyes of the little girl with the oversize and overwise head, while two young women with a dove beside them sit silently in the stands watching the scene.

When Picasso really wants to express 'the Monster', he represents it as a classic dragon, as in the 1933 engraving *Four Children Watching the Monster*, or in another from Boisgeloup dated 24 April, 1935. In the latter, the minotaur is dying in the arena, stabbed by a young man as handsome as a Greek god, and women spectators are eagerly leaning

149

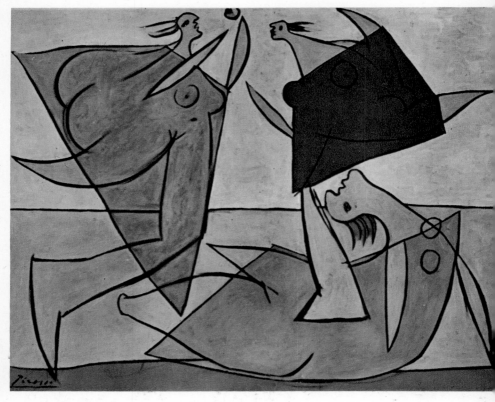

BALL PLAYERS ON THE BEACH. 1932

forward so as not to miss anything. This engraving, titled *Dying Mino-taur*, coincides in date with the *Orgy of the Minotaur*, showing the beast carousing with the sculptor who is lying like a replete Bacchus between two complaisant women. The theme of the blind minotaur is taken up again in 1935, but with greater contrasts, both literally and figuratively, the little girl with the head of a woman now carrying a dove.

The minotaur is a new element in the plastic language of Picasso. Just as he did not pursue monochromism, pure line, 'distortions', and 'metamorphoses' for their own sake, so the minotaur motif was not introduced merely as a diversion. In fact it embodies a further degree of liberty in relation to the inhibitions produced by Picasso's previous experiments. The appearance of a centaur in *The Rape* of 1920, and the

return in the following years to themes from the ancient world, had produced works altogether outside the painter's own life, completely objective and sometimes almost aggressively devoid of any emotional involvement. The minotaur is an impersonation in which Picasso indulges, an indirect self-portrait, as indicated in the plate of the *Young Woman Seated Looking at the Sleeping Minotaur*, dated 18 May, 1933.

The theme of the bullfight also has an intimate personal connotation. After a stay in Cannes Picasso took Marie-Thérèse to Barcelona in 1933. In 1934 they made a trip through Spain, from Saint Sebastian to Madrid and Toledo, and then back again to Barcelona. The lyricism, which gives the bullfights of this period the taste of a rediscovery of his native land, also enters directly into the image of Marie-Thérèse in

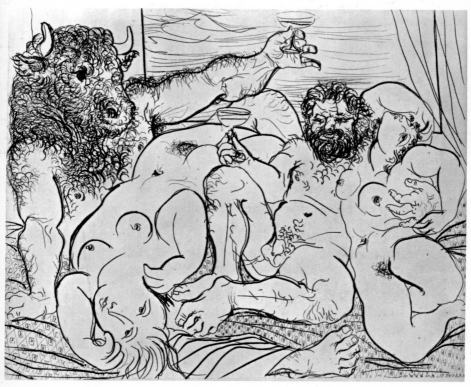

ORGY OF THE MINOTAUR. 1933

celebrating the theme of satisfied surrender. Sensuality governs the fluidity and the remodelling of forms quite as decisively as did anguish in the years 1927-29.

Not that unalloyed happiness now reigns undisturbed. Though the canvases showing young girls sitting at open windows, or just sitting reading, seem to suggest the calm security of the hearth, suddenly, and within the same framework, comes *The Muse*, or *The Studio* (now in the Musée National d'Art Moderne, Paris) to destroy the atmosphere of peace and serenity. There, the woman sketching is treated with merciless cruelty.

And yet even this brutal and merciless world of sharp, biting colours is very close to the tender, spring-like freshness of *Woman with the Red Bonnet*. There is the same projection of outline, the same hands like an ear of wheat, and the same tones, but here with the lightest touch, there howling. Picasso's own life parallels this contradictory image, his private life precariously balanced, like the civil peace of France and, indeed, the peace of the world.

Olga had withdrawn into her own world, and Marie-Thérèse was making herself an attentive but unobtrusive companion. However, a crisis arose in 1935 when it was discovered that Marie-Thérèse was expecting a baby. Picasso was deeply shaken, both by the breakup of his marriage, and by the impossibility of obtaining a divorce from Olga and thus being able to give his name to Marie-Thérèse's baby daughter Maïa, who was born that summer. The difficulty lay in his Spanish citizenship, which he had never been willing to abandon.

In the outside world the word went around that Picasso intended to give up painting. This was, incidentally, not the first time that such a rumour had circulated. The same thing happened in the years 1928-29, and again in 1933, the richness of which we have already seen. Then in 1935 Gertrude Stein, who was always prone to exaggeration, wrote that it was now two years since Picasso had painted or even made a drawing. 'It is extraordinary how anyone can stop doing something he's been doing all his life', she remarked, and recalled the silence of Shakespeare. Picasso, as usual, made no comment. The truth is that, because of external circumstances, he found it impossible to concentrate on his work. He suffered greatly under the situation. However, close attention to the dates of his canvases and engravings shows that the interruptions never lasted more than a few weeks.

Sabartès tells us that in the summer of 1935 Picasso never left Paris. 'This was the first time in thirty years. On 13 July I received a letter from him saying to my great surprise: "I am alone here. You can imagine what's happened and what's still ahead."' Subsequent events confirmed that 'what's ahead' was to be very painful for him: lawyers, litigation—in short, just about everything calculated to keep him from work. Sabartès arrived in Paris on 12 November in response to an appeal from Picasso. A month later Picasso did a portrait of his old friend—but for the first, and last, time it was not a painting:

> *Braise vive d'amitié*
> *Horloge qui toujours donne l'heure*
> *Drapeau qui flotte joyeux...*

('Live coals of friendship, Clock that always tells the time, Waving flag of joy...')

Sabartès knew that Picasso had been writing for a number of years without telling anyone, probably taking advantage of the peace and quiet of Boisgeloup. Picasso had already told Sabartès about it at the beginning of that same year, 1935, and had even sent him examples of what he had written. This time it was really a complete portrait 'painted in words with lines as taut as harp strings'. Later on Sabartès wrote: 'He takes pleasure in putting down on paper, in the form of words, the images which formerly inspired his plastic achievements. Sometimes the image dictates a word, and the word is the point of departure for a memory or a thought; and if a paradox emerges, he seizes it to hide a feeling and create an ambiguity, proving as he has already demonstrated a thousand times in his canvases, drawings and sculptures, that without the aid of falsehood it is difficult to make the truth credible.'

At the same time these lines give us one of the most accurate and profound portraits of Picasso: a picture of Picasso forged with Picasso's own weapons. There is no ambiguity, nor any play on words, because in that autumn of 1935 Picasso's defenses were completely down in the presence of his old friend. Outwardly, success was there on every side: the Rosenberg exhibition in Paris; and in Barcelona, his first exhibition in Spain since 1902; the new number of *Cahiers d'Art* published by Christian Zervos, in which a few of Picasso's writings appeared, including the portrait of Sabartès, with Picasso's own lettering repro-

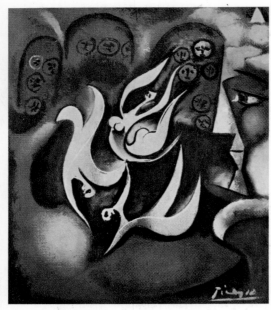

THE CIRCUS. 1933

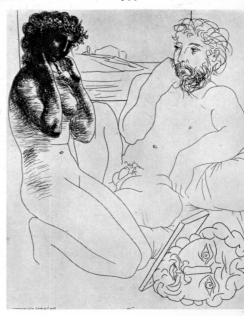

THE SCULPTOR'S STUDIO. 1933

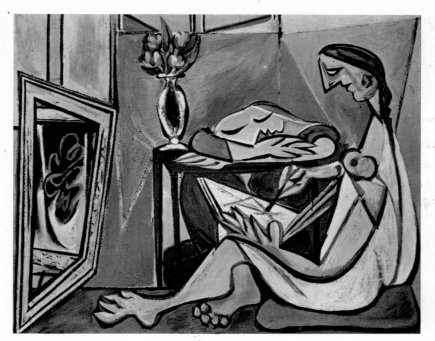

THE MUSE. 1935

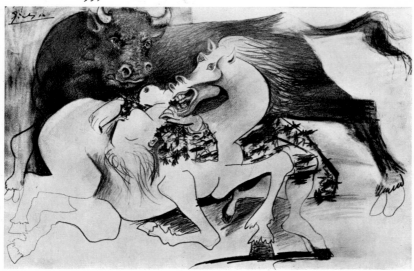

THE VICTORIOUS BULL. 1935

duced in facsimile. It was in fact more than success, more than steadily growing fame manifested by the big exhibitions in Paris, in London, in New York. It was the fervent homage of well-wishers, which Picasso could judge at their true worth, and beyond that, the enthusiasm of the younger, the republican generation in Spain, as well as the youth of France. But all this had no effect. Picasso stopped climbing the stairs of his studio in the rue La Boétie.

Suddenly, on 25 March, 1936, he left for the Côte d'Azur without telling anyone where he was going. A few days later, Sabartès received a letter from him dated 28 March, giving an address: Avenue du Docteur-Hochet, Juan-les-Pins: 'A small house with a delightful little garden close to the sea.' Sabartès was to address him as Pablo Ruiz. During this month of secrecy Picasso produced twenty-three canvases which are among the most curious, the most important and the most beautiful of all his paintings.

The first four of these canvases, dated 2, 3, 4 and 5 April, are outline representations of Marie-Thérèse executed in the manner of his wire sculptures. The first is the most abstract. The second is really an openwork sculpture painted with *trompe-l'œil* effects, as if posed on the beach. The fourth introduces various elements of reality, including a grid, a net and leafy branches. On 6 April Marie-Thérèse gives way to a minotaur drawing a cart containing a framed picture, a ladder, and a mare that has just foaled. The green sky is spangled with starfish, and the gulf with its somnolent sea has the same curve as at Juan-les-Pins. Never has the expression of the Minotaur been so gentle. From 9 to 26 April Marie-Thérèse dominates the scene once more—seated before a sideboard, or simply a face, or again pensively holding a book. Then, starting from this face that so moves him, Picasso develops a new drive toward stylization and reconstruction, though not without finding time to paint a bouquet of flowers, a loaf of bread and a jug.

On 29 April, the world falls apart: a canvas in blue-grey on blue shows two women embracing as though the rescue had failed and death were at hand. Their anatomies are depicted with an implacable cruelty of lines, wrinkles and details. And then, after two frantically tortured faces, come two canvases of a woman in double profile, her mirror image even more inhuman than that of *The Muse:* it reflects only black. These canvases date from 30 April to 2 May. Then come two less troubled still-lifes, after which Picasso returned to Paris.

GUERNICA

I am talking of the things that help me live, the good things. Man can live only in the reality that belongs to him. He has to be conscious of it. If not, he will exist for others only as a dead man, as a stone, a dung heap.

<div align="right">PAUL ELUARD</div>

A man's life cannot be sliced up like a cake. The break-up of his marriage, the birth of Maïa, the return of Sabartès, the poems, and the secret month at Juan-les-Pins were all signs that Picasso was changing. The beginning of his friendship with Paul Eluard is an event of at least equal importance. It takes us backward in time. The first indication of it is the date written under the portrait of Eluard in pencil: 'This evening, 8 January, XXXVI.' It is a portrait of the poet in his fortieth year, with the signs of youth still in his face.

As soon as Picasso returned from Juan-les-Pins he saw Eluard again. On 15 May Eluard wrote:

Bonne journée j'ai revu qui je n'oublie pas
Qui je n'oublierai jamais...
Bonne journée j'ai vu mes amis sans souci.

(A good day, I saw again one I do not forget
One I shall never forget...
A good day, I have seen my friends without trouble.)

Picasso was now gradually recovering his spiritual balance. His meeting with Eluard came during his period of poetic creativity. He has always paid great attention to poets, has needed their presence, but between him and Paul Eluard there now developed an exchange of very special quality. This was not merely because of common preoccupations, of their interest in Surrealism, but because they were temperamentally akin, despite the fifteen years that separated them. They understood each other very well, they had the same conception of man, the same outlook on life.

It was at about this time that Picasso first made the acquaintance of Dora Maar. Early in 1936 she was introduced to him by Paul Eluard

at St-Germain-des-Près. Her father was a Jugoslav and she had been brought up partly in the Argentine and partly in France. She was a friend of the poet Georges Bataille and had been attached to Surrealism since the thirties.

It was in the spring of this year, after the dissolution of the assemblies, that the Left, or '*Fronte Popular*', was victorious in Spain at the elections of 18 February, 1936. In the following June the French Left, or '*Front Populaire*', won a similar victory. Picasso was, of course, by no means indifferent to these political happenings. He was happy to feel that things were on the move in Spain, and, in particular, that the new intellectual generation was accepting his work. Eluard went to Barcelona for the inauguration of his exhibition. In May and June Picasso worked at Lacourière's studio in Montmartre engraving his illustrations for a new edition of Buffon's famous *Natural History*. On 24 May —thanks to a process invented by Lacourière—he designed a plate on which he wrote two poems dated 16 and 18 May, dedicated to Paul Eluard. On 3 June Eluard in turn wrote his poem *Grand Air* also on an engraver's plate:

> *Nous jouions au soleil à la pluie à la mer*
> *A n'avoir qu'un regard qu'un ciel et qu'une mer*
> *Les nôtres.*

> (We played in the sun, in the rain, by the sea
> Having only one view, one sky, one sea,
> And they were all ours.)

The next day, 4 June, Picasso framed it with figures which harmonized with the text and the layout so completely that something entirely new was created, a fusion of poem and engraving which accorded with his own preoccupations.

Picasso had accepted a commission to design a curtain for Romain Rolland's play *Le 14 juillet*, which was being produced in the spirit of the '*Front Populaire*' to celebrate the anniversary of the French Revolution. 'All men', wrote Eluard, 'will communicate by their vision of things, and this vision of things will serve to express the points that are common to all—to them, to things, to them as things, and to things as them. On that day true vision will integrate the universe with man, man with the universe.' Such a text is inseparable from Picasso, who inspired it; and it cannot be isolated from the great waves which were

then simultaneously arousing both the Spanish and the French people —the country in which Picasso was born and the country in which he had chosen to live.

Because Picasso's political reactions become integrated with his painting, and because they are never seen, so to speak, in the raw—that is, before they have become assimilated in his work—because they never appear before they have taken hold of him, become part of him, become a necessity for him, people are inclined to suppose that they are of secondary importance to him. Nothing is further from the truth. Picasso has never worked for orders, and he is completely indifferent to the claims of fashion—so indifferent that he just lets people say and write whatever they please. For him the thing that counts is his work, and the effect his work has on the lives of others.

You have only to consider how exacting Picasso is in his art to realize immediately that for him the responsibilities of the artist include moral and political responsibilities as well. If this were not so it would mean that there are two kinds of ideas: the ideas expressed in painting and social ideas. Picasso's whole work, including even that which appears to be most divorced from reality, testifies strikingly to the contrary. The continuity of Picasso's art is perhaps the continuity of precisely those choices which tend to break down prejudices, and which extract from reality just what the rich and powerful are unable to see, which takes from life that which moves forward—in his struggle to break the set moulds and worn-out forms, and bring to light what is germinating and springing up. In this connection Hélène Parmelin has observed very pertinently: 'If nine art critics out of ten make Picasso a painter of the bourgeoisie in decline, nine out of ten also fail to point out that Picasso has shouldered the tremendous task of wrenching so-called modern art from the bourgeoisie, in order to transform it and impregnate it with the dreams of the people.'

We have, in fact, now arrived at the moment when history bursts into Picasso's life with such violence that no one can pretend to ignore it. To say, like Gertrude Stein, that with the outbreak of the civil war in Spain on 18 July, 1936 Picasso first discovered that Spain existed, and that 'the existence of Spain awakened Picasso to the fact that he existed too' is merely a literary invention at Picasso's expense. It is an invention based on false premises, the falsest of which is the idea that it was only because of the civil war in Spain that Picasso regained his

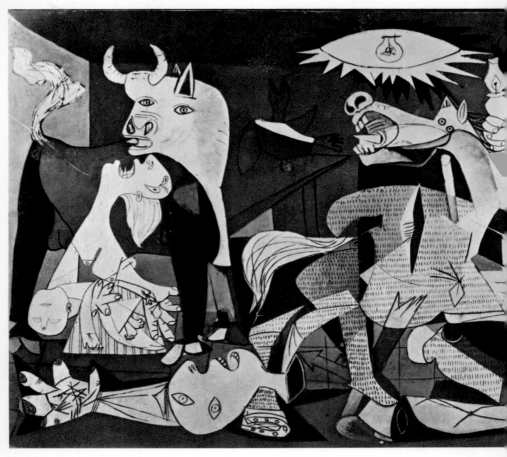

GUERNICA. 1937

desire to paint. Nor was Picasso's refusal to have anything to do with the 1914-18 war due to his being either a dreamer or a coward; it resulted from his whole outlook on life, including in particular his political outlook. It was from this that he drew the very considerable moral strength necessary to resist the tremendous pressure set up by the *Union Sacrée* for victory. The new factor in the present situation was that Picasso began to use his art to express his opinions directly concerning the civil war which was crucifying his country. And in particular

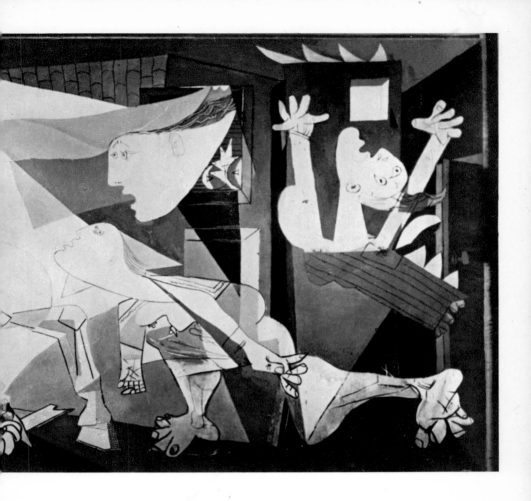

he was able to do this because the experiments of the preceding years had provided him with a language admirably suited to his purpose.

A failure to take into account the profound relationship which exists between Picasso and reality, total reality, and to underestimate the importance of the reciprocal exchanges between his art and reality, will inevitably result in an inability to understand subsequent developments. Incidentally, the effect of outside political happenings on Picasso's art was not a unique phenomenon—under the influence of the same causes

Eluard's poetry, and the poetry of the *avant-garde*, whether Surrealistic or lyrical, was becoming political poetry. It is absurd to speak of commitment in this relationship. The idea of commitment was originally a pejorative one, like the appellation 'Cubism'. But while the objection to Cubism was due to its being misunderstood, the idea of commitment or engagement suggests a falsification of the work itself and implies the subordination of artistic creation to an outside discipline essentially foreign to it—to the exigencies of political or military tactics, for example.

Eluard wrote in November 1936:

Regardez travailler les bâtisseurs de ruines
Ils sont riches patients ordonnés noirs et bêtes
Mais ils font de leur mieux pour être seuls sur terre
Ils sont au bord de l'homme et le comblent d'ordures
Ils plient au ras du sol des palais sans cervelle.

(Watch the builders of ruins at work
They are rich, patient, disciplined, black and stupid
But they do their best to be the only ones on earth
They are on the edges of humanity and heap it over with ordure
They flatten mindless palaces to ground level.)

But it was still his own poetry, just the same poetry as he sang in *La Rose publique* and in *Les Yeux fertiles*. It was 'pure' poetry, if there is such a thing. But it was poetry that writhed at the news of the massacres in Spain and the first bomber raids on Madrid. In the same way, when at the beginning of 1937 Picasso sprang into verse in a poem entitled *Sueño y Mentira de Franco* (The Dream and Lie of Franco), the poem, its torrent of images and its drawings, come out of the whole previous period, out of what had been elaborated in Picasso's art in the face of the great economic crisis and the rise of Hitlerism. The personage representing Franco developed out of the monsters of the 'metamorphoses' period, and the bull which holds the monster at bay and disembowels it has already appeared in Picasso's work of the Minotaur period. Thus it is not that Picasso is 'committing' his painting, but rather that his painting, his whole *raison d'être* now begins to speak.

The Spanish Republican Government made Picasso director of the Prado, in other words, of an empty museum, evacuated on account of

the war. José Bergamin told Picasso of an incident at Valencia when he was supervising the unpacking of the Prado pictures. In unrolling one particular canvas, he suddenly realized it was Velasquez' *Las Meninas*. This episode was perhaps to play a role twenty years later when, brush in hand, Picasso began his dialogue with Velasquez.

Picasso left Paris in August. This time he went with Eluard and they established themselves at Mougins, a little way back from the coast between Cannes and Antibes, in the Hôtel-Restaurant Vaste Horizon. 'I am not here incognito. You can give my address to anyone who wants it', he wrote to Sabartès. Dora Maar was staying with friends at Saint-Tropez, not very far away. At the end of August, driving back from Cannes he had a motor accident. He suffered bruises, in his own words: 'as though I had been beaten black and blue'. On another occasion—this time with Paul and Nusch Eluard—he discovered Vallauris, the village of potters, below Mougins towards Golfe-Juan.

> *Montrez-moi cet homme de toujours si doux*
> *Qui disait les doigts font monter la terre...*

> (Show me that man always so gentle
> Who claimed that the fingers make the earth rise...)

When Picasso returned to Paris he had not done a great deal of work. But there now appeared in his work, with the lively and piquant face of Dora Maar, the use of photographic techniques closely related to Corot's experiments in drawing on gelatin plates (cliché verre). In this technique there survives an admirable profile of Dora Maar, gone over with a brush, against a tulle mantilla background—the mantilla worn by Fernande at Gosol and by Olga at Barcelona. There is also a full-length portrait of her in a three-quarter length coat, in lively brush-strokes, dated 27 October, 1936.

Towards the end of autumn, having been told by Vollard of a studio he had had prepared for Rouault at Tremblay, on the Mauldre, between Montfort-l'Amaury and Trappes, which Rouault was not going to occupy, Picasso installed himself there. His stay at Tremblay gave us a number of new interiors, a series of very incisive still-lifes in what one might be tempted to describe as Dora Maar colour (those warmer tones which, however, did not come until the group of portraits he did of her). Of this period there are also some collages and montages: the

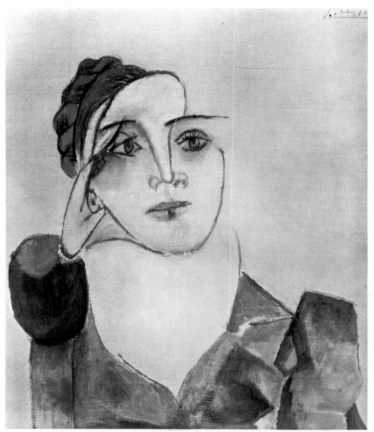

PORTRAIT OF DORA MAAR. 1936

Glass, Pipe and Matches (drawing and pasted paper), *Glass, Bottle and Mask* (wood and sheet metal), *Bottle, Napkin and Steel Wool* (the one Duncan had so much difficulty photographing). Picasso also painted a series of nudes by the sea: *Nude and Starry Sky*, for example, with reconstructed anatomy in the 1929 manner, but with greater harmony.

To get an adequate idea of the renewed creative exuberance of Picasso at this time we must add to all this—and to the first plates of *The Dream and Lie of Franco* executed in January—an extraordinary blossoming of ·portraits of Marie-Thérèse, of unprecedented purity: *Marie-Thérèse with*

a Garland of Lilac, Marie-Thérèse in a Béret, and so on. Five canvases in all, and all dated 6 March, 1937. To this inventory of the work from Tremblay, accented by the still-lifes and collages, must be added canvases that once more look like painted sculptures, but with new geometrical simplifications and new rhythms: *Girls with Small Boat, Nude Bather,* and, in particular, *Seated Woman with Book,* the figure seemingly pinkish wood or sandstone on a beach of the same tonality, against the arc of a bright blue sea and a sky which seems to come straight out of the blue canvases of Catalonia.

Picasso had promised to contribute something to the Spanish pavilion at the International Exposition to be held in Paris in the summer of 1937. No one with the slightest knowledge of Picasso would doubt that what he did would be very carefully calculated and thought out. His task here was to address himself to a wide audience, in a public building, and this meant a mural painting on a large scale, involving many separate problems, each of which had to be solved, but for which the painter had to find the common solution. The first problem which faced him was a strictly practical one—he had to find a studio big enough to allow him to work conveniently on a big scale. Dora Maar knew of a suitable building in the rue des Grands-Augustins, a seventeenth-century house which was part of what before the French Revolution had been the Hôtel Savoie-Carignan—the very setting used by Balzac for the *Chef-d'œuvre inconnu.* Picasso rented the place.

On 28 April the Nazi Condor Legion sent to Spain by Hitler to aid Franco carried out the first intensive bombardment of the civilian population. It chose Guernica, a town sacred to the Basques, and the raid was deliberately timed at an hour when the people were in the streets. Picasso reacted immediately to the news. His first sketches were made on 1 May, and the huge canvas—measuring 25 feet 8 inches by 11 feet 6 inches—was already stretched in the new studio. Dora Maar had the idea of photographing the various stages of the work. Thanks to her we have what is, so to speak, the first real journal of Picasso at work. Picasso was very much in favour of the idea and encouraged her, saying that 'this will perhaps give us a better understanding of the mental process which leads to the realization of an artist's dream.'

The story of how the great canvas developed confirms the severity of its structure, the aim to strip it down to essentials, to as clear and deliberate a simplicity of expression as possible. To this end Picasso

made use of everything his experience in the reconstruction, stylization and remodelling of the human figure had taught him. He brought forth the tragic subject onto the immense canvas in one great sweep of colourless grey with such ease and spontaneity that people were misled into thinking, as Maurice Raynal did, that there was no composition whatsoever, and that Picasso had just allowed his brush to do exactly as it pleased.

But in reality we are obsessed, assaulted by the implacable architecture of the picture. This is no historical painting to divert the spectator. Nothing separates us from the women screaming in terror as death falls senselessly from the sky. We find ourselves caught between the noble horse struck down and the bull, a brutal force of darkness. We are not just being told a story. No divine power is there to relieve us. The calamity is ours, experienced under a sun made by human hands. *Guernica* is the first historical picture painted for men consciously in the act of making their own history. It is the mirror-image of a world of atrocity and bestiality from which it is man's duty to emerge.

When, as in *Guernica*, the painting of ideas is no longer simply an idea painted, but a plastic expression of the idea, a proper understanding of the work depends to some extent on the ability of the observer to grasp the idea and hold fast to it. This is the antithesis of the old adage that if man finds that an axiom of geometry is not to his advantage he will certainly do his best to refute it. Undoubtedly, one of the factors in any failure to understand Picasso's paintings is the difficulty of accepting his ideas.

The really significant thing about *Guernica* is not merely that Picasso is taking a political stand but that he takes great care to dissipate all misunderstandings and to make his intentions perfectly clear, even going so far as to give his work a very specific title. In May, in the midst of his work, he declared: 'The war in Spain is the battle of reaction against the people, against liberty. My whole career has been one continual struggle against reaction and the death of art. In the painting on which I am now at work, which I shall call *Guernica*—and in all my recent works—I am very clearly expressing my horror at the military caste which has plunged Spain into a sea of suffering and death.'

Picasso was in fact facing a new problem, no longer the same as Calot or Goya had to face in their day. What Picasso was denouncing was not the calamity of war in general, or merely repression by a foreign

power occupying the land. There was no longer that clearly visible line between good and evil represented by the barricades among which Delacroix painted himself, weapon in hand, at the side of Liberty. Men now had to be saved from 'a sea of suffering and death', from the new barbarism which roars what Milan Astray shouted at Salamanca: 'Death to intelligence!' Picasso's reaction was to declare: 'No further doubt is possible', and that is the level on which the canvas *Guernica* is painted.

> *Parias la mort la terre et la hideur*
> *De nos ennemis ont la couleur*
> *Monotone de notre nuit*
> *Nous en aurons raison.*

(Pariahs, death, earth and the hideousness
Of our enemies have the monotone
Colour of our night:
We will get the mastery over them.)

These are the concluding words of Eluard's poem *La Victoire de Guernica*: it is the poem of the picture, the great encounter of men with their monsters. A quarter of a century later Roger Garaudy was able to write: 'It is not true that such works are unintelligible to the masses. Such art is inaccessible only to those who feel they must decipher each figure and its meaning as though it were a riddle, and, having done so, proceed to write trivial literature and shallow philosophy. It would be an odd conception of art, underestimating human intelligence, to claim that only the lowest common denominator and only the most superficial realism are within the reach of popular taste.'

THE WAR

I have always believed, and I still believe, that artists who live and work according to spiritual values cannot and must not remain indifferent to a conflict in which the highest values of humanity and civilization are at stake.

<div align="right">PICASSO</div>

Despite its size, *Guernica* did not exhaust Picasso's creative activity in that spring of 1937. On 2 March, he did a portrait sketch of *Dora Maar Sleeping* with all the finesse and tenderness of which he was capable. He painted a portrait of *Nusch Eluard* in a coat and close-fitting hat. He relaxed in peaceful still-lifes remarkable for their richness. Once the huge canvas was installed in the Spanish pavilion on the hill at Chaillot, far from withdrawing and feeling that he had done his share for his martyred people, he took an active part in all the great movements of solidarity, demonstrating that same quality of cold passion he was to show after the war when he attended the congresses of the Peace Movement in Wroclav, Pleyel and Sheffield.

At the beginning of the summer Picasso went to Mougins again, this time accompanied by Dora Maar. The Mediterranean sun warmed his palette, and in this period he produced two small still-lifes, a *Minotaur*, and some portraits of Dora Maar in the colours of high summer. A double profile portrait, dated 29 August, is an extraordinary example of vivacity, sparkle, brilliant plastic re-creation. Then there are the landscapes of the town baking in the heat of the summer, also a *Weeping Woman*, painted in the same flaming light. Picasso has not forgotten Spain with her mourning and her martyrs.

Sadness is almost always present, whether it is that *Head* with the purity of its oval, isolated as if decapitated, at the window near a vase; or a new *Woman at her Mirror*, turning her back to the window and reflected in the mirror in triangles of red and black, the colours of fire and blood. Sometimes the feeling of tragedy again rises to heights of violence, as in the *Shrieking Woman*, with hands and arms like spindles, dated 18 December. At the same time, Picasso produced a whole series

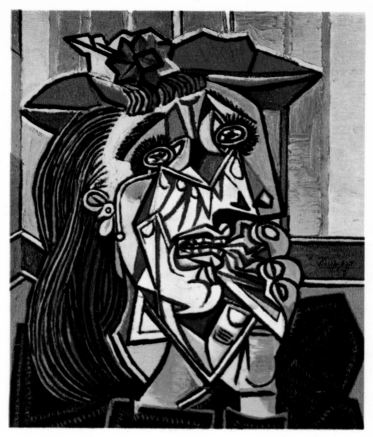

WEEPING WOMAN. 1937

of portraits of Dora Maar and of Marie-Thérèse, but at the close of the
year the Minotaur appeared again: first in the troubled and anguished
colours of Spain; then in the light of a Mediterranean morning when
sea and sky merge, Picasso tells the story of the *Minotaur Pierced by an
Arrow* on the shore, its plight discovered by three women in a boat,
one of whom tends and saves the Minotaur. In another canvas a young
woman, mirror in hand, ignores the Minotaur and lets it die. On the
other hand, in *Minotaur in a Boat*, the Minotaur at the peak of its strength,
bears a swooning woman amidst swimming figures that look like sirens.

Also, a god's head with horns appears in some still-lifes, in which the Minotaur seems to impersonate wisdom. However, it is useless to try to invent categories for Picasso's work. He painted *Woman Suckling a Cat* and a portrait of the American *Lee Miller* at the same time, collected pebbles to engrave, and went out more than usual, even on occasion travelling to see his fellow artists: Matisse in Nice and Paul Klee in Berne, where the latter had gone to escape the Nazi terror. He was literally experiencing a new youth, matched by colours of unprecedented gaiety in portraits of Dora Maar, as though seeking to vie with the red of her long painted nails, and affirm the joy of life to counter the chaos of massacres.

The portraits of Fernande are drawings of great finesse and profound tenderness. These qualities can be seen from 1906 on in his plastic experiments, though in this period it was the self-portraits that absorbed Picasso's attention. Eva does not appear at all, and when the portraits of Olga begin to arrive Picasso uses them to say what he has previously said with his own face. Between 1918 and 1923, these portraits represent a diary of serenity, peace and order in his life. The dialogue with Marie-Thérèse is one of physical entente, of happy sleep, of joyous curves. Dora Maar represents vivacity, intense happiness against a background of anguish. When Picasso paints her from memory, as he does in the canvas of November 1936 which shows her lying on the beach, full-face on her crossed arms and hair flying in the wind, Picasso shows in her expression her destiny and the world as it really is.

In the winter of 1937-38 *Maïa alone with her Toys* and *Maïa with her Mother* also reflect the news from Spain. In the play of the double profiles, the reconstruction of forms, and the free song of colours Picasso attains here what Stendhal would have called the sublime. On 22 January, 1938, there is a canvas in which hair tinted with green and lips tinted with blue compose an extremely charming picture of tenderness between mother and child; a gesture of refuge and protection, affection and anxiety. Picasso's new plastic language rediscovers and rehabilitates the essential human feelings which have been profaned, debased and scoffed at by academic affectation and artificiality.

Picasso continues with *Maïa and her Doll* and *Maïa with her Toy Boat*, and, compared with the portraits of Paulo, this series demonstrates — if further demonstration is necessary—the essential unity of the painter's principles. It also enables us to comprehend that the new ranges of

expression created by Picasso result from the discipline of his spirit and represent a matter of necessity. Fidelity to visual appearances ceases to be naïveté with Picasso and becomes an expression of harmonious balance, of security and confidence. And then unexpectedly, in that same year 1938, there comes, like an island of peace rising suddenly from a sea of torment, a *Head of Maïa* framed in a white hood as she gazes at the first snow she has ever seen.

On 18 February, there appears a still-life subject, an *Orange with Pitcher*. (The back country between Antibes and Mougins is a centre for the cultivation of bitter oranges.) As Duncan points out, the final version of this theme, dated 6 March, conveys almost unbearable tension. The orange is on fire, caught in a incandescent whirlwind which engulfs the black pitcher, in an obsessively fascinating image. Those early days of March 1938 coincide with the *Anschluss* crisis, which ended on the night of 11-12 March with the annexation of Austria by Nazi Germany.

At the same time Picasso completed a large canvas, *Woman with Cock*, which is a perfect expression of violence in plastic terms. The painter has seized on an instinctive act of everyday occurrence: a woman is holding a live cock in her lap and preparing to kill it. This image of the inherent cruelty of mankind is used as a metaphor to indicate the relationship between war and the way in which men kill animals for their food. There is no sentimentality, there are no accessories—as Eluard says, 'Picasso makes us see', he opens our eyes to the world, but also shows us what kind of creatures we are.

When summer came Picasso left once again for Mougins, together with Dora Maar and the Eluards. On 25 June, he painted Dora Maar in an excess of midsummer madness. 'Most certainly', remarked Picasso, 'if she had really gone out wearing that blouse she would have spent the rest of the summer in jail.' There are two more portraits, dated 2 July, full of the joy of the Mediterranean sun. Then there are some fine, equally capricious portraits of Nusch Eluard, and a more sober portrait of Inez, a young Spanish girl they had met in Mougins and who was to go back to Paris with them to act as housekeeper in the Grands-Augustins apartment. This collection represents a peak of lyrical intensity in Picasso's painting. There are harmonies of radiant tonality, exalted and yet somehow heavy with anguish which is all the more overpowering for being experienced before we are conscious of it.

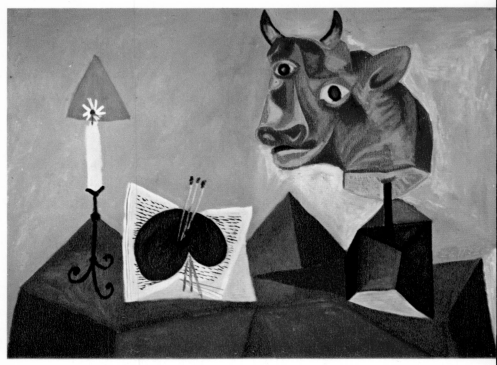

STILL-LIFE WITH A RED BULL'S HEAD. 1938

Some *Cocks* in strident colours reintroduce an element of raw violence once more. Then on 26 July comes *Man's Head with Ice Cream Cone*. With its enormous hat one might almost take it for another, if more earthy, image of summer. But before long the theme becomes paroxysmal, and on 6 August a blazing sun takes us into an incandescent furnace. On 14 August the sun is still heavy, but now the accent is on blissful animal joy. On 20 August a *Man with an All-day Ice Cream* is as lined as the straw of his hat. Animalism is dominant in the two versions of 30 August. The man sees no farther than his ice cream.

This complex exploration may serve to convey some idea of the interaction between suggestions of reality and the plastic orchestration of Picasso's creativity during this period of grave political tension. We are now introduced to another kind of subject matter with the reap-

pearance of one of Picasso's favourite figures, *The Sailor*, blood brother of the one rolling a cigarette at the time of the *Demoiselles d'Avignon*: the stolid and reliable sailor who in this tense world projects the peaceful reality of previous vacations by the sea—the *Boat on the Beach* of 13 August, 1937, at Juan-les-Pins, for example. The doubts, the fears, the hopes and joys of Picasso are translated into plastic realities in this sailor. Subject and composition are fused, mutually nourishing and fortifying each other. This does not come about without reflection or effort, without ceaseless struggle to master both spirit and matter; but emotions, states of the soul and the great problems of life well up out of Picasso's painting as in poetic creation.

On 14 August, the day the *Man with Ice Cream* appeared, there was also a *Woman's Head*, contracted and haggard, and with huge nostrils, going beyond even the distortions of a previous portrait. The date of this previous portrait is significant: 16 April, 1938, the day on which Franco's troops reached the Mediterranean at Vinaroz between Barcelona and Valencia, thus cutting the territory of the Republic in two. Mid-August saw the political tension intensify throughout Europe. Hitler was determined to 'recover' Sudetenland. On 29 August a *Woman with Braids* combines the violence of *Woman's Head* of 14 August with the anguish of the 'metamorphosed' monster in *The Dream and Lie of Franco* and the *Man with Ice Cream Cone*. On 4 September, after the first military measures had been taken, a simplified *Woman's Head* seems twisted like a winding sheet. Then on 10 September at the height of the crisis, a further version is even more brutally abstract.

In the meantime *Guernica* was sent from Norway to London. Penrose had asked Picasso if, despite the gravity of the situation, he should go ahead with arrangements for shipping the large canvas and the sixty-seven other canvases that were also there. 'The reply', he reports, 'was immediate and clear. I should proceed.' Picasso arrived at Tremblay in the night. In the release of tension after the Munich Agreement he returned to the Grands-Augustins. But his painting still remained disturbed, and *Maïa and her Toy Boat* of 29 October and *Seated Woman* of 1 November both reflect this disquietude. Only the still-lifes at the end of the month and the beginning of December bring some relief. Brushes, palette, head of Minotaur or bull convey an impression of calm in the studio. The biggest, *Head of a Black Bull*, has two sources of light, a candle and the sun of *Guernica*.

On 18 December Picasso suffered a painful attack of sciatica—a serious crisis which Sabartès has described, but which resulted in three portraits of this friend of his youth. 'With a ruff like a gentleman of the sixteenth century and a plumed hat to cover my denuded head,' Sabartès had specified, and so it was. The distorted *Head* reappears on 31 December in *Woman Leaning on her Elbows*. The year closed with a new Franco offensive which finally succeeded in breaking the Republican front in Catalonia. The little pitcher and the fiery oranges, *Maïa and her Toy Boat*, and all the versions of *Woman's Head*, whether they look like Marie-Thérèse or Dora Maar, reflect the external disaster as bluntly as the implacable cruelty expressed in *Still-Life with Bullock's Head* of 15 January.

The Birds sweep onward on a flight of colours amidst a whirling sky. By this time Barcelona and the whole of Catalonia had fallen to Franco. The agony of Republican Spain continued. On 28 March Madrid surrendered, and on the following day Valencia fell. In the meantime, Hitler

MAÏA: THE FIRST SNOW. 1938

PORTRAIT OF MAÏA. 1938

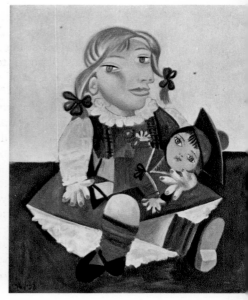

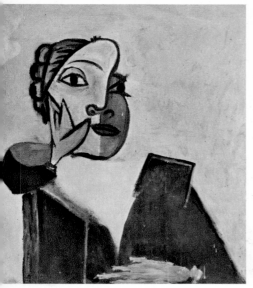
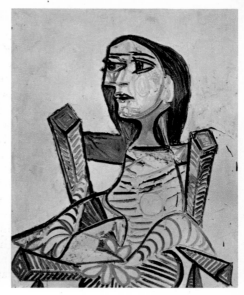

WOMAN IN YELLOW SWEATER. 1937 PORTRAIT OF DORA MAAR. 1938

had occupied Prague. The faces of the women on Picasso's canvases, near to tears on 5 March, now begin to shriek in panic and horror at the crimes that were being committed. On 19 March the twisted head reappears; and then, at the end of the month, the stare is hypnotized with terror. On 1 April a *Seated Woman* writhes in convulsions. The fantastic equivalence of violence attained by Picasso is so convincing that we are impregnated by the epileptic horror of this image. *The Bird* returns, and then, at the end of the month, there are two canvases of *Cat and Bird*, showing the bird in the jaws of the cat.

The portraits of May and June are full of mourning, distress and horror expressed with implacable hatching, dominating blacks, distraught and defeated faces. Then suddenly there is a double profile of Dora Maar, almost like those of the previous year when there was still hope, but now instead of the freshness of youth, irrepressible tears and over-whelming sadness. Madness continues to gain in the series of portraits of 17 and 18 June, and suddenly the depths of misfortune are plumbed in a *Little Girl*, which is like *The Bird* of 1928, but against a flaming sky.

In one hand she holds a toy boat and in the other a flower. Maïa was now four years old in that summer of 1939.

On 23 June Picasso painted an assaulted, inhuman face. The second world war was at hand. He had begun to write again. He had the idea of engraving some poems in colour, and started working on this project. He left for Antibes after having completed the saddest of all his versions of the *Woman in an Armchair*. He returned to Paris on 23 July, and about that time Vollard died.

On 28 July he was on the move again, this time to watch a bull-fight, and he induced Sabartès to accompany him. Afterwards he persuaded Sabartès to visit the Côte d'Azur, and then took him to Mougins. At the beginning of August he was reinstalled in Antibes and at work on a big new canvas. 'To keep from jumping out of the window', he told Sabartès, and he attacked the work with frenzy. The subject that imposed itself on him this time was a night scene of fishing by the light of lanterns. Fishing, fish and shellfish are often associated in Picasso's mind with cruelty.

Sabartès remarks that 'he concentrated again on putting the visionary element into this canvas of fishermen toiling to earn their living. The light of the lantern reflected in the water is barely indicated. He adds the light of the stars, which appear again in the crystal of the water, and then draws together the phantasmagoric gestures of the figures, which are hardly more than suggested by touches of colour. As Picasso began to paint he unfalteringly transformed the theme of the picture and even deepened the gloom of that battle in the dark. He gave full vent to the expression of deep emotion and his increasingly gloomy premonitions of events. The dim lantern seems almost to absorb more light than it sheds.'

This canvas, *Night Fishing at Antibes*, is one of Picasso's masterpieces, not only in the tragic symphony of blues, greens, violets, blacks and blackish browns closing in on the night, but also in the power of the painting to transmute reality. In that scene, Picasso projects his destiny and ours, and compels us to see it with the eyes of August 1939. He was still working on it when the mobilization orders were put up on the walls.

GERMAN RENDEZVOUS

There is a story of Abetz looking at a reproduction of 'Guernica' and asking: 'Did you do that, Monsieur Picasso? To which Picasso replied: 'No, you did!'

ANTONINA VALLENTIN

'The rest is known', writes Sabartès, 'to anyone who has ever travelled in a crowded train under a broiling sun on the eve of a catastrophe.' They arrived in Paris on the evening of 26 August. Picasso was suffering from the sudden interruption of his painting. He had got over the death of Vollard and had started to paint again, when the war broke out. 'I felt the urge. I was beginning to see my way, and then. . .' All around him there was the confusion of partings and uncertainty. Marcel the chauffeur had the big Hispano ready, loaded with luggage. No one knew what was going to happen, but everyone remembered the air raids in Spain and feared that the war would erupt with the roar of Stukas dive-bombing Paris. Picasso left the city the evening of 1 September with Dora Maar, Sabartès and Kasbek, the faithful Afghan hound. They arrived at Port de Royan at about seven o'clock the following morning. On the very next day Picasso started work again 'Just the minimum in order not to stop altogether while he was getting accustomed to his surroundings.' But he was again disturbed by the requirement that, as an alien, he had to get permission to remain in the country. A journey back to Paris settled the matter. In fact, Picasso's stay in Royan was interrupted from time to time by trips to Paris: once in October on his fifty-eighth birthday, then in December, and again in February of the following year. In the middle of March he went back to Paris and stayed there until the middle of May.

It should be noted that for Picasso the year 1939 had begun with the end of all resistance in Barcelona and the final victory of Franco. Just as in the first world war twenty-five years before, this new war also separated friends. Paul Éluard was called up. Nothing could be further from the truth than to imagine that all Picasso was after was some safe and comfortable spot in which to wait for the storm to pass. For him to stop work would have constituted surrender, flight and

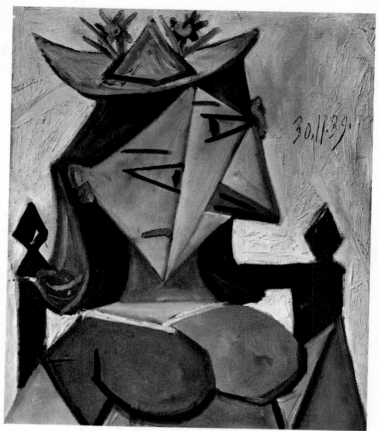

SEATED WOMAN IN A HAT. 1939

capitulation in the face of moral solitude. Instead, Picasso found his
bearings again and went on working. His huge retrospective exhibition
at the Museum of Modern Art in New York, 'Picasso—Forty Years of
his Art', in November, 1939, attracted widespread attention and subse-
quently travelled to three other cities in the United States. Picasso now
straightened out his various studios and stored his work away in a
safe place.

His first sketches at the outbreak of war were of horses he had seen
being convoyed to the front during his first journey from Paris to
Royan. Then he settled down satisfactorily in his new studio, and on

6 October he painted a *Still-Life with Sheep's Head*, as brutal as the *Bullock's Head* he had done at the beginning of the year. There was a haunch of raw meat by its side. He was now to return to portraits of his friends, but this new chapter in his life seems to resume some more profound tendencies in his work, a renewal of the old rivalry between Picasso the painter and Picasso the sculptor. He was, in fact, to take up sculpture again, at first with pebbles and bones during his stay in Royan, and then, after his return to Paris, on a grander scale.

The first evidence of this return to volume is a canvas *Two Young Girls*, a repetition of a picture first done in 1920. In this picture, the dissociation of outline and form cannot be attributed to his growing old, though the suggestion has sometimes been made, but rather to Picasso's cruelty and anger. It is the kind of exasperation that calamity

HEADS FROM A SKETCH BOOK. 1940

provoked in him which is responsible for the sadness of these two women, the sort of non-communication between them, between the one who is nude, with napkin in hand, and the one still clothed, seated in her armchair. The following autumn saw the production of a woman disso- ciated in a new way, the double profile being folded back to each side of the hair, like an open book seen from the back, as if we were simul- taneously on both sides of the canvas, as though the picture were its own mirror. In one portrait of this kind each profile of Dora Maar is, in addition, totally reconstructed. Nothing remains but stumps, bulbs, in the manner of the convulsed women painted the previous spring. However, the *Face* dated 1 November, 1939 is more serene.

At the end of the year, on 30 December, a full-length portrait of Dora Maar titled *Woman Doing her Hair*, is swept by the most terrible tornado: deformations, reconstructions and savage hatching turn her into a nightmarish creature who stands facing the devastating tempest. Eluard describes *Portrait of Mademoiselle D. M.* as a picture of war painted by Picasso, a moral portrait of his friend and of himself. In contrast to these dissociations is a *Portrait of Sabartès* painted by Picasso toward the end of October. Again taking up the idea of Sabartès, he presents him in a hat and ruff of the time of Philip II—'showing in this way,' com- ments Sabartès, 'to what extent he had racked his memory, unable and unwilling to separate the essential lines of my face from the idea he had of me on that day a year before, when I told him how I would like to see myself in a portrait.' The result is Sabartès, the war, the exodus- exile at Royan, Sabartès with his spectacles to the side of his nose, the boredom in his look, his mouth—all marvellously expressed in a single outpouring, with astonishing presence and resemblance.

The practical realities of war inspired the *Hooded Head* of 3 January, 1940, once again dominated by disproportion and violence. The 'pho- ney' war, which Janus-like turns its violent features inward, and its peaceable features outward towards the enemy, seems to have been portrayed by Picasso in that terrible picture *Nude Doing her Hair*. Here, after a complete turn the double profile is reunited, and one could swear that Picasso was moved by the same idea as Goya when he dissociated to 180° the double faces of *The Lie* and *Inconstancy*. The Royan sketch books and the *Head* Picasso painted on 11 June in the midst of the débâcle have the same vehemence and are marked by the same fury against the course of events and of the world.

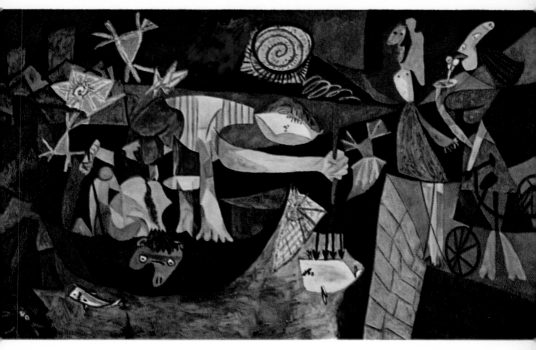

NIGHT FISHING AT ANTIBES. 1939

In three still-lifes of 27-29 March, 1940, Picasso in Paris recalls the fish market at Royan: *The Eel, The Spider-Crab* and *Soles*, all characteristic of the way in which he works, models, masters a theme that comes to him; they are also typical of his way of communicating brute reality, death, human and moral realities, the atmosphere of the day, humanity off its axis. 'I'm working, I'm painting and I'm fed up. I should like to be at Royan, but everything takes too long.' Then, announcing the new still-lifes, he writes to Sabartès, who had stayed behind in Royan: 'In short, I miss the market at Royan.' However, on 17 May he returned there and found the place full of people fleeing from the German advance, some embarking for the United States. He remained. Not for an instant did he entertain the idea of leaving the country. However, this was not easy; he was fully conscious of being a prime target for the champions of Nazi morality, who regarded him as the leading representative of 'degenerate', 'Negroid' art, of 'Kulturbolshevismus', 'Bolshevist' art.

He also knew that they would never forgive him for, say, *Guernica*. But Picasso is what he is. With the kind of courage he possesses, courage of the highest order, he would never change his way of life in the face of danger. He would never cease to be himself, to paint what he needed to paint, and say whatever he has in mind.

Sabartès recorded Picasso's reaction to the entry of Hitler's troops into Royan: 'They're a different species... They think themselves very clever, and perhaps they are. They've certainly made progress... Perhaps that's true, but what then? In any case, we are better painters. At bottom, if you keep your eyes open, you'll find they're a very stupid lot. So many men, so many machines, so much power, so much fuss to come this distance! We got here with a good deal less noise... What stupidity! What prevented them from doing what we did? I suppose they think they've conquered Paris. The fact is that without budging from here we took Berlin some time ago, and I don't think they'll be able to get us out.'

The German military headquarters was installed in the Hôtel de Paris, quite near Picasso. At the beginning of August Picasso painted the *Café at Royan*, one of his paintings in which summer bursts forth in sunshine and freshness. The picture now bears witness to a town which was wiped off the face of the earth by war. Nothing is left of the Royan of those days, not one stone left standing on another. I do not pretend that Picasso foresaw the destruction of Royan when he conceived that farewell canvas—nevertheless, one cannot help noticing that his work often has an element of premonition. For example, certain of his canvases of anger or suffering have suddenly organized reality for those who knew them. I experienced just that sort of catharsis in the concentration camp at Mathausen: that purification of horror seen through the eyes of Picasso who foresaw it, of Kafka who had anticipated it. I am not saying this in order to justify Picasso in the minds of those who expected clarion calls and martial appeals from him, and who resent what they call his pessimism. I say it because through his art Picasso conquered the means of mastering horror by revealing it, denouncing it, depicting it, stripping it bare. I am also saying it because it is impossible to understand his humanity if one feels that he has merely used optical illusions and the other tricks of the painter, without realizing that his whole work is directed against the lies and deceptions of morality and society.

He returned to Paris, first to the rue La Boétie; then, when the German occupation and the consequent restrictions made things difficult, he installed himself in his studio in the Grands-Augustins. Now a four-year period opened up in his life, a period characterized by unity of location and atmosphere, since he was now practically immobilized in Paris. It should be pointed out that he could have taken up residence in the so-called unoccupied zone, but he remained facing the danger—unafraid like a good bull.

He never ceased writing poems. In this respect at least he could let himself go, and in four days of January 1941 he wrote *Le Désir attrapé par la queue*, or 'Desire Caught by the Tail'. It is a cruel farce dealing with the preoccupations of cold, hunger and love, and written in an extraordinary language in which ideas coalesce with the ease and flow of automatic writing. The hero, Gros Pied, a poet living in the studio of an artist, has a rival, his friend Oignon, with regard to Tarte. Tarte has two friends, thin Anguish and fat Anguish. The play is built around obsessions, but is really unique. Picasso has stripped language as he has stripped painting, and he plunges us into a surrealist spectacle—in the sense that his friend Guillaume Apollinaire called *Les Mamelles de Tirésias* a surrealist drama—a world in which beings and things are truer than in nature, and more natural. The torrent of images, the acid humour, and the enormous verve make the piece a kind of indirect portrait of himself and of his life, in the same way as he had written the portrait of his friend Sabartès.

The face of Dora Maar obsessed him as when Éluard wrote:

> *Une foule de portraits*
> *L'un est dédain l'autre est conquête*
> *Un autre eau claire et clapotante*
> *Un autre cloche de rosée*

> (A multitude of portraits,
> One is scorn, another is conquest,
> Another clear and rippling water,
> Another drops of dew.)

But though Picasso still celebrates her qualities like a poet, as in the admirable *Head Painted and Constructed in Paper*, the 'portraits of his friend', also filter through the ruthless *Head*, a wash drawing published

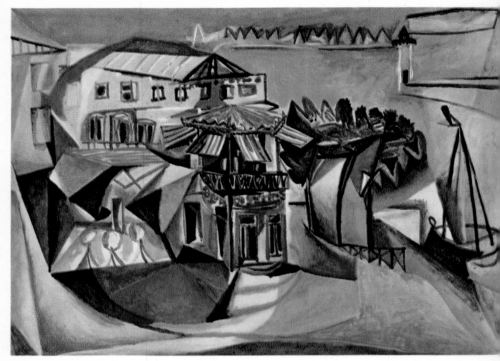

CAFE AT ROYAN. 1940

in *Paris-Soir* in November 1941 during the occupation, and dedicated to Georges Hugnet. Dora Maar is also the *Nude Bust*, defenceless, sad and humiliated. On another occasion he transfixes her with panic, eyes wide open and a petrified jaw: the canvas is in lively colours one might call gay, but which shriek the anguish of those dangling arms and of the body holding itself upright by sheer force of habit. This canvas is dated 9 October, 1942. Two hundred hostages had been shot to death in August and September on the 150th anniversary of the Battle of Valmy.

On 20 May, 1941, came the splendid drawing of *Reclining Woman*, in which Picasso returns to the idea of two profiles joined by the head of hair as in the 1939 portrait. Now back and front are combined with the same ease as in the *Metamorphoses* of the earlier period. This leads to the picture *Woman Asleep*, less complicated, restricted to the torso—a

184

peaceful, intimate, and confiding canvas. The next day, 21 May, a page of sketches shows us a series of reclining nudes as stiff and dead figures, boldly treated in large decisive planes, the face reduced to a sort of muzzle, as in the *Seated Woman*, recalling the shattering horror of the *Seated Woman* of the spring of 1939—just as the expression in the *Portrait of Dora Maar* of 1942 is very close to that of 9 June 1939. *Woman Seated in a Rocking Chair* and *Reclining Nude* lead up to *Aubade*, of the Musée d'Art Moderne, Paris, in which the seated woman is holding a mandolin without playing on it, looking instead at her nude companion who seems supported by the inexorable stripes of the divan on which she is lying as if stiffened by torture. The mirror on the floor reflects nothing but the ceiling. Never had the theme of the *Two Women* been stamped with such cruelty. The gouache which also bears this title unites them on the bed, front and back juxtaposed, as if in a prison cell.

Many other canvases represent everyday reality, a kind of painter's diary. *Still-Life with Flowers* and *Boy with Lobster*, both of 1941, are comparatively relaxed in manner. Likewise *Savoyard Buffet*, with a blood sausage, a bottle of wine, and cutlery in the drawer, all of which proclaims good eating. The *Still-Life with Chicken* of 1942 marks a new analysis of space, combining cutout planes with projections in perspective. The same rigorous, trenchant language prevails in the still-lifes which follow: *Flower Vase* and *Still-Life with Flowers* of 1942 and 1943; and we meet it again, though consolidated and more deliberate, in *Still-Life with a Basket of Fruit*, and *Still-Life with Ears of Wheat*, which speak longingly of harvests in that time of shortages. *Woman's Bust* and *The Lovers* use the same manner to represent human beings, a prelude to the landscape with the spreading branches of *Vert-Galant*.

More traditional for Picasso is the *Still-Life with the Matador's Sword*, which introduces a new note of brutality, somewhat in the spirit of *Still-Life with Bull's Head*, a cry of mourning with violet, black, green and dark blue, the colours of the black-out and the alert. This canvas is dated 5 April. On 27 March Picasso had learned of the death of his old friend of 1908, the sculptor Julio Gonzalez, his Boisgeloup collaborator. *Woman Seated in an Armchair* of 23 April maintains the same note of bitterness.

Perhaps it was the war and the occupation that sharpened Picasso's need to create objects, sculptures. Kahnweiler lists a hundred pieces

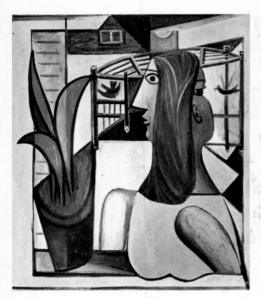

STILL-LIFE WITH WOMAN'S BUST. 1942

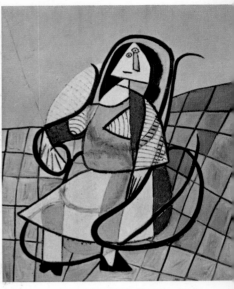

WOMAN IN A ROCKING-CHAIR. 1943

produced between 1940 and 1944. They include pebbles, cartons, boxes, match boxes, torn papers, plasterwork, copperwork, bronzes —not forgetting the famous *Bull's Head* made of a saddle and a pair of handlebars, the stork or flamingo created out of a child's scooter and a feather, the *Vase with Flower* made of a lump of bread and some paper. Whether in the costumes he designed for *Parade* or in the penknife carvings of modern women in the style of Cyclades goddesses, Picasso always had the ability to extend the innate tendencies of the

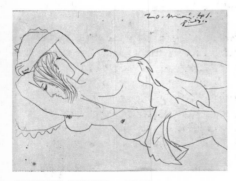

SLEEPING WOMEN. 1941

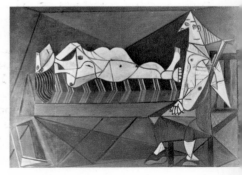

AUBADE. 1942

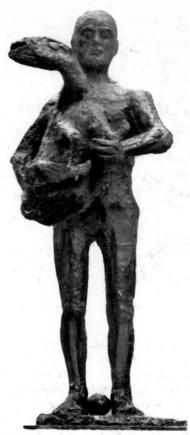

MAN WITH A SHEEP.　1943

material or of the given object in his own language: discarded *Gitanes* packets become pictures in relief, pebbles become human skulls, a *Death's Head*.

The large sculpture, *Man with a Sheep*, of 1943, represents a new peak. It is the culmination of quantities of experiments and sketches. Unquestionably, Picasso never before attained such equilibrium or expressed with such calm power his profound confidence in man and in life, in the face of destruction and ruin. This great sculpture leads us back to the painter whom nothing can defeat, conscious both of his power and of his responsibilities; it recalls the sculptor of the very beautiful *Head of Dora Maar* in 1941; the creator of drawings like

the *Portrait of the Author* seen from above (published in *Le Désir attrapé par la queue*), the radiant *Portrait of Nusch, The Bibliophile, An Old Woman*, the *Portrait of Stéphane Mallarmé*, and portraits of his daughter Maïa on her eighth and ninth birthdays; the painter of *Painter Asleep in his Atelier*, the bearded model holding a bull's head mask in his hand while a naked child plays a trumpet, of the *Baby with Doves*, and *The First Steps* of the son of Inez.

The Picasso I am now talking about is the man who dared to be present at the funeral service for Max Jacob, the friend of Picasso's difficult beginnings in Paris, who had been incarcerated as a Jew at the Drancy concentration camp and died there of pneumonia in March 1944.

To Dora Maar, the mediatrix and companion of those tumultuous days at the start of 1943—when the Nazis were caught as in a vice at Stalingrad—he presented a copy of Buffon's *Natural History* that Fabiani had managed to publish despite all the difficulties of the time. As a frontispiece he drew Dora Maar as a bird, like a sphinx, filling in all the margins and thus creating a new work of art.

The seated women of his paintings now had a different outlook on the world. The *Woman's Bust, Woman's Face, Dora Maar in a Blue Bodice, Dora Maar in a Black and Mauve Hat*, the *Woman in the Blue Hat*, holding an orange in her hand, all vary. The *Seated Woman* of 1943, likewise the woman's outline seen in *The Interior* of 1944—with round head, a large, high, symmetrical bosom, and a heavy mass of hair framing the face—seem already to suggest *The Flower-Woman* of 1946, which is a portrait of Françoise Gilot.

When the Liberation came, Picasso progressed from still-lifes of subjects as ordinary as those of the Cubist period—the *Coffee Pot*, the *Candlestick* (electricity was frequently shut off in those days), *Still-Life with Tomato Plant* (tomatoes were then being grown in pots on window sills and balconies)—to a *Bacchanalia* after Poussin. As a matter of self-discipline, Picasso continued to work during the street battles that were now raging, but all the time he was transforming Poussin into a hymn that celebrated the tumultuous joy of an armed people liberating itself in battle from its enemies. On the back of the coloured drawing are recorded the dates from 24 August to 30 August —marking real battles taking place in the streets, with bullets whistling round the painter's ears.

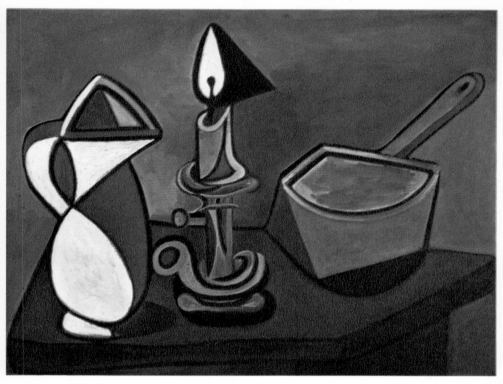

STILL-LIFE WITH CANDLESTICK. 1945

THE LIBERATION

'Picasso was one of the few painters to act as he should,' wrote Eluard in September 1944 to Penrose, 'and he continues to do so.' Nothing made him diverge from his path—neither when Vlaminck and Mauclair denounced him to the Nazis, nor when he was decried for cosmopolitanism and degeneracy and even for having Jewish blood. One day the question was raised, to which Picasso replied that, as far as he knew, he had no Jewish blood in his veins. 'I wish I had,' he added. Thus in the eyes of the world Picasso found himself symbolizing the art which defied Nazi barbarism.

The Salon d'Automne, which opened at the beginning of October, accorded him the supreme homage of a hall to himself—the first time this honour had ever been paid to a foreign artist. On 5 October, the day before the opening, it was announced that Picasso had formally joined the French Communist Party, and it was to the accompaniment of this piece of news that seventy-four of his canvases painted since the beginning of the war were exhibited. Some of them, for instance the portraits and the *Seated Woman*, were related to works which had been seen before the war, such as *Weeping Woman* and *Man with Ice Cream;* but others were quite different, notably *Aubade*, the style of which was resumed in the summer of 1944 with a new theme: *Woman Washing her Feet* and a big *Reclining Nude*.

The organized scandal that now broke out was directed both at the artist and at the Communist. Young fascists joined with conventional bourgeoisie to tramp through the Picasso room shouting 'Give us our money back!' and 'Pull them down!' They did take some paintings down and would have destroyed them if they had not been prevented by other artists. Distinguished writers and intellectuals protested. The attack on Picasso misfired, but it provided material for his enemies, and led Picasso at the end of October to make a public statement of his faith. 'My membership in the Communist Party is the logical consequence of my whole life and work. Because, I am proud to say, I have never regarded painting merely as an agreeable distraction. Through drawing and painting, since these are my weapons, I have sought to penetrate ever more deeply into a knowledge of the world and of men, so that this knowledge might more and more serve to bring us freedom'.

In the meantime Picasso continued to paint. He did a series of *Views of Paris* which were a hymn of praise in honour of Paris saved from destruction—'Paris Freed by Itself' sang Aragon—expressed in lilac and blue. One of these canvases shows the Sacré-Cœur dominating Notre-Dame, disrupting the geography of the city and perhaps recalling that first landscape of the *Avenue Frochot* of 1909. Still-lifes carried his conquest of reality a stage further. A canvas of 1943, *The Window*, opens onto roofs at night, with in the foreground a radiator and central heating pipes. Another canvas, *Still-Life with Candlestick* includes a blue enamelled casserole. In March 1945 a series, *Still-Life with Skull*, and *Still-Life with Leeks*, continues in the same style, and in between there is a *Still-Life with Lighted Candle*, and a curious canvas, *The Little Girl*.

In the winter Picasso started work on a big canvas, *The Charnel House*, of unequalled clarity and brutality. A tangled pile of slaughtered corpses lies against a background setting of a kitchen table covered with a rumpled cloth on which stand a jug, a casserole and a loaf of bread. Sharp flat tones of greys, blacks and whites are likewise contrasted with certain unfinished parts of the picture, producing a powerful effect and carrying the implication that everyday life was going on simultaneously with the murder of innocent people, and conversely, that there is very little separating life from death. This canvas was shown for the first time in February 1946 at the Musée National d'Art Moderne in Paris in the exhibition of 'Art and the Resistance'. Included in the same show was his painting *To the Spaniards who Died for France*, in which the colours of the French flag are accented.

In August 1945 Picasso returned to the Midi for the first time since 1939, and he stayed at Golfe Juan, putting up at a hotel in the port there. He spent most of his time moving around, in particular going to see a house at Ménerbes in the Vaucluse, on the slope of the Lubéron over-looking a tributary of the Durance. Someone had shown him a photo-graph of the place and it took his fancy. He acquired it by exchanging it for one of his still-lifes and gave it to Dora Maar. There seems to have been at this time a certain pause in his painting. Fundamentally, *The Charnel House* and his still-lifes were still motivated by the war and German occupation, but by August—with the surrender of Japan—the world was finally at peace again.

The change was evident on Picasso's return to Paris, where he made the acquaintance of Fernand Mourlot and took up lithography again, something he had not touched since 1919. A new face now appeared in his work, that of a young woman named Françoise Gilot. However, the change was not a fundamental break. Thoughout the period of the occupation Picasso had been making working drawings. These drawings follow their proper course; they are explorations: 'All Picasso's models look like their portraits', remarked Eluard. 'Picasso's drawings re-estab-lish the truth of things because, from infinitely varying appearances, from millions of instantaneous views, he disengages one constant, thus perpetuating the sum of images, totalizing his experiences.'

The drawings are dated. On 20 May 1941: a single pencil line, as already noted, develops the double outline of a young woman reclining. On 16 April 1942: a young nude watches a man with a head like a

Greek god, keeping vigil as he sleeps. On 29 March 1943: a solemn-faced young man carrying a lamb. 1944: a leafless tree raises a clamour through all its branches. At 4.30 on the afternoon of Monday, 22 April 1946: the face of Françoise Gilot. On 27 April: her silhouette in the nude. On 4 May 1946: a couple in red and blue pencil strokes. On 20 May: another portrait of Françoise Gilot. On 29 June: yet another portrait. Intervening between them is a series of stylizations and extreme abstractions. This is more or less Paul Eluard's choice of his friend's drawings.

Françoise Gilot is Picasso's new model, the new medium through which he will sift all the ideas and plastic themes that come to his mind. The double arc of black eyebrows, the perfect curve of her face, her slender waist, her large round breasts—these are the symbols of Françoise in the language of Picasso. He makes a circle for her head, a kind of flattened oval, which he engraves on pebbles, on a small piece of bone, or draws with all the suppleness possible to a lithographic stone. He rounds it out like a sun, frames it in the waves of her long hair. Françoise is the *Woman-Flower* in the big canvas of 5 May 1946. Picasso perhaps never so perfectly elucidated Rimbaud's dictum: 'We shall wrench painting from its old habits of copying and endow it with sovereignty... We shall communicate feelings through line and colour and design extracted from the outside world, simplified and mastered.' Françoise is the sun, the flower, a goddess of fertility, reconstructed, re-created, re-inscribed. Françoise catalyzes the pagan world to come, of which she will be queen.

A new period now opened up in Picasso's creative activity, revealing more directly than ever before the lyrical resources he has at his command. We are made aware of the sovereign ease with which he develops the harmonies of his model's personality, orchestrating the similarities and antitheses, and producing a whole world governed by a plastic melody. No doubt Picasso interprets Françoise in the light of what he already knows, but it is also probable that she conjures up solar myths, fauns and ancient pastorals in Picasso's mind and memory. He painted a large picture, *The Rape of Europa*, which carried the decisive style of the *Vert-Galant* to extremes and which is entirely typical of that double movement away from Françoise, and back to Françoise.

As so often in Picasso's life, circumstances now intervened to amplify an original impulse. In the summer of 1946, after having stopped off to

visit Dora Maar at Ménerbes, where he painted two landscapes, Picasso installed himself at Golfe Juan with Françoise in the villa belonging, to Louis Fort, his first engraver before Lacourière. It was on the beach there that Picasso met Dor de la Souchère. 'When we started,' recalls Picasso, 'we had no idea what we were doing. If you had told me: "We're making a museum," I wouldn't have come. But instead you said to me: "Here's a studio." You didn't know yourself what you wanted to do. That's why the thing was a success—because you didn't imitate a museum.' The fact is that Dor de la Souchère offered Picasso the upper floor of the Château d'Antibes, which has become the Musée Grimaldi, of which he is curator. Then suddenly, in the month of July 1946, Antibes once again became *Antipolis*, the town colonized by the Phocaeans at the same time as Malaga. The canvas that bears this title is an idyll of Theocritus and shows a shepherd playing his flute before a goat. The whole picture breathes a spirit of dignity and peace in the Mediterranean sunshine.

JOIE DE VIVRE : PASTORAL. 1946

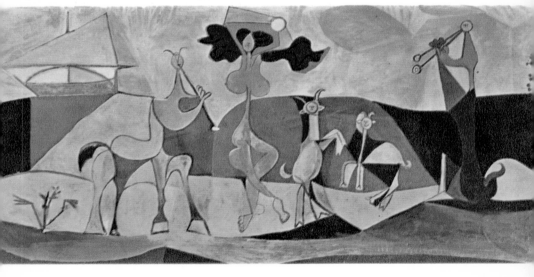

'I have never seen anything so striking and so beautiful,' wrote Maupassant. 'Those towers outlined against the milky whiteness of the Alps, against the vast and far-distant wall of snow that enclosed the whole horizon.' But for Picasso that landscape was also the setting for paintings, the place overlooking the harbour he had painted by night in 1939, the streets, the beaches and the sea he had been frequenting for a quarter of a century. In five months, from July to December, twenty-three paintings were born, fourteen oils on paper, and thirty drawings. Fauns, satyrs, centaurs and a lively goat celebrate the most delightful series of fêtes for the young nymph with a tambourine.

The major work of the group is *Pastorale*, sometimes called *Joie de Vivre*, painted on a panel of fibro-cement. It is a particularly impressive picture in which stylization is combined with the purest and gayest lyrical movement. The inventions of *The Dance* of Monte Carlo twenty-one years later animate the young goddess with the tambourine, while the centaur and the faun sweep the whole of nature and the sea along to the rhythm of their flutes. This is a brilliant demonstration of Picasso's art. In this reorganization of reality he attains the limpidity of classic Greece, but entirely with his own means and in his own language, expressing a renewed happiness, his materialistic confidence in life, the harmony of nature, peace regained. It is a song of victory over the night, a song of the birth of a new love.

All of Picasso's Antibes creations display the same audacity, the same perfection, the same ease of execution. The remodellings which had once served the purposes of disproportion, imbalance and madness, now express equilibrium, measure and the natural order of things. *Recumbent Woman*, *Woman with Sea-Urchins*, *Atlantide Asleep*, and *Still-Life with Bottle, Sea-Urchins, Fruit Dish and Three Apples on a Table*—pictures which are among the freest of Picasso's geometric projections—mingle with *Seated Fisherman*, *Fisherman Resting on his Elbows*, *Owl on a Chair with Sea-Urchins*, *Still-Life: Octopuses and Cuttle Fish*, *Vase with Flowers and Sea-Urchins*, and two other versions of *Still-Life with Sea-Urchins*, which are among the finest interpretations of reality Picasso has ever painted. Some of these still-lifes are of unusual dimensions: both the *Still-Life with Sea-Urchins and Fruit Bowl* and *The Watermelon* are about six feet long, and the composition known as *Fish and Coffee Pot*, or *Symphony in Grey*, is actually eight feet.

It is senseless to read into these Antibes productions what Picasso

thinks, or doesn't think, about social realism. The relationship with reality—including social and political reality—is, as always with Picasso, on a much higher plane. 1946 was the first year of peace—the only year of peace France was to know between 1936 and 1962, although of course no one realized this at the time—the year in which the programme of the Resistance began to be carried out. For Picasso, it was a year in which a new personal happiness was in harmony with the prevailing optimism and with the joy of painting big surfaces in a place of his choice.

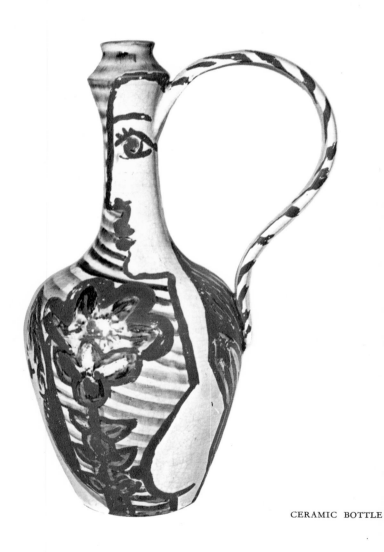

CERAMIC BOTTLE

WAR AND PEACE

Today millions of people know Picasso as the creator
of 'The Dove of Peace', as a man of peace; and in so
doing they are infinitely nearer to the real Picasso than
those stunted aesthetes who delight only in certain of
his pictures, seeing nothing but coloured surfaces without
objective significance, and who turn away in disgust from
a picture like 'Massacre in Korea'.

DANIEL-HENRI KAHNWEILER

When Picasso returned to Paris the war in Indo-China had already
started, and the first icy skirmishes in the Cold War had been experi-
enced. On 15 May, 1947 Françoise bore him a child, a son, Claude,
who strikingly resembled his father. During the first few months of
1947 Picasso appeared to be following up his Antibes work in litho-
graphic experiments in Mourlot's workshop. Fauns, centaurs both male
and female, owls and pigeons emerged rapidly from under his hands.
Fernand Mourlot recalls that Picasso, ordinarily a late riser, 'would
arrive at nine o'clock in the morning and often stay on until far into the
evening at the printer's shop in the rue Chabrol. And this went on for
four months. Picasso had given instructions at home not to disclose
where he was, and his daily absence caused a minor sensation among
the *habitués* of the rue des Grands-Augustins. But Picasso remained
serene throughout; he had become a "professional lithographer, faithful
and accurate". '

This account must be supplemented by saying that just as he did
with Fort and Lacourière in copperplate engraving and etching processes,
Picasso tried out every imaginable method of lithography, direct or by
transfer, not satisfied until he had tried everything himself, including
even abandoned techniques and new ones never before attempted. The
new theme this spring was taken from Cranach's *David and Bathsheba*
in the Berlin Museum. He also illustrated *Twenty Poems* of Gongora
with etchings and drawings and painted a series on the *Owl on a Chair*.

The Mediterranean once again brought order into this tumultuous
creativity. The previous year Picasso had returned to Vallauris, of

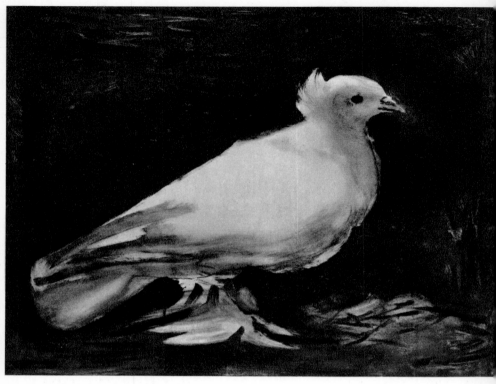

THE WHITE DOVE. 1949

which Golfe Juan is a part. He was looking for the old potters' work-shop he had seen there with Eluard before the war, and took the occasion to visit the town's annual exhibition of locally produced ceramics. He found the little town in a bad way economically. During the war and the occupation, pottery had largely replaced unobtainable metal kitchen utensils, but now with falling sales one kiln after another was closing down. There Picasso met Georges and Suzanne Ramié, who had set up an electrically-fired kiln and were struggling to get things going again, and he modelled three small pieces himself. At the beginning of the summer of 1947 he visited Vallauris again to see what had become of his figurines.

Picasso has never regarded ceramics as a minor art. His whole work prior to 1947 demonstrates that pre-Hellenic or Greek pottery, likewise

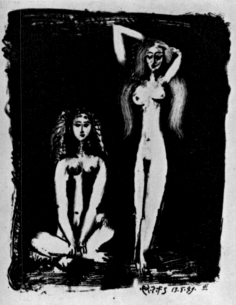
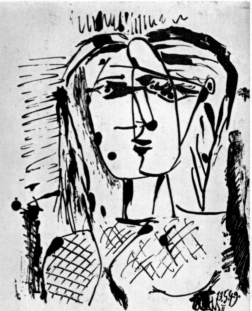

CORSAGE COUPANT LE PAIN MIS VOLONTAIREMENT
DROIT SUR LE MATELAS CREUX DU SIFFLET INONDÉ
DU METAL FONDU DES ABEILLES LA CHUTE HERI-
SSÉE DE CLOUS ET D'ÉPINGLES
L'I REMET SA PIPE DANS LA POCHE DE SA
BOUCHE SE MOUCHE SCANDALEUSEMENT
ET ROTTE LE II ÉTENDU PAR TERRE
RONFLE ENDORMI. LES ENFANTS
REVENUS SUR L'HERBE SÉCHANT LEURS
HABITS À L'OMBRE. GOUTE APRÈS GOUTE
LES PIERRES SE GONFLENT ET
VOMISSENT SUR LE MORCEAU DE
MER QU'ON APERÇOIT CACHÉ
DERRIÈRE LES CHANTS ET LES

15

MUSIQUES DES LILAS POSÉS SUR LES
MEUBLES LA CLOCHE FRAPPE CONTRE
LES NUAGES QUI S'OUVRENT COMME UNE
FLEUR À LA PORTE ARRONDIE PAR LA
VOIX DU SOLEIL QUI DÉCHARGE LA PATÉE
D'OS ET D'ARÊTES DE SES GRANDS MANTEAUX
ET ROBES D'APPARAT. LES MILLE
QUATRE CENT FRANCS DONNÉS À L'AMI
VÉNU CE MATIN FLEURISSENT DÉJÀ
MÛRSENTISSE LES DRAPS — VENEZ VOIR
LES ENFANTS LES EMPREINTES LAISSÉES
SUR LA FARINE QUI RECOUVRE LA ROBE
BLEUE DE MARIÉE QUI BRULE SUR
LE FEU LA CHEMISE DE DENTELLES
NOIRE LES BAS ET SES BIJOUX
REGORGENT DU FESTIN DE SON CORPS
ET L'ANIMENT DES VOLUBILIS DE
SES GRÂCES ET ALLONGEANT SA
JAMBE JUSQU'AU BOUT DE SON PIED

16

POEMS AND LITHOGRAPHS. 1954

the pottery of Pre-Columbian civilizations, have always been important subjects of meditation and study for him. But now a veritable passion for pottery seized him. He loved the feel of the docile clay between his fingers, the transmutation of the oxides, the slip-decorations, the enamels in the firing; he admired the collaboration between the potters, and the whole atmosphere of that little town of craftsmen and peasants in the heart of the Côte d'Azur.

Today, after sixteen years, one can no longer regard Picasso's activities in ceramics merely as a pastime or amusement. Naturally, he found mental and physical relaxation in this different kind of work; but one need only recall his incessant preoccupation with volume—his struggles with relief, chiaroscuro, perspective and projections in colour, then with pasted paper and collages—to see the part sculpture played in the development of his art, and to understand that for him ceramics—the intimate fusion of three-dimensional form and the language of colour—was a synthesis of all those earlier experiments which until then had remained isolated from each other.

In addition, Picasso felt that this new activity would enter into the lives of other people, would actually modify their lives. Picasso has always dreamt of his canvases as living things that would come down from the walls. When he donated his *Man with a Sheep* to the town of Vallauris he specified that it should be erected in the square so that the children could play around it and the dogs cock their legs against it. In the same way you can put real fruit in his dishes and water in his pots, and can eat off his plates; and anyone who uses his ceramics for practical purposes is certainly much nearer to Picasso than those who display his pottery in glass cases. Picasso is convinced that the day will come when all men will be able to live like the rich and powerful of former times, surrounded by everyday objects conceived and realized by the best artists, surrounded, in short, by beauty. In the meantime, his achievements as a potter have made him feel that he has helped to make that prospect less utopian.

The first phase of Picasso's activity as a potter, as can be seen displayed at Antibes, is characteristic both in a return to traditional forms —whether in the traditions of Vallauris, Greece or Mycenae—and in the systematic experimentation in all directions, whether in line with those traditions or counter to them. Once again Picasso tried out all possible techniques, pushing them to extremes, taking advantage of

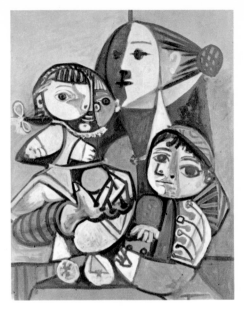

MATERNITY WITH ORANGE. 1951

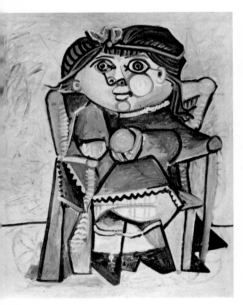

CHILD WITH ORANGE. 1951

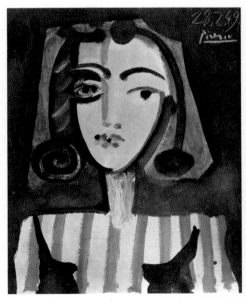

BLUE AND WHITE BLOUSE. 1949

failures, accidents and, as always, the unexpected — whether a piece would stand up in the kiln, or what would happen to its colouring.

The results of his ceramic activities are fascinating, particularly for anyone interested in following the course of Picasso's wrestlings with the material he employs. He takes utilitarian objects—dishes, plates, jugs—to realize the ideas they conjure up: sun motif plates, bull ring plates, figurine vases, human-headed pitchers and so forth. Some are real *tours de force*, executed with such ease that they look completely natural: the vase-statuette in the form of a woman whose gracefully upraised arm forms a handle holding another, smaller vase; the vase-statuettes of kneeling women, marvels of simplicity and elegant balance.

The year 1947 saw almost two thousand pieces issue from the hands of Picasso. But even this tremendous production did not prevent him from pursuing his lithographic work with Mourlot, who supplied him with zinc plates. Nor did it prevent him from going off at the end of August on what was a long and very unusual journey for him. He had decided to take part in the Congress of Intellectuals for Peace which was to be held in Wroclav (formerly Breslau), Poland. There he mounted the rostrum to demand the release of his friend Neruda who had been thrown into prison in Chile. With Eluard, he also visited Cracow and Wawell Castle and saw the restoration of the Veit Stoss frescoes. It was from this journey that he brought back the embroidered coat in which Claude is shown in the canvas painted on 23 October, 1948.

At Vallauris Picasso established himself in the villa La Galloise in the Basses Mauruches, the hills that dominate the Golfe Juan. From the moment of his taking over we have two big canvases of *The Kitchen*. They are almost monochrome, and everything is re-created in lines of equal strength set strictly in the plane of the canvas. This represents the furthest venture into abstraction and reorganization of space in all Picasso's work. There are also numerous canvases of Claude playing around in the new house, all in the same lyrical and joyous vein as the Antibes paintings. Soon Paloma arrived, born in the spring of 1949. Her birth coincided with the first World Congress for Peace at Pleyel, which Picasso attended, following the appeal issued at the Wroclav congress, and this would explain the name he gave his daughter, Paloma the dove, the dove of peace.

Paloma, the dove—that spring the walls of Paris and of all big cities all over the world were covered with one of Picasso's lithographs, a

white dove, perhaps the work in his whole production which best evokes the idea of perfection. In the United States it was awarded the Pennell Memorial Medal by the Philadelphia Academy of Fine Arts.

Incidentally, this dove was not drawn specially by Picasso to serve the purpose it was made to serve. Aragon had come to him to ask for a design for a poster for the peace congress. Looking through a folder of Picasso's work, he discovered this lithograph and carried it off, thus starting it on its prodigious flight. I was privileged to witness Picasso's joy at this adoption of his work, *The Dove*, by the peoples of the world. Although by now Picasso had become used to not having his paintings understood—which was especially the case in the Soviet Union—he is nevertheless much happier when they are.

Now if there is one thing which is foreign to Picasso it is the intoxication of success, or, indeed, losing his head in any way. There is some reflex in his blood, a reflex which is not so much Mediterranean as characteristic of those stony countries where the gods live at the level of the clouds, and where men instinctively draw back from anything that goes beyond reasonable bounds—it was called *hubris* in Greek tragedy, and has been known as excess since the Middle Ages. As far as Picasso is concerned, he was born with the faculty of self-criticism, not only in art, but in every one of his gestures, all his reactions, a sort of omnipresent representative of all the Greek gods that were ever invented. And ever since reaching the age of reason he has wrestled with that whole pantheon, more than all the interdicts the Church could hurl, and has equally resisted the attemps of all atheists, anarchists, inconoclasts, Cubists, Dadaists, Surrealists—in short, he fights alone on his mountain, exposed to every blow. By 1949 this had gone on for fifty-five years. But there have always been those who helped him to carry his burden. In the five years which preceded the First World War it was Braque. From 1936 on it was Paul Eluard. Today it is Jacqueline.

In 1949 appeared a series of portraits of Françoise: *Lady in Blue*, then *Woman against a Background of Stars*, showing her pregnant, in the armchair in which Picasso had already painted Olga, and also a few of his saddest *Women* of the war years. In this one, there is a wonderful night in the background. A particularly serene lithograph shows Françoise as the *Woman in the Armchair* wearing a blouse with puffed sleeves. In May Picasso returned to Cranach and produced a lithograph, *Venus and Cupid*, in which he presents Venus as a modern young woman

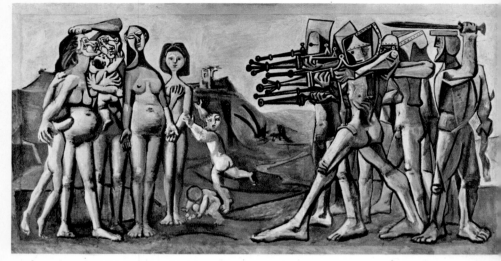

MASSACRE IN KOREA. 1951

of our own day. Another lithograph, *Young Woman Inspired by Cranach*, bears traces of the spatial reconstructions which have obsessed him, since *The Kitchen* in the autumn of 1948. This was to culminate in a dialogue with Courbet. In February 1950 the *Demoiselles by the Seine* of 1857 developed under Picasso's brush into *Demoiselles by the Banks of the Seine*, after Courbet. Picasso has flattened out the planes, the river vista in Courbet's canvas, to the surface of the picture, thus considerably reducing the height envisioned by Courbet, reinforcing the mass of trees and flattening the young girl in crinoline.

It seems to me that in his own way Picasso has made it very clear that this is in no way a polemic against Courbet's realism, because ten months later he took *Lady with Gull*—executed by Courbet towards the end of his life when he was in exile in Switzerland as an expression of that exile, of the breach with his own country—and turned it into one of the *Faces of Peace* designed to decorate the Vélodrome d'Hiver. In taking the *Demoiselles by the Seine* Picasso chose a Courbet in which the volumes, the masses, the presence of reality and the modulations of space are rendered with particular vigour—a picture which draws the observer into its own space. Picasso has re-created everything that is in the picture, using his own specific means to walk around the figures,

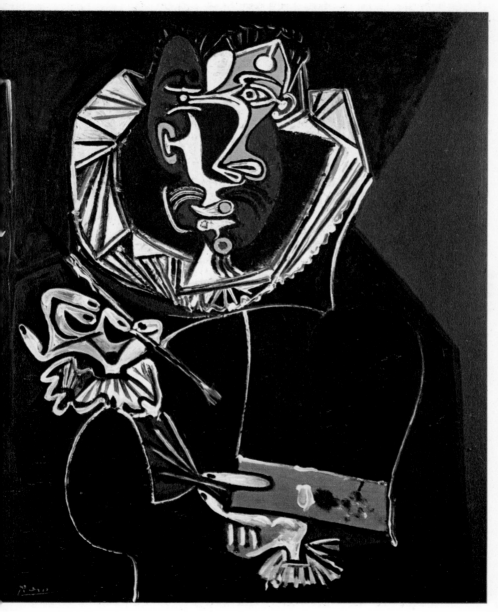

PORTRAIT OF A PAINTER AFTER EL GRECO. 1950

to show all their sides simultaneously, trying out his new treatment of space by means of crossed and curved lines and defined zones, somewhat in the manner of the contour lines used by mapmakers to indicate relief.

The result takes on the significance of a manifesto. 'You see,' Picasso seems to be saying, 'I have let nothing escape; not the pumps, nor the crinoline, nor the hat, nor a single detail of Courbet's. Nevertheless I have extracted them out of their picture as I did in Cranach's *Venus*.' A few days later Picasso turned with equal vigour to the *Portrait of a Painter* by El Greco. The transformation here is just as radical, but the basic resemblance, the transcription, is amazingly preserved.

The summer of 1950 saw the outbreak of war in Korea, and it is impossible to isolate this event from the portraits Picasso did at that time of Claude and Paloma, alone or with their mother. Nor is it possible to isolate it from the numerous landscapes of Vallauris, the peace of the *Villa with the Palmtree*, the *House at Vallauris*, or the *Smoke of Vallauris* with all the potters' kilns going full blast as the town recovers, and the splendid *Nocturnal Landscape*. Picasso was continuing his activities as a supporter of peace.

In the spring of 1951, Picasso having reached the age of seventy, there emerged a big canvas which he titled *Massacre in Korea*. Here the reference to Goya and *The Third of May* is obvious—a people in the throes of a foreign war. The meaning of the picture is unmistakable, but Picasso has introduced matter which up to then had been considered refractory to painting—modern arms. But he has reconstructed them to look like ancient armour, emphasizing the mechanical, robotlike, inhuman side of the massacre.

The effect of this picture was disconcerting, even baffling. Picasso had against him not only all who expected another *Guernica*, and those opposed to the political implications of the picture, but also the Communists, who found the picture not sufficiently 'realistic', too 'abstract' for the actualities of that war. Yet Picasso had summoned up all the accuracy in plastic expression of which he was capable, in order to bring out his idea, even emphasizing it by the direct reference to Goya. Picasso thereby rises straight away above circumstance to the level of history. Today, in retrospect, the canvas has lost nothing of its power, it is a vivid evocation of what we call the Korean War.

The picture is also deeply bound up with Picasso's own being; its roots were in the heart of a father with young children, who in all

masquerade, staged, played and drawn with stupendous art. Picasso's virtuosity here is breath-taking, and never for one moment does he lose his firm hold on us. As soon as we open the album of *Verve* in which the series is collected we are seized and captivated by the paint-ter's revelations and inventions, ceaselessly moving from pathos to the comic, alternating between anger and humour.

The main theme is one to which Picasso has returned time and again— the painter and his model. But this time it includes *all* painters: old doddering ones; a romantic young man obviously very pleased with himself and his work, while his model, to whom he shows his picture, is just as obviously perplexed; some are meticulous, others free; some abstract—a whole assortment, including women painters and even a monkey. As for the models, they are all beautiful and enormously desirable. They triumph and make game of admirers, adorers, passionate or indifferent ones. The whole series is a hymn of praise to women, to youth, to feminine beauty, turning into a hymn to life itself and its perpetual renewal, to the triumph of life over art and over the artist provided only that he lets it go its own way, escape, flout him.

Picasso's criticism of reality was never so ferocious: criticism of old age and what it does to men and to women, whether they are painters, critics, patrons or models. But the crux of it all is his criticism of artistic creation. It should never be forgotten that for Picasso, art is identified with life itself. In the love that Picasso has for a woman, who can dis-sociate the eye of the lover from that of the painter? Art is a reflection of life. But it sometimes happens that mirrors reflect nothing at all. Has Picasso pursued the dialogue with mirrors far enough? Mirrors reflecting beauty, all beauty, even aspects hidden from view, like the mirror of Velasquez held by Cupid revealing the unseen beauty of Venus. But there are also mirrors which contain nothing but blackness and death. Painting itself is a living mirror. In 1928 the painter and his model told a story that we should always bear in mind where Picasso is concerned: the story of a painter and his model reconstructed by Picasso in a rather abstract studio, in which the brush of the artist sets down the natural profile of the model's face on the picture.

In short, we must not regard this series of the painter and his model as a temporary dialogue with this or that form of painting, but as an attempt to penetrate to the heart of things, to express the drama of the painter at grips with his canvas, who ends by seeing no farther than

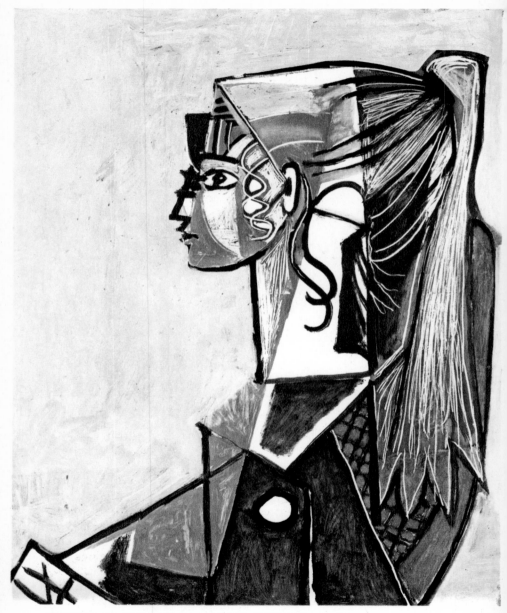

PORTRAIT OF SYLVETTE IN A GREEN ARMCHAIR. 1954

DRAWING FROM VERVE. 1954

his canvas, who is incapable of seeing even the most beautiful woman
except with the eye of the painter, who is unable to love her even when
she offers herself, gives herself, dreams in her sleep that she is taken.
As always with Picasso, there is no symbolism; that is to say, in no case
do the objects or beings cease to be themselves in order to represent
an idea or an abstraction materially. The objects and the beings are
themselves, with all they really and truly represent in human life. The
woman is always truly present in these models: the woman whom the
painter pleases as a man, or does not please, as the case may be; the

woman who wishes to be treated as a woman, or who, on the contrary, desires that he should see nothing in her but the model while she is posing; the woman who is aging and has lost her beauty.

I do not agree with Rebecca West in her preface to this collection of drawings published in *Verve* when she writes that she finds it 'surprising to observe signs of impatience and even disgust in Picasso in those drawings which show the artist using an old woman for a model. Judging by the spirit that pervades the whole collection, that old woman must symbolize the brutal aspects of nature.' She then goes on to cite Rembrandt as 'proof that an artist who rises above a certain level can find just as much material for a very good picture in an ugly old woman as he can in a young and pretty one.' Perhaps, but what has that got to do with what Picasso has drawn here? He has proved—if only in his *Portrait of an Old Woman* of 1941—that the problem is just as definitely resolved for him as it ever was for Rembrandt. But where is beauty when old age withers and destroys it? *'Dictes moy où, n'en quel païs.'* (Tell me where, in what country?) What is the power that enables the artist to transfix fleeting beauty? The beauty which never inhabited the slovenly paintress herself, but which she now seeks to seize in her model? And what about that doddering old painter?

Ingres was eighty-three when he painted his *Bain turc*, having 'in the space of six months of suffering found a fortnight, and an interrupted one at that', to complete his picture 'in the way it required.' And then there was the old Matisse, as he was sinking into his final illness, the Matisse of the *Odalisques*. For the first time Picasso was no longer content to put to the test only the model and the picture; now he would also examine the man or woman doing the painting. In other words, he was taking in all the actual data of the creative situation: the model as a human being—Picasso showed that he already knew this at the age of fifteen in his first *Diploma Drawing*—the painter himself, all the painters he had ever known, all the painters he had ever been, the painter he was then during that solitary winter, and the man that he actually is. All this data was used to reduce the plastic creation, the creation of beauty, to its human elements, its human reality. No god presides over these mysteries—simply man in his condition as man, with all the whims of his spirit to aid, disarm or distract him.

This is what justifies that other appreciation of Rebecca West when she declares that this series 'could be the most prodigious artistic event

of the century.' Because, just as Chaplin was doing in *Limelight*, Picasso was throwing his whole life into the scales, all his creative experience, everything the craft of painting had made of him, had taught him about himself and about the world, to wrench from his art the very meaning of life. The author dominates here by expressing and knowing how to express that comedy in which he is sometimes only one of the actors. It is art which can help life to win its battles. This is certainly true in the first place of the artist himself and of his own life; it is also true of the lives of others, of life itself. This is why all shallow discussions about optimism and pessimism are just as false here as those about beauty and ugliness, youth and age, reality and abstraction. Picasso's message is not concerned with whether life is beautiful or hideous, or whether there is one kind of art or another, but with the fact that the art of man can bring beauty to old age, youth to ugliness, life to the void. This is the tremendous lesson of *Peace*, discussed here step by step and line by line in the banal everyday realities of the studio, in the crude details of creation.

The *Verve* series, despite its complexity, its scope and its richness, did not entirely absorb Picasso. There is also a lithograph on a related subject, *Répétition*, which carries still further the mask theme which appeared in the series. The coloured drawing of 3 February 1954, shows a masked painter before a masked model, and on the canvas between them there is the outline of a painter holding his palette—it is the Minotaur kneeling before Beauty, in the act of removing its bull-like mask to show a bearded Greek god, while Beauty aims her banderillas at the bull's head mask. The spring which now came into Picasso's work was the spring of Sylvette, a young girl so fair that in Vallauris she was called the English girl. She came to sit for Picasso accompanied by her fiancé.

The series of portraits of Sylvette that now followed seem to bear traces of everything that Picasso had taught himself during recent years. There were thirteen of them, all executed in a relatively short space of time and all closely related. They constitute a new experiment in plastic language, with the accent placed on the exploration of the model, on the means of expressing her characteristics as completely and specifically as possible. Marie-Thérèse, Dora Maar and Françoise Gilot had almost always been treated metaphorically, as though Picasso could win his creative liberty only by displacing the image into a dimen-

DRAWING FROM VERVE. 1954

sion external to the model: sensual lyricism, the reflection of political events, pagan suggestions. But these thirteen canvases of the young girl with the 'pony tail' hair dispense with that duality. The dialogue runs directly from the eye to the hand of the painter, and from the model to the style which expresses it. This immediate reference to the model reveals the degree of liberty Picasso is able to master.

Thus, just as 'distortion' and the process of abstraction are for Picasso merely ways of coming closer to reality, so in the same way the accented reference to the model here emphasizes the power and independence of the plastic language itself. Creation for Picasso is always action and reaction, a double movement between reality and his work, between the world and the artist. Thus the portraits of Sylvette are linked with

Picasso now left Vallauris to move back into the studio at the Grands-Augustins. At the end of October he offered his help in the book sale organized by the Comité National des Ecrivains. The old Vélodrome d'Hiver at Grenelle was filled to overflowing, and crowds besieged Picasso's stand all afternoon. They came to congratulate him on his exhibition at the Maison de la Pensée Française, in the summer of 1954, which brought together the pictures in the Shchukin collection and a few others, notably the Gertrude Stein collection, representing a unique coverage of the Blue Period, the period 1906-07, and the phases of Cubism up to 1914.

A version of Jacqueline, with the darkest of eyes and hair, a Jacqueline liking to crouch, dominating all others, but with a veiled look, had already been painted by a rare rival of Picasso's, accepted by him as such: Delacroix, who put her in his picture the *Women of Algiers* of 1834, as the woman with the rose in her hair, holding a hookah. But in the version of 1849, Delacroix lost her, allowing the sharpness of her features to escape him. Quite certainly this resemblance is one of the keys to the catalysis which provoked the series of Picasso's reactions to the theme of the *Women of Algiers*, a catalysis directed towards the East, towards the *Odalisques* of Matisse.

When Picasso started work on his *Women of Algiers*, Matisse had just died. Subsequently Picasso was to tell Penrose: 'When Matisse died, he bequeathed to me his *Odalisques*.' In 1932 Picasso explained to Tériade: 'Fundamentally everything depends on the individual. It's a sun bursting with a thousand rays. Nothing else counts. That is the only thing that explains Matisse. He had that sun inside him. And that's also the reason why now and again something happens.' 1954 was one of those years in which death seemed to strike particularly hard at the world of painters: first it was Derain, then Maurice Raynal. Derain had been lost sight of, but Maurice Raynal had remained the old friend of the Bateau-Lavoir. At the beginning of the year he had published a new edition of his *Picasso*, which remains a definitive book. And now Matisse. He had, of course, been ill for many years, but his death struck close. Manet's *Olympia*, Matisse's *Odalisques*, Picasso's *Joie de Vivre* and the *Demoiselles d'Avignon*—what a period of creativity! Half a century!

Does Jacqueline plus Matisse equal the *Women of Algiers?* Not really, although that coincidence and the multitude of encounters in Picasso's

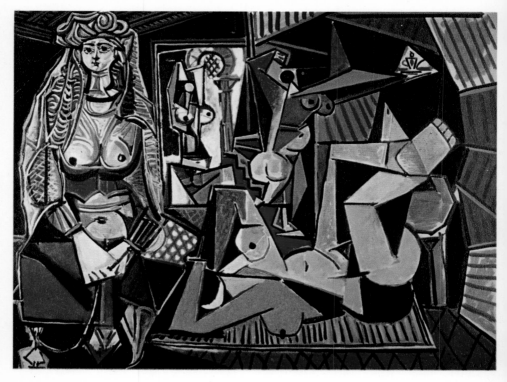

THE WOMEN OF ALGIERS. 1955

life make it possible for us to observe two of the motivations in this one series. This doesn't in the least mean that the preceding series were not just as deeply rooted in Picasso's life, but simply that we know less about them. To this should be added, with regard to the *Women of Algiers*, the additional coincidence between the theme and the Algerian insurrection of November 1954.

There are fourteen canvases in this series, dating from 13 December, 1954 to 14 February 1955, and once again one can say that Picasso brings his own life into play; once again he puts all of himself and everything he knows into a new series. The difference here is, first of all, that this whole series was devoted to a dialogue with one picture— two perhaps, since Delacroix re-opened the discussion with himself after an interim of fifteen years, but this makes no fundamental differ-

ence. It was a séries, not just one canvas as it was in the case of Pous- sin's *Bacchanale*, Courbet's *Demoiselles* and Cranach's *Venus*. When this undertaking became known it baffled the critics. They were inclined to regard it as some sort of game, an attempt to rival Delacroix. But it was truly a discussion, just as in 1952 when Picasso took *Maternity* from his friend Edouard Pignon and painted it in his own way. Writers set their discussions down in words; but Picasso, being a painter, puts his down on canvas. It has always been like this—from Lautrec's lessons to Picasso's homage to Cézanne, from the collages to this monu- mental series. There are whole passages from Plutarch in Shakespeare's *Julius Caesar*, but no one has ever accused Shakespeare of having tried to 'rival' Plutarch.

Thus Picasso is not playing a game with Delacroix. Working in his Grands-Augustins studio, he was to bring out the beauties of the harem, unclothe them, open wide the windows to daylight, lower from the ceil- ing the black mirror in Delacroix's canvas, and extol the glories of the naked body.

The last of these canvases has the dissymmetry of the *Demoiselles d'Avignon;* the woman standing on the left, full-face, bare breasts, is treated without transpositions, while the other two women and the servant, the image reflected in the mirror, are nude and freely projected into different planes. The colour range has little relation to Delacroix, but it is very close to Matisse's works of the years 1948-50. The unity and the hymn of this great canvas are perfectly pure. Nothing clashes. Picasso has liberated those beautiful recluses to allow them to express the luxury, calm and voluptuousness of his old companion who had been carried off by death.

The year 1955 in Paris saw the great retrospective exhibition of Picasso's works in the Pavillon de Marsan, and the exhibition of his graphic art at the Nationale. Picasso left for the Midi. Jacqueline now presided over his life as she presided at his side at the first *Corrida* in Vallauris. She loved bullfights, and in the summer of 1954 Picasso took her to Perpignan, Céret and Collioure. In 1955 they took their first house together, La Californie, on the side of the observatory hill at Cannes overlooking the Golfe Juan, the Cap d'Antibes and the Lérin isles. It was a very big house with high-ceilinged rooms. Those on the ground floor opened out into a terraced garden with palms and eucalyp- tus trees. The statues in the garden seemed to belong there. Picasso

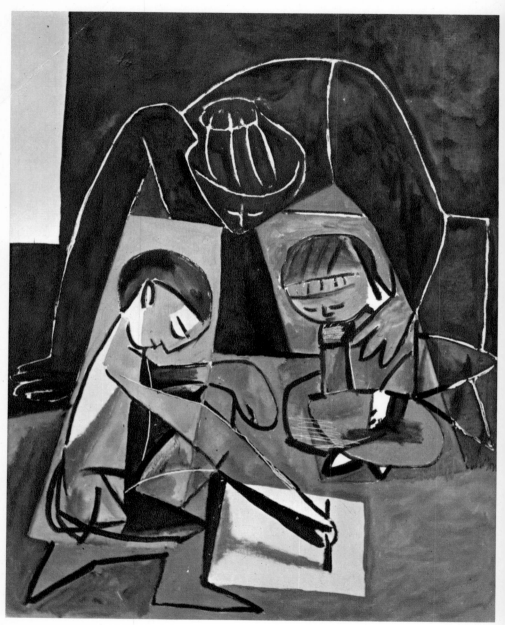

THE LITTLE ARTIST. 1954

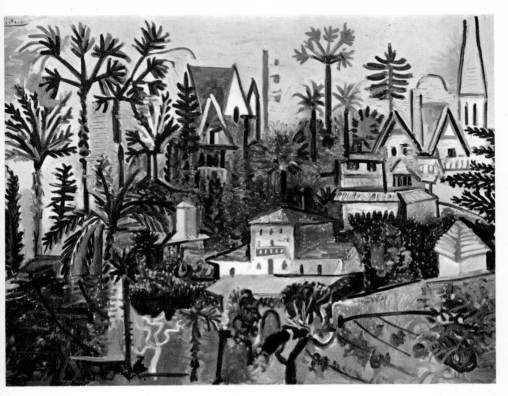

THE HILLSIDE AT 'LA CALIFORNIE'. 1959

and Jacqueline had found the house of the *Women of Algiers*, and very often views of the studio of La Californie are confused with the fourteen canvases of the Grands-Augustins, particularly because of the design of the high arched windows in the style of 1900 and on account of the portraits of *Jacqueline in Turkish Costume*.

LA CALIFORNIE

Picasso... is one of those major intelligences compelled by his character to step outside of himself, to place himself at a distance from himself in order to exercise a detached judgment.

<div align="right">HÉLÈNE PARMELIN</div>

Picasso in the years 1955 to 1960 is described by Hélène Parmelin in her book *Picasso sur la Place*, in which she has re-created the life of the 'king of La Californie', as she calls him, with the same success as Jaime Sabartès re-created Picasso's youth and his life during the civil war years. In the summer of 1954 a new period opened up in Picasso's life with his love for Jacqueline. When we consider the next ten years we are struck in particular by the fact that the differences in style are primarily related to the places in which Picasso lived and worked. There is a tone and a quality which say 'La Californie', a Vauvenargues palette, and light peculiar to Mougins. His work varies according to these places, though it would be a mistake to try to make too much of this, Picasso having gone from one place to another according to needs and circumstances, finishing off work in one place that was begun in another.

In October 1955 Picasso's stay in 'La Californie' produced a portrait of Jacqueline in white, black and grey, of marvellous tenderness and simplicity. This portrait also represents a return to painting after a summer spent in work of a most unusual kind for Picasso, making a film in collaboration with the famous director Clouzot. It was entitled *The Mystery of Picasso*.

Unlike the other films about Picasso, whether *Guernica* by Resnais with a script by Paul Eluard, which is done in *montage*, or *Picasso* by Luciano Emmer, which is a rather stiff documentary, Clouzot's film is on Picasso as a creator. Clouzot devised the technical procedure which allowed him to film the back of drawings being executed in coloured inks that penetrate through a special paper. Picasso thus personally directed the action with the white paper as his setting. The film provides a marvellous record of Picasso's composition and the way he makes

corrections and changes. The film deals exclusively with the final stages of the process of creation, as the painter realizes his ideas and struggles with the material and the control of his movements. By the time Picasso arrived at the Victorine Studios in Nice where the film was to be made, he had already thought out very carefully what he proposed to do. I emphasize this because in demonstrating Picasso's incredible virtuosity of execution, the film tends to give the spectators an exaggerated idea of his facility.

This is the exact opposite of the truth. The long hours of work during the hot summer in the heat of the projectors, and Picasso's own keenness and application in this new kind of work, as, indeed, in all his other projects involving teamwork, reflect only a fraction of the enormous creative activity of Picasso in this film. So much so that Picasso, who ordinarily is only fatigued by inactivity, was affected by the tremendous expenditure of energy involved in making this film to such an extent that in the winter of 1955-56 he had to consent to taking a rest—something he had not done since his attack of sciatica seventeen years before.

However, this period of rest must not be taken too literally. Between the series of *Plages de la Garoupe* which Clouzot recorded in cinemascope, the *Portrait of Jacqueline* on 12 October 1955, and the series of *Studios* or the *Interiors* at 'La Californie' which began on 23 October and gave way in November to *Jacqueline in Turkish Costume*, Picasso's activity appears practically uninterrupted. If you study the catalogue of the exhibition Kahnweiler had planned for 25 October 1956, to celebrate Picasso's seventy-fifth birthday—which was not actually ready until 1957, and then in the new premises at Monceau to celebrate the fiftieth anniversary of the opening of the gallery in the rue Vignon—you will find at the outside a pause of about a month in December 1955. Then came the nudes in flat cut-out surfaces dating from the beginning of January, (*Squatting Nude* on 3 January and *Toilette* on 4 January), followed by a somewhat longer pause before a big canvas in the Antibes style, *Spring*, completed on 20 March. Then came a return to interiors, this time with the added presence of Jacqueline, and these hold the centre of the stage until June 1956.

This amounts to more than fifty canvases in eight months. The 'interior landscapes', as Picasso called them, mark his taking possession of 'La Californie'. They are gay and marvellously free canvases,

in which you sense the painter's desire to integrate this new place into his painting, to master and express it. Thanks to a chance present, Jacqueline appears in Turkish costume, after which Picasso painted her seated in a rocking-chair, and then combined the two images in the series of *Women in the Studio*. The canvases painted in April and May 1956 tell everything in a few strokes of colour.

This is the first systematic series of canvases on such a scale to deal not only with the same subject but also quite literally with the same reality. At first one is tempted to see a process of abstraction and the elimination of everything which is not plastically indispensable for arriving at the essential image, in the way, for example, that Picasso dealt with the bull and the owl. Indeed, there is something of this if you compare the canvases of the end of October 1955 with those of April 1956, which pick out certain significant elements and forms. The process of abstraction that we saw in the period between *Woman with Mandolin* in 1909 and *Young Woman* of 1910 is fully explored here. Picasso seeks the core of his subject, the heart of its plastic expression by means of eliminations, simplifications and condensations. What forty-five years earlier had been a secondary discovery, one of the consequences of his analysis of volume, was now the main object of exploration.

But now another phenomenon appears. When at the end of the series, Jacqueline, sitting in her armchair in the studio, is expressed—as in the canvas of 4 April—with a minimum of lines and vigorous flat tones, it is the whites which simultaneously provide the light, all the sparkle of light and the lighted depths—the architecture of the picture as it is accentuated, projected by the sun. This is the opposite of chiaroscuro and not merely its negative. White-on-light, and not black-on-white, light itself, the whites convey what chiaroscuro entrusts to shade, while sharp cut-outs of primary colours replace the effect of diffused light which alters colours. *Studio II* of 2 April is witness to this dialectic, employing whites, lines and flat tones to express the studio in half-light, while a canvas on an easel emerges from the shadows—here by means of chiaroscuro.

In the midst of this series it is interesting to note canvases like *Man and Woman* of 18 April, and *Woman's Torso, with Blue Trousers* of 19 April harking back to canvases painted at the end of December 1953 in which Picasso's shadow is silhouetted against the window while the sunlight spotlights in white the nude woman on the bed and a portion of the

226

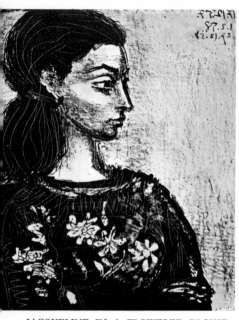

JACQUELINE IN A FLOWERED BLOUSE.
1957-1958

JACQUELINE IN PROFILE. 1957

BATHERS. 1957

LE TREMPLIN. 1956

wall. White catches the light; it can express light trapped by skin, by objects, by relief. The quest culminated in August with canvases exulting in the exuberance of the garden of 'La Californie', and in the gaiety of the children: *The Dance, The Family, Nude Woman in the Garden.* Towards the end of September the *Man in Striped Jersey* brings back the image of the sailor. At this moment Picasso sketched a new *Beach at la Garoupe*, the first approach to a big canvas which was to be completed in the summer of 1957, after studies in cut-out silhouettes. Picasso adopted new forms for this picture—underwater masks, flippers and so forth—incorporating the effects of a modern beach.

I met Picasso at the end of June after *Le Monde* had published Khrushchev's famous anti-Stalin speech to the Communist Party Congress. Picasso is by no means the romantic, sentimental Communist some people would like to make him out to be. There have always been people who thought they could spare his feelings by not telling him the whole truth—either about the effect produced by his pictures, or about other things. The fact is, however, that Picasso is always trying to find out the whole truth about things. He can't stand what is sometimes called diplomacy or the empty forms of politeness either in politics or in art. And it must be remembered that he places politics on a level with painting. In short, he was well aware that what is now called the process of de-Stalinization was being carried out to its logical end.

It was in this state of mind that he entered the winter of 1956-57. For a time he stopped painting and engraved a series on the bullfight instead, among the finest he has ever done. And in ceramics he executed a series of large dishes with thematic motifs. He never ceased sculpting, and inventing subjects for sculptures. *Paloma Skipping Rope*, a new *tour de force*, is an example of this. He was working here in cardboard or metal cut-outs, in two dimensions or mounted on the same axis and describing a certain angle. He studied in particular the way these objects took the light and how they projected themselves in space. Then he returned to painting and executed a series of canvases after the profiles of Jacqueline he had created in this way.

In August he turned to *Las Meninas*. Of fifty-eight canvases executed in little more than four months, forty-five represent his dialogue with Velasquez. Picasso now left the studio of the 'interior landscapes' to establish himself on the second floor of 'La Californie'. A large window whose sill was frequented by pigeons looked out over the sea and the

THE STUDIO. 1956

LA GAROUPE. 1955

Lérin isles. It seems in retrospect as if everything was calling Picasso to the master of Seville's major canvas: the organization of space and the figures, the relief, the instant seized for eternity, the painter and his models. But Picasso does not return to the dialogue with Courbet, or to the liberation of the *Women of Algiers*. He of course opens windows, enlarges the hall and gives greater prominence to Velasquez at the easel; but then he quickly turns his attention to the Infanta and to what is taking place between her and the maid of honour offering her the tray.

Picasso was not content until he had brought them out and mastered them so effectively that they moved. Only then did he return to the ensemble in two canvases of 4 September, which are both full of movement and rhythm, before taking up again the study of the Infanta. But between 6 and 14 September he became absorbed by the great window opening out onto the sea and the isles of Lérin, and by the pigeons whose kingdom the window sill was. Once again we have all the variations of light from morning to evening, and, as in 1919, the sky and the Mediterranean, but this time without the pedestal table and the still-lifes—just the pigeons, the light, the trees and the blue of the sky and the sea.

When Picasso returned to *Las Meninas* again he seemed to have obtained greater detachment and more freedom. He gives the impression of having re-created the picture by resorting to the different approaches he had been experimenting with during the past few years, using the simplifications of the recent 'interior landscapes', or organizing all the space in coloured compartments, as he had done with Courbet. Sabartès notes very acutely: 'The similarities which appear at different periods reside in the aspect, the character, the general view—what one can take in at a glance. But the language used is always distinct. It varies with the subject, and always uses precisely the right expression, the only one that corresponds to what Picasso wants to say, in exactly the way he wants to say it.'

Thus, after a red silhouette pausing at the piano, we are introduced to the authentic language of *Las Meninas*, the vision of a small Infanta, a little lost perhaps, but still the daughter of a king, whose melancholy in a slight movement of withdrawal conveys the whole world of the court, its etiquette, the pages and the maids of honour, and the aging Velasquez. This is followed by landscapes which seem to be shaken by the high winds of autumn, then a portrait of Jacqueline, luminously

triumphant, and, finally, as though by contrast on the next to the last day of the year, the saddest of all the Infantas, slightly leaning to one side and making the last curtsy before quitting the scene—what one would imagine if the verses of *Macbeth* applied to her, as though she had strutted and fretted, and then was heard no more.

The UNESCO commission followed almost immediately, and the problems of the approximately 120 square yards he was asked to cover were solved by Picasso very much in his own way. He assembled the panels, each measuring about six and a half feet, and without pause launched into the work in January 1958. Plunged would be nearer the mark, as he had done with *Las Meninas* and, before that, with *War* and *Peace*. It was a new *tour de force*, having to work from a small-scale model and on a mural which was part of a whole complicated ensemble including a passageway across a hall, and columns. The result, though it surprised and confused many who had a set idea of what Picasso should do, brought the painter's world right into the heart of the UNESCO building. The subject was the fall of Icarus with a beach and bathers, a drama of our own time conceived during the first flight of the sputniks, full of classic grandeur: *La Baignade*.

This spring also produced the curious figures of the bull-matadors, which seemed to foreshadow the events of 13 May 1958. At the moment when the crisis reached its height, the theme *Still-Life with Bull's Head* reappeared, as under the German occupation, and the window of *Las Meninas* was blood-red from the wild reflections of the sun. 'A picture painted with curses', Picasso was to say. During the course of the summer he returned to the ground-floor interiors with the high arched windows. Using a good quill he also executed with great finesse the head of an *Arlesian Woman*, on which is inscribed the dates of sittings, from 8 July to 15 August. In the beginning of October he completed another big canvas, *The Bay of Cannes*, which he had started early in May. This is a thoroughly controlled, peaceful landscape. As Picasso was putting on the last brush strokes he had already left 'La Californie', at least in spirit. It had become crowded. Picasso no longer felt at home there. Douglas Cooper suggested to him that the château and property of Vauvenargues was for sale. Picasso acted immediately, and thereupon became the new owner of the Montagne Sainte-Victoire. 'Congratulations, but which one?' said Kahnweiler when he heard the news. He thought that Picasso had bought a Cézanne.

LAS MENINAS. PLATE 53. 1957

SPAIN AT VAUVENARGUES, AND LE DÉJEUNER SUR L'HERBE

> *Pictures are always painted the way princes produce children—with shepherdesses. You never paint the Parthenon; you never paint a Louis XV armchair. You make pictures out of some little house in the Midi, a packet of tobacco, or an old chair.*

<div align="right">

PICASSO TO TÉRIADE IN 1932

</div>

It is only about a two hours' drive by car from Cannes to Vauvenargues. It is still in Provence, but the smiling coast has given way to austerity and tragic grandeur. The landscape is dominated by the bare limestone of the Sainte-Baume and Montagne Sainte-Victoire, with harsh wooded hillsides relieved occasionally by an oasis of greenery from a stream. The Château de Vauvenargues, massive and noble, harmonizes with the countryside. Maurice Jardot records that when Kahnweiler warned Picasso against the melancholy of the place, Picasso quietly replied that he was a Spaniard. And to a certain extent Vauvenargues represents at first a return to Spain in Picasso's work, a resurgence of Spanish soil with a sober, intense palette, deep reds, mature yellows, shady greens, marrying the Attic Aix countryside to the colours of Spain.

Picasso attached special importance to the tone of Vauvenargues, and in January 1963 he held a separate exhibition for those of his works that bore its imprint. However, having said this, it should be pointed out that Picasso never lived entirely at Vauvenargues, and that, indeed, he continued to work in 'La Californie' until the beginning of June 1961, when he moved to a farmhouse, Notre-Dame-de-Vie at Mougins. There he developed the series after Manet's *Déjeuner sur l'herbe* which he had begun at Vauvenargues almost two years before. As usual, we must take care not to regard the landmarks in Picasso's life as so many neat pigeon-holes in which to classify his creative work. Allowing for breaks, we can say that from February 1959, when he first settled in Vauvenargues, to 20 April 1961, two days before the Algerian uprising, when he ceased to work there, the place is associated with more direct and intimate works, whereas the work he did in 'La Californie' is characterized more by abstract experiments and sometimes by very daring recompositions—such as the *Girl on the Beach* of 12 April 1960.

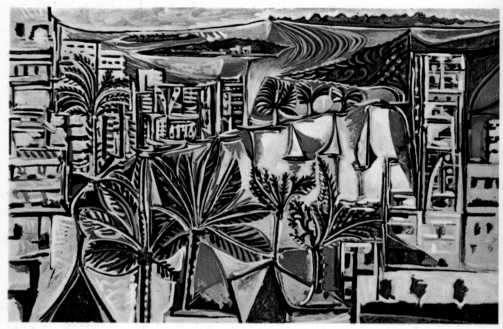

THE BAY AT CANNES. 1958

In reality the Vauvenargues phase actually began at 'La Californie'. It was there on 18 February that Picasso painted the enormous black sideboard of Vauvenargues and his Dalmatian dog Perro, the first canvas of a series of which the largest, with a little girl, and a bust at each side of the buffet, was continued at Vauvenargues on 23 March 1959 and finished on 23 January 1960. There was a month at Vauvenargues, or rather twenty extraordinary days from 10 to 30 April 1959, in which, as was Picasso's invariable custom, he 'took possession of the place' by painting. This was marked by a series of still-lifes on a theme which had not been seen in Picasso's work for more than thirty years, practically since the years 1925-26: *Mandolin, Jug and Glass on Table*. An almost tragic sobriety enters into these pictures, and a singular homogeneity. Their general tone has been aptly described by Maurice Jardot as a *cante jondo*.

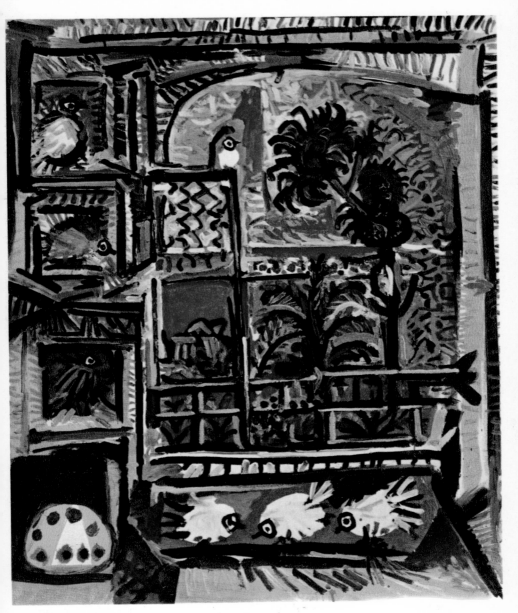

THE PIGEONS. 1957

On 14 April, at the height of this Spanish verve, Picasso painted *El Bobo* after Murillo, and this extraordinary little rogue can almost be regarded as the particular signature of Vauvenargues. As the days passed Picasso's work turned toward Jacqueline and he produced *Jacqueline at Vauvenargues*, paying homage to the spirit of the place through her. Then he turned to the village itself and painted three canvases, one of them on 29 April with the rain falling. In June there was a new and shorter period of creation. *Woman with Dog* and *Crouching Nude* seem to return to the preoccupations of his stay at 'La Californie', although two admirable still-lifes, *The Mandolin* and *Still-Life with Demijohn* pursue the April themes.

From this same period the sketch-books published by Charles Feld under the title *Toros y Toreros* reveal another Spanish subject continued around the theme of bull fighting. At the beginning of March there are strange combats at the feet of a crucified Christ, who intervenes to protect the man on the ground from the goring bull; then a *Mater Dolorosa* in the Baroque style, and a Christ bearded like the Minotaur. Then Jacqueline appears: *Jacqueline as Queen of Spain* of the time of Velasquez, some lovely *Jacquelines on a Caracoling Horse*, or simply *Queen Jacqueline*. These date from 10-12 March. From the beginning of April there is a whole *Corrida* in black and white, first reversed, in lithographic pencil on flat tones of Chinese ink, then with the brush, with the amazing precision with which Picasso is able to seize movement at the moment of utmost tension, but without immobilizing it. In July there are toreros again, and in October a whole new series of *Corrida* executed in sepia.

But by this time Picasso was already engaged in a new adventure. Ever since 1948, to reduce the cost of making impressions and to enable him to have the work done at Vallauris, Picasso had used linoleum cuts for engravings, making posters, particularly for the annual pottery exhibition there. In 1958 he returned to this technique again, but this time for its own sake, and he engaged in an extraordinary exercise in virtuosity, in the *Woman's Bust after Cranach the Younger*. In the autumn of 1959 toreros and the conflict between picador and bull provided the theme of the initial trials, and the experimentation can be followed through engraving after engraving. This particular technique involved monochrome colour, or at least significant areas of flat monochrome colour. Picasso was not satisfied until he had explored every possibility, whether in plastic harmony, as in the *Vase of Flowers*,

or in precision of line, as for example in *Picador, Woman and Horse*, or in movement and inter-relationships of figures. Picasso was then led to do two new series, one on the theme of *Reclining Woman and Guitarist*, the other, in particular, on *Bacchanalia*.

The *Bacchanalia* is clearly related to the *Joie de Vivre* of Antibes, but now the sea gives way to the mountains, as if the fauns and nymphs had taken possession of the Sainte-Victoire. Once again movement triumphs in the simplicity and restraint of the means used. Once again Picasso has mastered his own virtuosity. The experiment had been carried through to its conclusion.

The important thing in the meantime is that the *Bacchanalia* of the interior, without the sea, overlaps another theme in Picasso's mind dating back to the summer of 1959—the *Déjeuner sur l'herbe*. The first sketches inspired by this famous painting by Manet date, in fact, from 10 and 11 August at Vauvenargues.

Manet is an old companion of Picasso's dreams, and this first series has all the freedom of a discussion between colleagues. Both the black and white drawings and the two in colour place the accent on a figure to which Manet himself attached a certain importance: the woman in chemise standing in the stream. Picasso resumes her, appropriates her, showing her nude, bending forward in an attitude reminiscent of the foreshortenings so dear to him—a successor to any number of *Toilettes, Women in Chemise, Women Washing their Feet*, scattered throughout Picasso's work ever since the beginning.

Beyond all doubt this figure played a role in the catalysis, but in the same way Picasso also stresses the clearing in which Manet had already enclosed Giorgione's *Concert Champêtre*, closing in the undergrowth even further. The influence of his stay at Vauvenargues is marked here, just as formerly the summer spent at Rue des Bois led to the *Nudes in the Forest*. Vauvenargues—perhaps also the Montagne Sainte-Victoire and memories of Cézanne—reinforced Picasso's taste for landscape, a taste which, incidentally, he has never at any time really lost, if you include his beaches. To be more precise, however, Vauvenargues represents both mountain and forest.

One final point: the *Déjeuner sur l'herbe* is a figure composition more complex and more mysterious than the *Women of Algiers* or *Las Meninas*. And perhaps more stimulating, though I am not altogether convinced of this. I think there are other reasons for the constant increase of

Picasso's work devoted to certain masterpieces of the past which absorb his attention, particularly with reference to his greater freedom, and his compulsive need to say everything he has to say. However, the facts are there and they provoke thought. From one canvas, a study, a watercolour or a lithograph after Poussin, Cranach the Elder, El Greco or Courbet we go on to fourteen *Women of Algiers*, around fifty on *Las Meninas*, and a hundred and fifty drawings, linocuts and so on, and thirty canvases after the *Déjeuner sur l'herbe*. In all, Picasso remained in close working contact with Manet for about two and a half years, from

WOMAN WASHING HER FEET. 1960

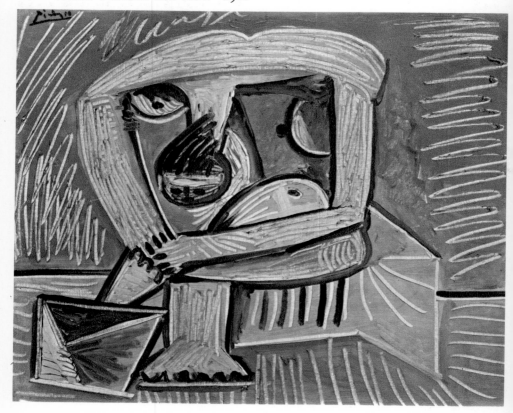

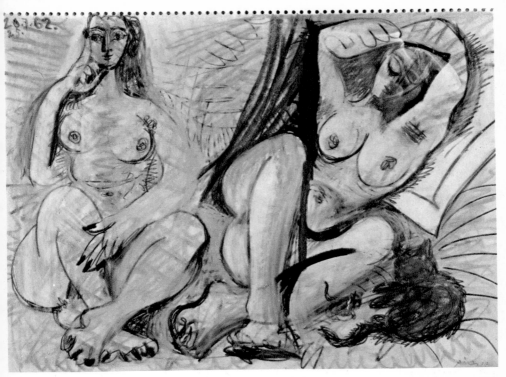

TWO WOMEN. 1962

August 1959 to the end of 1961. And even when Picasso is not dealing directly with the *Déjeuner sur l'herbe* one can observe identical preoccupations in his painting. This is notably true in the case of his *Leaning Women*, painted at 'La Californie' in February 1960, and also of the dislocated figure of *The Bather* painted in April of the same year.

When we follow Picasso's adventure with the *Déjeuner sur l'herbe* in the series of drawings, studies and pictures collected and published in Charles Feld's and Douglas Cooper's album which constitutes a diary of the creation of the *Déjeuners*—a counterpart to the one on *Las Meninas*—the most striking thing is the way in which Picasso interrogates each of Manet's figures, confronts them, isolates them, and constantly modifies their relationships in order to extract their utmost

possibilities, certainly not in any critical or captious sense, but as a painter and on behalf of painting. The interrogation goes far beyond Manet, or Giorgione through Manet; it goes beyond anything that can take place between the man who is speaking—the talker, as Douglas Cooper calls him—and the nude woman who is listening or has ceased to listen, as the case may be, or another woman who is thinking of something else altogether, of bathing in the river, perhaps, or of picking a flower, or of some other man, who is reading, or just looking, or sleeping, or isn't there at all. It is not a question of knowing merely what they can be up to in that undergrowth, or what the man who is talking all the time can possibly be saying, but also, in particular, of understanding what it is that fascinates Giorgione, Manet and now Picasso himself.

One is tempted to reply: pure painting, painting for the sake of painting: what arises from the encounter between these nude women and these clothed men, as it developed in the studio between the painter and his model. There are also direct references—particularly in Picasso's return to the theme of the *Déjeuner sur l'herbe* in August and December 1961—to the series of drawings published in *Verve*. But this answer, which is in reality no answer at all, is dismissed by Picasso himself the moment he takes up the question—it is dismissed by the very insistence with which he asks himself why he is so attached to this particular theme. There is something else, but what? Picasso himself keeps alive all the reality of this burning question. In a masterly series executed at Notre-Dame-de-Vie in July 1961 he returns to the subject of the bathers as though harking back to the great *Baignade* of the Icarus at UNESCO. He also takes up the theme of the *Old Musician* after Manet. And dominating this whole new blossoming is the nude woman leaning forward. In the last canvases of the *Déjeuner sur l'herbe*, those of August, she continues to dominate the scene no matter what the proportions of the talker and the woman in the foreground. She is obsessive, imposing, simultaneously present and absent, humble and domineering. And in the ultimate series of drawings, those of December 1961, in which the talker is doing his utmost to attract the interest of his companion, the same silhouette, reduced in the distance, continues to pick a flower, completely indifferent to what is being said.

In the last analysis, Picasso is conducting the dialogue with himself and with his whole world, assembled in the clearing which Manet has substituted for the open landscape of Giorgione. In any case, the

plastic discussion which dominates the series of the *Women of Algiers* and *Las Meninas* seems to have been settled here right from the start. Picasso presents the adventure in his own language, and when he changes his language, when he returns to a more classic mode of expression, it is for reasons of his own and associations which have little to do with Manet. It is easy to imagine the various versions of *Las Meninas* assembled in a gallery. I believe that the *Déjeuners* will survive in every way, also in the form of a creative diary—a new kind of alliance between painting and printed book which is made possible by modern techniques, and which allows us to follow step by step the discussions and struggles of the painter.

Although 1960 and 1961 will always remain the years of the *Déjeuners*, Picasso did not allow himself to be completely absorbed by them. From these years there are also admirable 'La Californie' windows, particularly at night, besides pigeons, portraits of Jacqueline, and ceramics.

THE MASTER OF MOUGINS

*Art in the twentieth century, like science, has ceased
to be a patchwork of discoveries. We cannot remain
uninterested in what others invent; we can only give them
sense and direction, and organize the continuity of art
in accordance with the historical development of humanity.*

LOUIS ARAGON

Woman and Dog under Tree, which was started on 13 December 1961,
and finished in January 1962, is thus hedged around by the last series
of drawings of the *Déjeuners*. The canvas is related to the experiments
of August and is on a level with the *Déjeuners*, but was intended to
present the world of Jacqueline, the Afghan hound Kaboul and the
Mougins valley. *Bust of a Woman Wearing a Hat*, and *Seated Woman* are
stages in Picasso's tireless stereoscopic search for opposed profiles.
Woman Reading under a Lamp, done on 12 April, is one of those shat-
tering pictures which mark another triumph for the painter. He masters
the space, the modulations of light and the intimacy of the subject so
completely that he confers the dimensions of eternity on that moment
of silence, of absorption in reading. At the same time every element
is present in its own right, in its true function. The lamp is lowered
to light the book. No effect extraneous to what is being said; but at
the same time, no illumination. The light no longer serves, as with
Caravaggio and La Tour, to bring out the subject. It is just light, as
space is space, and the woman reading is a woman reading. She is at
home, in a room whose warmth, silence and intimacy are familiar to
Picasso, profoundly intent upon expressing the human quality of these
realities, each one separately, and all together.

I visited the January 1964 exhibition in the Galerie Louise Leiris, in
Paris, again and again in order to check the documentation for this
book, and each time I was struck by this picture and the appeal of its
light and warmth. Fundamentally, one of the abiding manifestations
of continuity in Picasso's art is founded on his efforts to liberate paint-
ing from the falsification of light. From his blue monochromism to
rose and whirling blacks, to the 'primitive' representation of space and

242

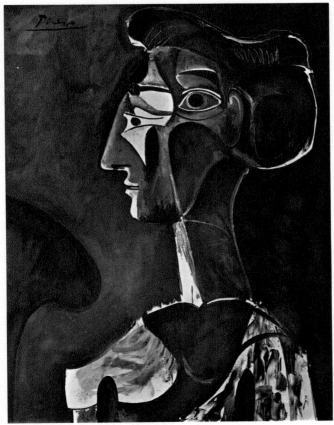

WOMAN'S HEAD IN PROFILE. 1963

relief, to Cubism, one can say that Picasso was always striving to approach
nearer to reality *qua* reality, the reality of things and of beings, of space
and of movement. Independent of Impressionistic lighting. Picasso
is not a painter of variations of climate or season, or momentary effects
of lighting. He is the painter of the human aspect; independence
meaning dependence in relation to man. The culmination of such a
quest is the independence of lighting. Each element can then be taken
independently, for itself and in itself, in terms of painting.

In my view, *Woman Reading under a Lamp* is a declaration of this pro-
gramme. I am not mistaking Picasso for Louis de Broglie, but it is a
fact that they are contemporaries. Picasso is the painter of the century
of Max Planck and Einstein, of wave mechanics and nuclear physics.
He is the painter of the period in which physics is radically probing
all tangible appearances—incidentally, it is also the period in which
the physicist is confronted with the thermo-nuclear warfare he himself
devised. Picasso's painting is that of an artist humanly responsible
to his fellow men, just as the physicist is for the implications of science.

Who could possibly doubt this when we are shown Picasso's Afghan
hound Kaboul examining crustaceans with claws as inhuman as those
of the *Young Girl*, the praying mantis of 1929? This big canvas bears
a date inscribed in numerals larger than the signature, and whenever
Picasso prints the date in this fashion it is because the picture in question
is of some particular private or public importance. The date on this
one is 22 October, 1962, the day which saw the beginning of the grave
international events called the Cuban crisis. The following day yielded
some shellfish and a cat as ferocious as the one devouring the bird in
the spring of 1939, when Madrid surrendered and Prague fell. The
day after that, when it looked as though thermo-nuclear war might
break out at any moment, came a canvas the brutality of which was
more directly human: *The Rape of the Sabines*.

This is a title common to both Poussin and David, but unlike Poussin,
who painted a scene of violence enclosed in an Italian town square,
David painted a scene of reconciliation at the foot of medieval ramparts.
In fact, the titles are not exactly the same, since David's picture is called
The Sabine Women Halting the Conflict between the Romans and the Sabines.
The latter canvas was painted in 1799, the year Napoleon Bonaparte
came to power, and the painting is a hymn to national unity in support
of the new regime.

Picasso's canvas has puzzled certain critics. He did not return to the
Women of Algiers or to the *Déjeuners;* instead he raised an outcry against
war itself and its crimes. The whole might of Rome is shown mar-
shalled against a small people. A caracoling horse threatens to trample
a Sabine woman under foot, and the canvas expresses the fear of a new
Guernica on a much greater scale. The astonishing Mediterranean
associations of this canvas which are intimately related take on the value
of 'Latin' Hispano-Cuban affinities.

244

It is interesting in connection with what Picasso may have had in mind at this time of crisis to read in *The Autobiography of Alice B. Toklas* what is said of his first meetings with Gertrude Stein: 'I did not realize at the time to what extent Gertrude Stein is an American. She is, in fact, entirely and completely so... She had a collection of very fine photographs of the American Civil War, and she and Picasso spent hours looking at them. Occasionally the question of the Spanish-American War came up in their conversation, and then Picasso would become very Spanish and very bitter. In their persons Spain and America exchanged some very harsh truths.' Picasso was seventeen years old when the Americans expelled the Spaniards from Cuba.

It is worthwhile noting here that on 25 October Picasso painted a canvas on a very different subject, although it also dealt with violence: *Bicycle Accident*. Picasso never limits himself to a single assault; he makes multiple attacks, lays ambushes, and launches offensives in order to arrive at the fullest and most accurate expression possible of the thing that obsesses him, or that he feels he must communicate.

The development of Picasso's painting carries him steadily towards greater precision, whether in his methods, his subjects or the plastic orchestration of his themes. The dark canvas of the charging horse has something of the Giaour in Delacroix's *Massacre of Chios* about it; and, more peacefully, it seems as if Picasso had inherited from Goya the features of the Duchess of Alba in his pictures of the spring of 1963: *Woman's Head*, *Woman in Armchair*, and *Woman's Bust*.

The series of canvases under the title *The Painter and His Model* also bears witness to freedom of execution of an astonishing level. In his studio at Mougins Picasso now resumed the exploration of the 'Interior Landscapes' begun at 'La Californie', although now directly dealing with the essential. In the very first canvases from the beginning of March 1963, the place, the space, the light, the atmosphere and the personages are expressed with the minimum of colour on white, the white of the prepared canvas, and the whole gamut of whites, applied not only in light touches, but also thickly, and in impasto.

This full range of whites allows colour to serve completely the function of drawing, of line, creating its own space, its own movement, its own light. The concision and dialectics of the means of painting are thus simultaneously carried to an extreme. Each colour and each white is reciprocally enhanced, creating relief and hollows, solids and

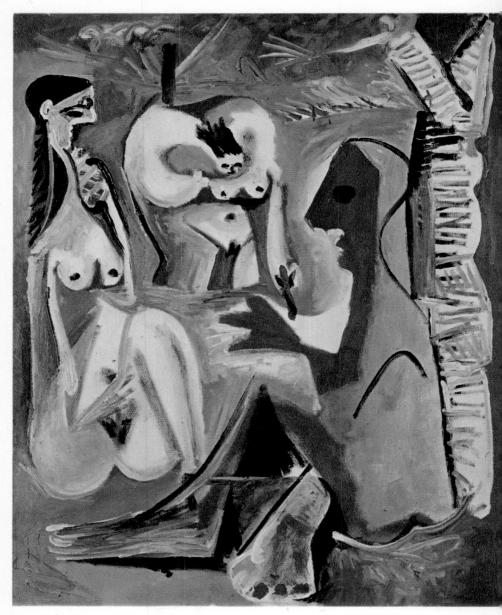

LES DÉJEUNERS. PLATE 152. 1961

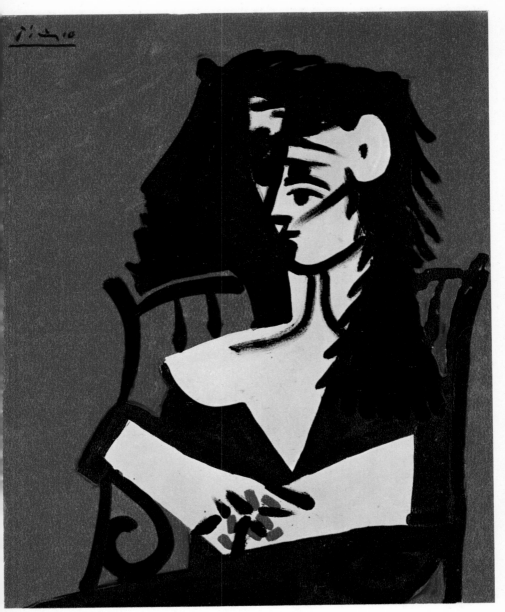

WOMAN'S PROFILE ON RED BACKGROUND. 1959

voids, light and shade. This mode, which treats virgin white as a colour, allows an extraordinary range of intensities with unheard-of transmutations, in which the form of a female nude catches the light, curves over, and projects from the canvas because it is 'not painted' but expressed, in the intimacy of the studio, by waves of colour.

A somewhat earlier canvas allows us to measure the significance of this procedure. The *Landscape at Mougins*, painted between 26 December 1962, and 16 January 1963, marks a stage just as important as *Woman Reading under a Lamp* in this search for painting totally objective in its means of expression. According to the way it is used, concentrated, diluted, splashed or dripped onto the virgin white of the bare canvas, or on painted white, exactly the same blue suffices to create distance, sky, mountains, a lake, and even the diffused radiance of winter and the chill in the air. Rejecting excessive polish, finickiness, unnecessary filling-in and every kind of mannerism, Picasso rehabilitates and justifies every possible way of treating the canvas and the colour, including each gesture of the painter, his accentuation or absence of it, in short, every act of his creation, of his plastic expression.

The series of *The Painter and His Model*, far from being a mere repetition of earlier investigations, is a complete dialogue between painting and reality and their human incarnations: the painter, caught here at the peak of creative tension, and the model, never before worked over with such relish, in the calm of the studio, in the warm air of the garden, in the depth of the forest. Nothing counts that is not necessary, yet nothing is lost of the richness of the outside world, of the very sap of life. The rigour, understatement, stripping down to absolute essentials bring out their opposites: expansion, even exuberance, the endlessly changing and endlessly renewed variety of impressions and perceptions— Poussin at grips with all the sensual temptations of nature and woman.

But this conflict, this combat, is never seen from the outside, never described abstractly, but on the contrary altogether revealed in plastic terms. To paint man in his creative struggle Picasso uses other means than when he paints the model, whose task it is to wait, and who aids or resists the work of the painter. In a certain sense the painter is independent of the studio; the model, on the other hand, is defined by the surroundings. In 1950 in his dialogues with Courbet and El Greco Picasso sought to conquer the uniformity of the space between the figures, or between them and objects of nature. The series of *The*

Painter and His Model, the forty-five or so canvases on this theme executed between March and June 1963, still further developed the investigations Picasso had been conducting since the *Women of Algiers*, on the complex organization of personages in an enclosed space. The result was a differentiated representation of space, which is not the same around the constantly moving painter as it is around the immobile model.

An intermediate series helps us to understand what Picasso means by increased precision, greater exigencies in the plastic re-creation of the world, and of ideas concerning that world. I am referring to the drawings brought together by Michel Leiris in an exhibition at the beginning of 1961, entitled *Romancero du Picador*. 'The painter and his model, the woman and her image, the lover and his beloved, the picador and the bull, are they not—if it is permissible to use such a thread to guide us through the Daedalian maze of Picasso's art—the avatars at the two poles of a kind of dialectic in which everything is based on the unresolved opposition of two beings facing each other, the living image of that tragic duality of consciousness affronted by what is unfamiliar to it?'

The *Romancero du Picador* gives us not only the bullfight, its jousting and its extraordinary picaresque obverse—the workmen of the arena, its whores and ponces, its dancers and duennas—but also, by means of wash and pen-and-ink drawings, that qualitative exploration of space which Picasso's other series, *The Painter and His Model*, was to carry out with such thoroughness. The astonishing dancer in wash drawing No. 2, of 16 June 1960, facing a picador who, frozen in immobility, contemplates her, prepares the way for the conflicts and audacities that resolve them in a radiance of colour and light in the self-portrait of *The Painter and His Model* of 26 March 1963.

Undoubtedly, before a work of such importance, one is immediately carried away by its graceful ease, the astonishing freedom of the composition and the gestures of the painter, the imprint of which is preserved in the colour. But there is nothing wanton or gratuitously serene about this grace and equilibrium. Picasso succeeds in harmonizing the rigour of his conception with suggestions of spontaneity by freely accepting the contradiction; in fact the very subject of his canvas becomes an attempt to resolve the contradiction, to go beyond the conflict by the means of art itself.

This re-evaluation of the means of painting reaches such a level that it appears pure improvization, producing a feeling of freshness,

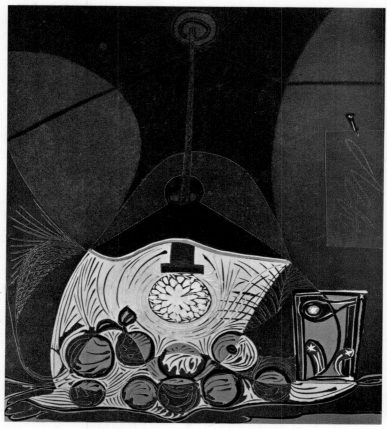

STILL-LIFE BY LAMPLIGHT. 1962

a direct and limpid contact with the world which is irremediably destroy-
ed by illusionist finish and polish. So much so that the proponents
of academic and decorative painting, confronted with this work, call
it nonsense. One, and not the least, of the strengths of this hymn to
the joy of painting is that it is also a hymn to the joy of creating. 'Paint-
ing is stronger than I am', wrote Picasso on 27 March. 'It makes me do
what it wants.'

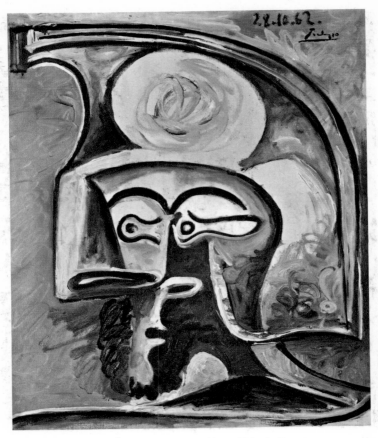

THE WARRIOR. 1962

These were the words with which he welcomed us into his studio two days later. The great canvas of 26 March radiated amidst the twenty he had finished since 22 February, when he returned to the theme of the painter in his studio. Despite this cold day of early spring, the sun was shining through the large bay windows, making the colours and the whites sing. 'It's crazy what it makes me do, isn't it?' he exclaimed. In accordance with his usual habit he had arranged the canvases

251

that particularly interested him so that he could take them all in at once, and from one end to the other of the long room they made a circular front of painters at work on their models.

A year later in mid-April 1964, we were once again together in the studio. This time he was entirely taken up with some big canvases, predominantly white and green, representing Jacqueline holding a little black cat. One is captivated by a sensation of serene melody, a very pure and peaceful song—by beauty. This new series also throws further light on the series of *The Painter and His Model* and makes a harmonious conquest of it. However, after this series of Jacqueline and the little black cat will come other canvases which will again modify our point of view and we will learn to see certain signs in the preceding ones that had escaped us at the time.

Picasso's observation that painting is stronger than himself must also be understood in relation to the continuity of his art, wherein it is invariably the new paintings, the new canvases that enlighten, go beyond and enrich those that preceded. The fact is that Picasso cannot be understood outside of the unity of his work and the extraordinary determination which sends him back tirelessly to fight the same battles in a continuity of will that is altogether amazing. Nor can he be understood by anyone who turns his back on the jolts and shocks of his creation, at his willing obedience to the call of reality, at the diversity of his genius, and at the sudden impulses of his sensibility.

Picasso is well aware of these inherent contradictions in his nature. His work and the discipline he imposes on himself add up to a series of struggles to master the things that agonize or fascinate him. Dialecticism, in the Hegelian sense, is thus perfectly natural to him, and he is the most profoundly dialectical of all painters, the painter who has the clearest and sharpest realization of the contradictions to be overcome in order to give the raw material of reality, always deceptive in appearance, the most rigorous plastic form possible. He is a painter who knows that painting is also, and precisely, the art of appearances.

This is the level on which Picasso invites us to adapt ourselves. It is now thirty years since he said to Christian Zervos: 'You can't go against nature. She is stronger than the strongest man. We can allow ourselves a liberty or two, but only in details.' This statement dates from a time when most people just did not understand the relationship between Picasso's painting and nature, a time when, in fact, most

people would have said that there was no relationship at all between the two, and that Picasso quite deliberately distorted nature. The truth is that in his own sphere Picasso has always respected Bacon's dictum that you can master nature only by obeying her. After all anyone can see perfectly clearly the sun going around the earth; but the fact is that obeying nature often means contradicting the way in which she shows herself to us.

It is strange to observe that in a way Picasso now substitutes painting for nature. Times have changed. In the spiritual confusion brought about by the extent and the rapidity with which our lives have been transformed, particularly since the end of the Second World War, the idea has spread that the only valid basis for painting was to discard all relationships with natural form, in other words, to deny the whole organization of visual perception. It is in this context that Picasso points out that you can master painting only by obeying it, painting for him being a living phenomenon, governed by the laws of nature, a human re-arrangement of form and matter.

To be fully and completely a painter, the painter must become painting made man. But at the same time he must not cease to be the man he is. This is the source of the rending, the anguish and the happiness that Picasso has experienced, since sixty years ago he chose to obey painting and nature in defiance of the conventions elaborated and established in the *Quattrocento*.

And the struggle still goes on. Picasso has made an important contribution to the technique of the lino-cut—by making successive hollowings, the same plate can serve for different inkings, which allows a more precise registration of the prints. The two hundred ceramic dishes exhibited at Vallauris in the summer of 1963 reveal a new freedom in the use of enamels and in the composition of coloured motifs. Picasso's experiments with engraved terra-cottas and with relief in white impasto have also produced interesting results. A series of portrait drawings of the old French Communist leader Marcel Cachin, and another series executed at the request of Anne Villelaur for the Shakespeare number of *Lettres Françaises*, display audacities and omissions of stroke—like ellipses in language—that combine resemblance with abstraction in an altogether unique fashion.

The faces of Shakespeare, with or without Hamlet, in the graveyard with death and the gravedigger, are all dated 17 April 1964. The pre-

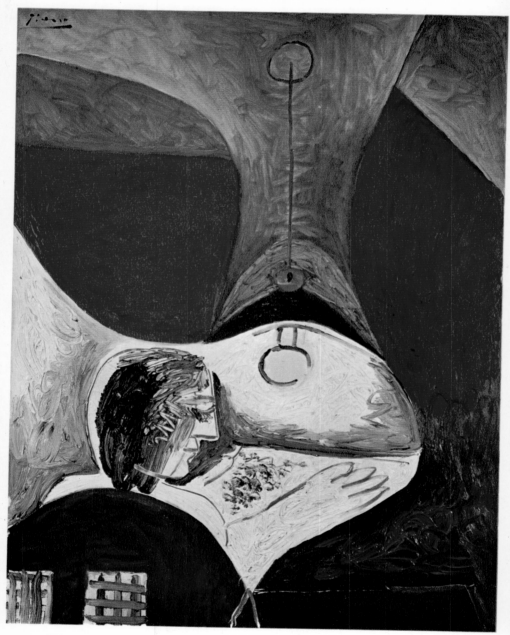

WOMAN READING UNDER A LAMP. 1963

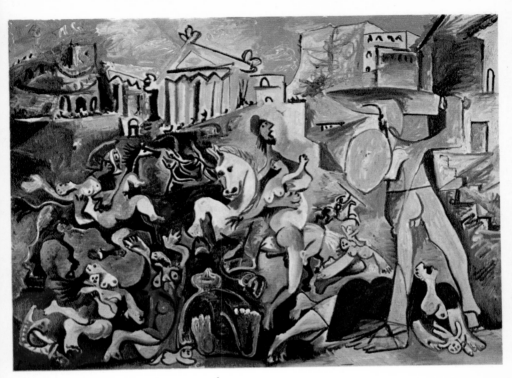

THE RAPE OF THE SABINES. 1962

vious day Picasso had received organizers of his exhibition in Japan, to which he had sent the fifty-eight canvases of *Las Meninas*. Now he drew his name in Japanese characters, studying their relationship to the page, trying to master their structure, and ending up by painting in the background as well, only leaving a white margin around the characters. As I write this a couple of weeks later, I am quite sure that the arrangement of the studio has been altered. Some of the pictures which were in the front have now been covered up by others, and vice versa. Picasso has perhaps returned to one or more earlier canvases and completely repainted them. Some new drawings may have been made, undoubtedly new experiments tried. Perhaps the drawing after Poussin's *Bacchanalia* which dates from the tumultuous day of the liberation of Paris, is still on the cabinet in a corner of the studio, next to two small

portraits by the Douanier Rousseau of himself and his wife—just as in the other studio which has recently been reclaimed from the courtyard there may be a drawing dating from 1920 representing *Le Rapt*. Or perhaps not. The arrangement of things here keeps changing according to the rhythm of the painter's work, and the latter is as limitless as human knowledge itself. There will always be something left for Picasso to discover, to learn, to attempt—always some previous experiments to take up again and carry still further. His is an art the aim and significance of which coincide with life itself. 'What can I do?' says Picasso wryly when the urge to work takes hold of him and he shuts himself up is his studio. 'I have no choice but to *earn* my life.'

Launay, 5 October 1963—2 May 1964

Picasso had just opened a big portfolio stuffed full of engravings, with all their different states. It was a series of *The Painter and His Model*, done later than the painted series, the majority having been executed in November and December 1963. The first states resembled the wash drawings of the last series of *Toreros*, although here the figures were silhouetted in white by the surrounding space which was formulated in black and grey areas. The final states, re-worked and completed with the burin, bluntly accentuate the hiatus of the contours. I found the same process of ellipsis which had struck me so forcibly in the drawings for the Shakespeare series. Once again Picasso had carefully studied how far he could carry elision and the deliberate abstraction of details. Here he resorts to different registers of the engraving to obtain the dualities present in the canvases of *The Painter and His Model* series, contrasting the black areas, the lines and the whites. By this means, he guides the eye of the observer to reconstitute and conceive contours which are not actually present, to 'imagine' depth, relief and movement.

The significant thing here is that the observer does, in fact, re-create contours which are neither sketched nor suggested, not even hinted at. With the aid of one or two signs indicated by modulations of a continuous line the painter actually directs our eye and our understanding. What Picasso puts in parentheses, so to speak, is our common experience of reality. He leans on what we already know in order to

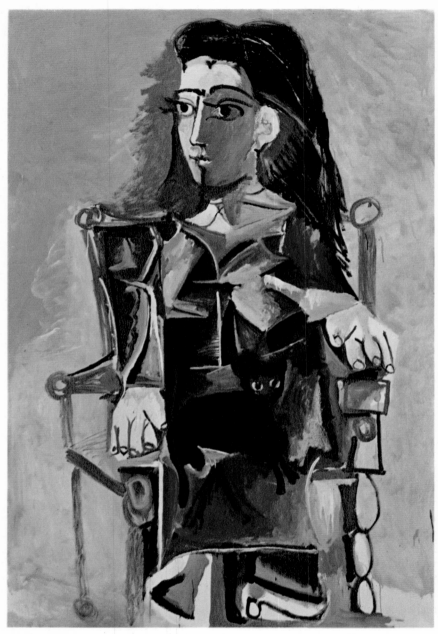

JACQUELINE WITH BLACK KITTEN. 1964

have complete freedom to lead us on to what he alone knows and intends to tell us. After more than half a century he re-opens avenues of research he initiated in the *Girl with the Mandolin* of the Penrose Collection—except that this time the elisions and the simplifications are no longer conducted towards an abstract geometrical reconstruction of space in the style of Cadaqués, but rather towards a true image of reality.

Whereas in 1910-11 Picasso guided the observer amongst his 'Cubist' transpositions by means of untransformed references such as Braque's *trompe-l'œil* nail, today with the interrupted contour of homogeneous form, only the reference points subsist. Now the movement of our eye from one to the other creates a new unity of representation, an exchange between reality and the observer, in which the latter plays an active role.

Perhaps the fact that we can all see that shoulder, that torso and that arm quite clearly, although they are neither stated nor shown directly, is the real context of Picasso's remark: 'I've caught something of reality there.' However, there was also something else in his urge to confirm that he really had 'caught something of reality,' although I did not understand this until later. After looking at that first portfolio of engravings we went upstairs to see the new studio Picasso had had built next to his own room. Both studios—one on each side of the living room—were full. At least they were in the sense that it was now no longer possible for Picasso to clear them up sufficiently to allow him to start off on some new adventure. He needed space. Things would have to be re-arranged, which meant destroying the sort of harmony between him and his surroundings which he needed to give himself over to his work.

The terrace roof, supported by metal scaffolding, was already finished. By the side of the house was a yellow crane. Picasso said that he liked having it around and would like to keep it. The view from here extends beyond the line of big olive trees over all the country behind Cannes, which Picasso painted in his *Mougins Landscape*. The new highway cuts a gash there through the country which I hadn't noticed in Picasso's painting, but which is there just the same, as is also the gulf of La Napoule which, however, from there looks like a lake. The cypresses were particularly beautiful in the summer light. 'And look,' said Picasso, 'each one has been planted in exactly the right spot.'

On the other side of the house, next to the bathroom, was an unfurnished room piled full of lino-cut proofs. Picasso opened the windows

and on a chair placed another portfolio of drawings just as full as the first—they were the series of engravings of *The Painter and His Model*. The transformations between the various states plunged us into the very heart of Picasso's creative work, and this insight into the progressive stages of his expression was fascinating. I thought of Rembrandt —the different states of *The Three Crosses*, for example—Rembrandt who liberated engraving from the hard and fast rules of the burin technique, who opened up a whole range of processes and combined them, who also took advantage of accidents. A whole family of painters have felt the need to extend the resources of engraving and to utilize them to the full—it runs from Rembrandt through Goya to Picasso.

Picasso showed us some pulls he had made himself. He took a lino-cut from the *Bacchanalia* series and gave it to Jacqueline to ink. Then we watched him pull it. Then taking another lino-cut, Picasso made a different drawing, recutting and going over the original impression, resulting in a new work combining the engraved parts with the fresh drawing.

We now ascended to the roof terrace of the farmhouse where there is a strange collection of chimney stacks. 'All they need is arms', said Picasso, and he made a gesture as though to add what was required. Perhaps someday a whole crowd of statues will rise on the terrace. We again looked out over the countryside; it was even more beautiful from this height. And the cypresses, arranged as in a Poussin. 'Poussin knew it all down to the tiniest line', remarked Picasso, and a gesture of his hand described the line of cypresses in perspective—a point of reference, a 'hinge', as Eluard once wrote.

After a while we went back to the living room. On a small side-table was the yellow catalogue of the Picasso exhibition in Tokyo, together with some books by Sartre, including his latest in which he returns to old articles containing attacks on Picasso. On the table in the middle of the room was a list of the names of the founders of Marseilles in whose honour Picasso had been commissioned to design a monument. Elsewhere, on top of a book just published about *Les Dames de Mougins*, stood a photograph of a site in Chicago, hemmed in by skyscrapers under construction, where they want Picasso...

Such is his life. The world is beating a path to his door in Mougins. There is no end to the orders, the discussions, the appeals, the attacks. Just now, after going the rounds in Europe for ten years, Papini's

imaginary interview with Picasso, which some people pretend to regard as a confession of imposture, has reached New York. It has always been like that, certainly since the days of the *Demoiselles d'Avignon*. No one is going to give in. And why should they, since Picasso himself has never laid down his arms?

The conversation turned to the Biennale in Venice which had just crowned American Pop art, which some people connect with Dada. Picasso made one of his inimitable gestures to indicate that Dadaism was something very different. 'There was truth in our montages of fifty years ago', he said. Incidentally, it was Hélène Parmelin who observed that for Picasso, reality was more and more referred to as the truth.

It seemed to me now that I could better understand his remark a little while back in front of his engravings: Picasso setting himself apart from that allegedly modern painting which did not fasten on to reality, to the truth. It was as though he had read my thoughts: 'When we came along with our collages and our montages—the first ones, those before 1914, they knew it was a revolution. Moreover, when they really did make the revolution in 1917 they had a pretty good idea of what we were trying to say. At least at first. But after that?'

Then came another gesture which did not finish the phrase. Nor did it end the conversation, nor anything else either. That is always the way. That's the way of truth. Every day brings its battles; the same battle and yet a new one; the same reality and yet a new reality, which Picasso will seek to catch by means of his painting—the very means employed by the artists of Altamira and Lascaux, and yet at the same time different and new ones—just as painting itself is always the same, with always the same problems, and yet with new ones.

LIST OF ILLUSTRATIONS

Italic figures indicate colour plates

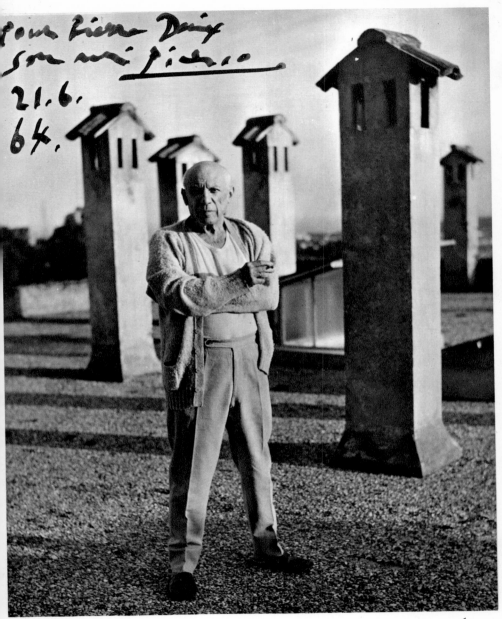

PICASSO ON THE TERRACE OF THE ROOF OF NOTRE-DAME-DE-VIE AT MOUGINS. 1964

266

268

INDEX OF NAMES

PRAEGER WORLD OF ART SERIES

ART OF CHINA,
KOREA, AND JAPAN
Peter Swann

ART OF THE
BYZANTINE ERA
David Talbot Rice

THE ART OF
THE RENAISSANCE
Peter and Linda Murray

A CONCISE HISTORY
OF MODERN PAINTING
Sir Herbert Read

THE ART OF
THE ANCIENT NEAR EAST
Seton Lloyd

A CONCISE HISTORY
OF PAINTING
From Giotto to Cézanne
Michael Levey

BAROQUE AND ROCOCO ART
Germain Bazin

EARLY MEDIEVAL ART
John Beckwith

ISLAMIC ART
David Talbot Rice

A CONCISE HISTORY
OF ENGLISH PAINTING
William Gaunt

ROMAN ART
AND ARCHITECTURE
Sir Mortimer Wheeler

GREEK ART
John Boardman

EUROPEAN SCULPTURE
From Romanesque to
Neoclassic
H. D. Molesworth

A CONCISE HISTORY
OF MODERN SCULPTURE
Sir Herbert Read

ANCIENT ARTS OF
CENTRAL ASIA
Tamara Talbot Rice

ANCIENT ARTS OF
THE AMERICAS
G. H. S. Bushnell

A CONCISE HISTORY
OF RUSSIAN ART
Tamara Talbot Rice

PRAEGER WORLD OF ART PROFILES

PICASSO
Pierre Daix

KLEE
Gualtieri di San Lazzaro

CHAGALL
Jean Cassou

SEURAT
John Russell